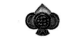

# The Fabergé Menagerie

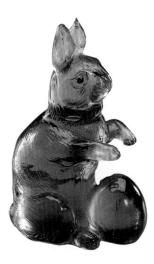

# The Fabergé Menagerie

Organized by the Walters Art Museum, Baltimore, in cooperation with the Fabergé Arts Foundation, Washington, D.C.

The WALTERS
ART MUSEUM

Philip Wilson Publishers

© The Trustees of the Walters Art Gallery, Baltimore

ISBN (the Walters Art Museum softcover edition) 0-911886-55-9
ISBN (PWP hardcover edition) 0 85667 563 6

Edited by Deborah E. Horowitz, the Walters Art Museum
Designed by Peter Ling
Printed and bound in Italy by EBS, Verona

First published in 2003 by Philip Wilson Publishers Ltd.
7 Deane House, 27 Greenwood Place, London NW5 1LB

Distributed in the United States and Canada by Palgrave Macmillan, 175 Fifth
Avenue, New York, NY 10010
Distributed in the UK and the rest of the world by I.B. Tauris & Co. Ltd., 6
Salem Road, London W2 4BU

Photo Copyrights: All photographs in the catalogue of the exhibition are
copyright of the lender unless otherwise indicated. Courtesy of A La Vieille
Russie: figs. 12, 13, 16; Courtesy Department of Library Services, American
Museum of Natural History: cat. nos. 96, 107, 115; From the Castle Howard
Collection: cat. nos. 76, 108; John Dean: cat. no. 16; Fabergé Arts Foundation:
fig. 3; The Forbes Collection, New York: figs. 5, 17; Hermitage Museum: figs. 4,
10; Courtesy Royal Family of Thailand, from *Fabergé*, B. Krairiksh, ed. Bankok
n.d.: fig. 8; Collection of Ulla Tillander-Godenhielm: fig. 9; Courtesy of
M. Swezey: figs. 14, 18; Van Pelt Photography: cat. no. 95; Walters Art
Museum: figs. 1, 2, 15; Courtesy of Wartski, London: figs. 6, 7, 11

Photography by: Howard Agriesti: cat. nos. 53, 77, 79, 91; J. Coscia, Jr.: cat. nos.
21, 25, 78; C. Chesek: cat. nos. 107, 115; H. Peter Curran: cat. nos. 39, 70; John
Dean: cat. no. 16; Ali Elai: cat. no. 84; David Fischer: all Andre Ruzhnikov and
John Traina, Jr. objects; Helga Photo Studio: cat. nos. 29, 75, 86; Marvin Lyons:
fig. 5; Joshua Nefsky: cat. nos. 24, 54; E. Owen: cat. nos. 7, 8, 69; Prudence
Cuming Associates, Ltd.: cat. nos. 57, 94, 110, 116, 121; Larry Stein: cat. nos.
48, 52, 105; M. Swezey: fig. 14; A. Tillander: fig. 9; Susan Tobin: all Walters Art
Museum objects; Van Pelt Photography: cat. no. 96

The following objects will be exhibited at the Walters Art Museum only: cat.
nos. 1, 24; the following object will be exhibited at the Walters Art Museum and
the Portland Art Museum only: cat. no. 86

## Venues of the Exhibition

| | |
|---|---|
| 13 February–27 July 2003 | The Walters Art Museum, Baltimore, Maryland |
| 12 October 2003–4 January 2004 | Columbus Museum of Art, Columbus, Ohio |
| 8 February–2 May 2004 | Portland Art Museum, Portland, Oregon |

## Cover Illustrations:

Front: Cat. no. 115 (Seals on an Ice Floe)
Back: Cat. no. 18 (Box with Miniature of *The Return from Church*)
Spine: Cat. no. 69 (Rabbit and Egg)
Front flap of hardcover edition only: Cat. no. 25 (Apple Gum Pot)

# Contents

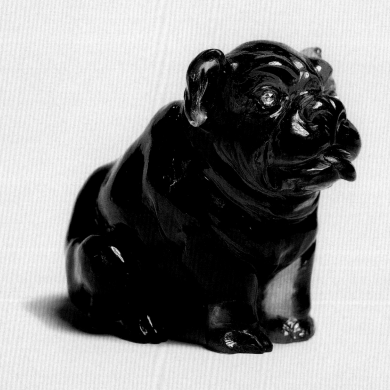

# Foreword

Henry Walters purchased his first pieces from the House of Fabergé during a visit to its headquarters in St. Petersburg in 1900. During the following thirty years, he acquired other exquisite items—including animal carvings, decorative accessories, and two famed Imperial Easter eggs—both as gifts and for his own collection. The current exhibition provides the Walters Art Museum with the rare opportunity to display some of the gems of its holdings along with those from museums and private collections around the world, many never before exhibited.

*The Fabergé Menagerie* focuses on the firm's innovative use of the colorful minerals and stones that had recently been discovered in Russia. These richly hued and textured materials were an essential element in creating the craftsman's unique and elegant style. This exhibition presents over one hundred pieces that demonstrate the full range of Fabergé's creations. Although the Imperial Easter eggs and accessories such as cigarette cases and parasol handles are perhaps his most famous works, Fabergé's animal carvings have a universal appeal that has charmed his clientele and viewers for a century—and these finely detailed, miniature masterpieces take center stage here.

This celebration of Fabergé's artistic mastery has been assembled as part of the festivities throughout the city of Baltimore to mark the 300th anniversary of St. Petersburg. This Russian capital, founded by Peter the Great in 1703, has a rich tradition of art and culture, to which Fabergé was a notable contributor, and the Walters is pleased to bring some of the most exceptional of his creations to the United States.

This exhibition has been organized by the Walters Art Museum in collaboration with the Fabergé Arts Foundation, and both would like to take the opportunity to thank curators William R. Johnston, Associate Director and Curator of 18th- and 19th-Century Art at the Walters, and Marilyn Pfeifer Swezey, from the Fabergé Arts Foundation, for their work on this project. The museum would also like to thank Marianna Chistyakova from the A. E. Fersman Minerological Museum, Russian Academy of Science, Moscow, for her contribution to the catalogue, as well as Deborah Horowitz, Editor of Curatorial Publications, and Susan Tobin, Head of Photography, from the Walters for their efforts.

GARY VIKAN, *Director*
*The Walters Art Museum*
*Baltimore*

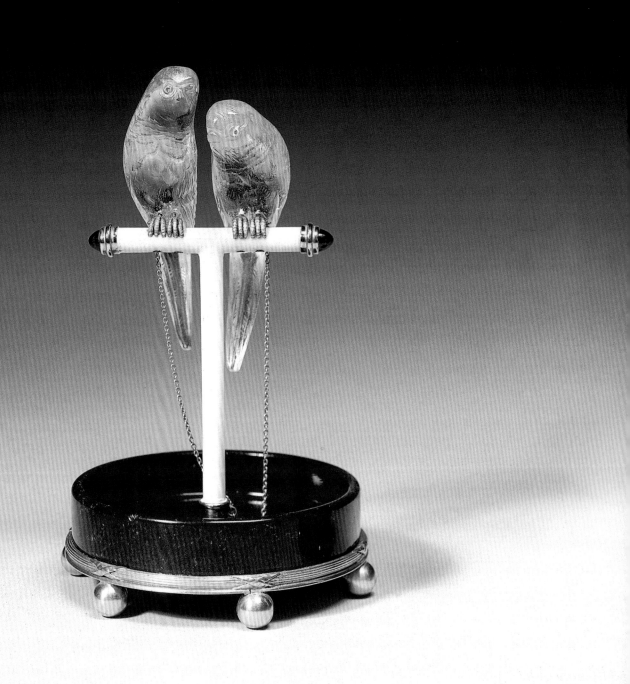

# Preface

Peter Carl Fabergé was nothing if not courageous. He had a sure hand, was certain in his taste, and uncompromising in the standards of his craft. His ability to be an innovator, to do what other jewelers did not dare, to learn new techniques even while the undisputed "Crown Jeweler" of Europe, was a mark of his authority. Born of this unshakable confidence was Fabergé's introduction of hardstone—*semi*precious stones—into the serious art of silver- and goldsmithing. Why not? He was unburdened by "what others may think." His was a light touch, a sense of fantasy that could soar. And indeed it did.

Before the nineteenth-century discoveries of new varieties of hardstone in Siberia and the Urals, hardstone was of marginal interest to the firm of Fabergé. However, the master jewelers in Peter Carl Fabergé's St. Petersburg workshop were often called upon to repair hardstone objects elsewhere, at costs often exceeding their original prices. In 1908, Fabergé made the decision to open his own stone-cutting department. The craftsmen in this new venture soon perfected the technique of cutting, polishing, and coordinating hardstone with gold and silver. The stones of Siberia found an elegant place in Fabergé's fine repertoire of jewelry and decorative art objects.

During the last decade, in European capitals as well as in great and small American cities, people have queued up to admire the design and extraordinary craft of pieces produced by Fabergé's St. Petersburg workshops; each object of art produced with the demanding standards of the man himself. Legend has it that Carl Fabergé would not hesitate to use his famous gold mallet to smash a piece that one of his artisans had worked on for more than a year if he found a single flaw. Other jewelers competed for center stage in the international market by a larger production of precious gemstones, but Fabergé's semiprecious hardstones, transformed into objects of art or intermingled with gold and silver, stayed the course; the charm, craft, and artistry of Fabergé's work survived as art while that of many of his competitors came to be recognized simply as advertisements of wealth.

*The Fabergé Menagerie* was developed by the Fabergé Arts Foundation in collaboration with the Walters Art Museum over a period of years. Our object was to interest and amuse—above and beyond the line and contour of the objects. Fabergé's animals win your heart, whether the eosite pig or the humble bowenite toad. The Fabergé animals remind you how recent was the discovery of Russian hardstone in Siberia and the Urals. The animals will elicit admiration for Fabergé's uncanny ability to transform the netsuke art from Asia into a familiar western menagerie. The use of Russian hardstone commands your eye to concentrate on its seemingly infinite variety of color and striation. Hold a rough-cut morceau of Siberian jasper in the palm of your hand and begin to understand Faberge's mastery of a complex technology. The goal was to create an exhibition for the whole family: for adults to appreciate the art of Fabergé and for children to see a piece of seemingly ordinary rock transformed into an animal. The Walters Art Museum has organized the exhibition with the expertise in Russian art for which, under the direction of Gary Vikan, the museum is widely recognized.

Fabergé's courage, integrity, and spirit of entrepreneurship continue to inspire. The Fabergé Arts Foundation is grateful for the meticulous research and unfrayed enthusiasm of both the Walters' Curator of 18th- and 19th-Century Art, William Johnston, and its own curator, Marilyn Swezey, as well as the indispensable support of our Board of Directors. Since 1990, we have been inspired by Carl Fabergé's work to assist in conserving St. Petersburg's cultural heritage. We salute the city on its Tercentenary celebration in 2003 and offer this exhibition as our gift.

Joyce Lasky Reed, *President*
*Fabergé Arts Foundation*
*Washington, D.C., and St. Petersburg, Russia*

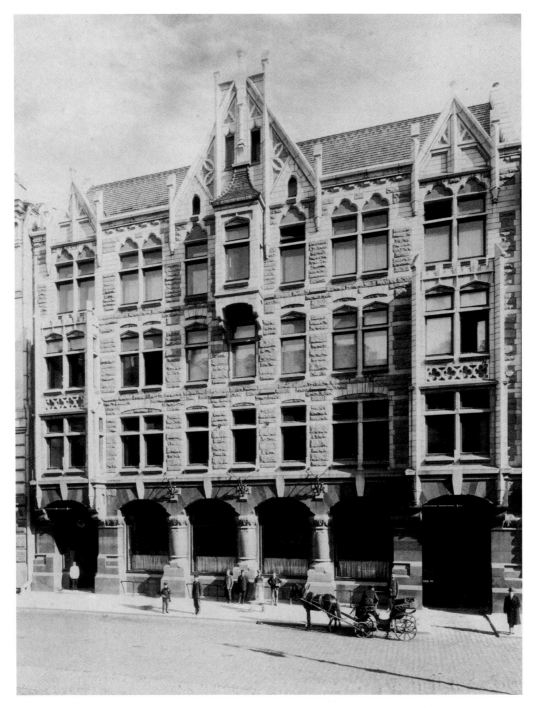

*Figure 3*  The Fabergé shop at 24 Bolshaya Morskaya. Above the shop on the ground floor were offices, workshops, the design studio, and the apartment of Carl Fabergé and his family

# The House of Fabergé: An Historical Overview

WILLIAM R. JOHNSTON

During the summer of 1900, Henry Walters, accompanied by family members and guests, cruised the Baltic Sea on his yacht, the *Narada*. Reaching St. Petersburg, they steamed along the Bolshaya Neva River, a course that presented a commanding view of the city founded by Peter the Great in 1703 (*figure 1*). Once berthed, they were welcomed and given a tour by their friend Julia Grant, the former president's daughter, who had recently married a Russian nobleman, Prince Michael Cantacuzene. A highlight of the visit was a stop at 24 Bolshaya Morskaya, the newly opened headquarters of the House of Fabergé. Henry, an ever-generous host, purchased a pair of jeweled opera glasses for his friend Mrs. Pembroke Jones (*figure 2*)[1] and parasol handles for his other guests (cat. nos. 49, 50, and 51), as well as several carved hardstone animals for himself (cat. nos. 74, 101, and 109). In so doing, he had the distinction of becoming one of the first Americans to patronize the establishment.

The year of Walters' visit was a landmark in the history of the House of Fabergé. With the completion of the imposing four-storied granite building on St. Petersburg's most fashionable shopping street, Peter Carl Fabergé (1846–1920) consolidated his firm's display room, principal workshops, library, and studio under one roof. Also that year, in what was to be its most auspicious venture outside Russia, the Fabergé firm participated in the Paris Exposition Universelle, exhibiting several Imperial Easter eggs[2] together with miniature replicas of the Imperial Regalia. In addition to attracting an international clientele, the firm won numerous prizes. Carl Fabergé, who served on the jury and was therefore *hors concours*, received a gold medal and the cross of the *Légion d'honneur*, and his sons Agathon and Eugène, as well as his head workmaster Mikhail Perkhin, were also awarded honors.

The House of Fabergé was already fifty-eight years old in 1900. Carl's father, Gustav (1814–93), whose Huguenot forbears had fled France during the seventeenth century, moved to St. Petersburg to apprentice as a goldsmith. In 1842, he opened a modest jewelry shop specializing in conventional gold, diamond-set, and enameled jewelry. Eighteen years later, Gustav placed two associates, Hiskias Pendin and V. A. Zaiantkovski, in charge of the business and retired to Dresden with his family. During the reign of Augustus the Strong (1670–1733), the Saxon capital had become renowned for its luxury arts, especially jewelry, lapidary work, and porcelain. In 1723/24, its state treasury was converted into a public museum known as the Grünes Gewölbe (Green Vaults) in which masterpieces of jewelry and lapidary work, notably those by the late Baroque jeweler Johann Melchior Dinglinger, were displayed (see cat. no. 1). The influence of the Grünes Gewölbe on young Carl is demonstrated in the current exhibition by the Renaissance Egg (cat. no. 21), which replicates a chalcedony casket in Dresden made by the eighteenth-century Amsterdam jeweler Leroy. Subsequently, Carl Fabergé continued his foreign studies, visiting Frankfurt-am-Main, Paris, London, and Milan.

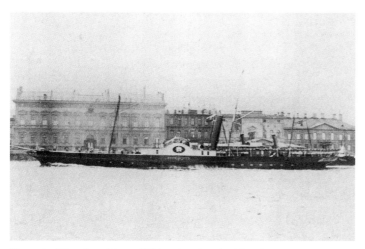

*Figure 1*   View from Henry Walters' yacht, the *Narada*, in St. Petersburg, 1900

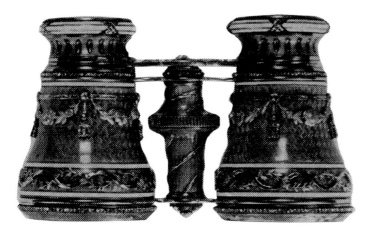

*Figure 2* Jeweled opera glasses purchased by Henry Walters

In 1864, he returned to his father's shop in St. Petersburg, assuming control of it eight years later.

His younger brother Agathon (1862–95) joined the business in 1882. He has been characterized as the more imaginative artist of the two,[3] and together they decided to emphasize the production of *objets de fantaisie* rather than jewelry. While Carl adhered to classical styles, Agathon, who was reputedly of "a more lively and impressionable nature," sought inspiration from a wide range of sources, including ancient Scythian artifacts, oriental art, and the direct observation of nature.[4] Also that year, Carl participated in the Pan-Russian Industrial Exhibition held in Moscow, where he not only won a gold medal and the ribbon of the order of St. Stanislav, but also drew the attention of Empress Marie Fedorovna (1847–1928, wife of Alexander III), who purchased a pair of gold cufflinks shaped as cicadas. Three years later, Fabergé was designated Supplier by Special Appointment to the Imperial Court.

Although a member of St. Petersburg's Merchants' Guild since 1867, Carl Fabergé regarded himself less as a merchant than as the "artist jeweler" ultimately responsible for all his firm's products.[5] A manuscript outlining the history of the firm, written by its senior master craftsman, Franz Peter Birbaum, indicates that Carl, together with his brother Agathon, and as many as twelve other artists including the writer were responsible for the designs of the pieces.[6] Their fabrication,

however, was assigned to various workshops, which were independently owned but integral to the House of Fabergé. These shops usually worked solely for the firm, adhering to its designs. In St. Petersburg, the workmasters who headed the shops were entitled to stamp their wares with their personal marks. A range of craftsmen were employed, including mounters who assembled the pieces, metal engravers and embossers (the latter casting and chasing the metal), gem-setters, polishers, turners, and *guillocheurs*, who engine-turned the patterns into the gold or silver surfaces that would subsequently be enameled, as well as numerous apprentices. Accounts vary, but from most reports the workdays were arduously long, sometimes over eleven hours, especially near holidays. According to Birbaum, the Russian workman's rate of productivity lagged behind that of his counterparts in other countries.[7] However, the firm's remarkable output and the extraordinary quality of its wares attest to the commitment of the workers, many of whom were foreigners, notably Scandinavians and especially Finns, who had been drawn to St. Petersburg by the city's burgeoning market for luxury goods. Altogether, in the firm's heyday at the beginning of the twentieth century, Fabergé had over 600 employees, half of whom were Russian.

The early success of the House of Fabergé owes much to the talents of Mikhail Evlampievich Perkhin (1860–1903), who became head workmaster in 1886. He helped to set the course that the firm would pursue until World War I, producing such *objets de fantaisie* as tobacco boxes, picture frames, bell pushes, and parasol handles, as well as some of the most refined Imperial Easter eggs (cat. nos. 21–24). Having studied the French and Russian eighteenth- and early nineteenth-century goldsmiths' works in the "Golden Treasury" of the Hermitage Museum, Perkhin succeeded in mastering such techniques as *quatre-couleur* gold, in which various alloys are used for different colors, and guilloché work, in which the metal surfaces are engine-turned with engraved patterns prior to enameling. Although he favored the rococo revival style fashionable during the 1880s and 1890s, he also occasionally drew from Renaissance sources (cat. no. 21).

Reportedly overcome by stress, Perkhin died in an asylum at the age of forty-three, leaving his workshop to his assistant, a Finnish craftsman named Henrik Emanuel Wigström (1862–1923), who loyally maintained his mentor's level of

quality. Wigström, however, preferred to work in a classical vein that recalled France's Louis XVI and Empire styles, gradually simplifying the decoration—even anticipating in some instances the Art Deco movement of the 1920s. A recently discovered album of over 1,000 drawings records the Wigström workshop's output between 1911 and 1916 and provides an invaluable insight into its range of wares.[8]

August Holmström (1828–1903), another Finn who had originally been employed by Gustav Fabergé, headed a workshop known for the exquisite quality of its diamond-set pieces. Highlights of its production included miniature replicas of the Imperial Regalia made for the Exposition Universelle of 1900— the large crown alone required as many as 1,083 brilliant-cut diamonds in addition to 245 rough, rose-cut stones. Following August's death in 1903, the Holmström workshop was left to his son Albert (1876–1925), and a daughter, Hilma Alina, who became a designer. A notebook of sketches dating between 1909 and 1915 illustrates the range of Albert Holmström's production, which included three Imperial Easter eggs from between 1909 and 1914.[9] The Holmström and Perkhin/Wigström workshops, together with that of August Frederik Hollming (1864–1916), who specialized in cigarette cases and miniature Easter eggs, were housed together in Fabergé's headquarters at 24 Bolshaya Morskaya. Smaller workshops based at the same address included those of Alfred Thielemann, Victor Aarne, Hjalmar Armfelt, Andrei Gorianov, Anders Nevlainen, Feodor Agnassiev, and Vladimir Soloviev.[10]

A small but key workshop for Fabergé's production was operated by Alexander Fedorovich Petrov (active 1895–1904) and eventually his sons Nikolai and Dmitrii, and specialized in *en plein* enameling, the demanding technique in which successive layers of translucent enamel (metallic oxides in a molten glass matrix) are applied at diminishing temperatures to silver or gold grounds that have been prepared with engraved patterns to better grasp the material. The extraordinary extent of their palette, over 144 tints, and the extremely fine finish of the surfaces distinguished the Fabergé enamels from those of competitors both in Russia and abroad.

Julius Alexandrovich Rappoport (1851–1917), a silversmith of Jewish background who had trained in Berlin before opening his own establishment in St. Petersburg in 1883/84, operated a highly productive workshop. Silver and gilded bronze mounts for

hardstone articles and silver animals were among his specialties. In about 1890, he began to work solely for Fabergé and continued to do so until he retired in 1909, leaving his tools and molds to his workmen, who established the First Silversmiths' Artel, a cooperative, which continued to supply the Fabergé firm.

In 1887, a Fabergé manufactory was established in Moscow that specialized in silverwares, jewelry, and cloisonné enamels. Moscow, the capital of Russia prior to the reign of Peter the Great (1672–1725), had remained more inward looking than St. Petersburg, which, from its beginnings in 1703, was more closely aligned with western Europe. During the second half of the nineteenth century, therefore, wealthy Moscow industrialists and capitalists tended to be more receptive than the court and nobility at St. Petersburg to the Pan-Slavic movement prevailing in Russian arts and literature at this time. The emancipation of the serfs in 1861 contributed to a renewed consciousness of national identity and nostalgia for former times. Artists now looked to their country's past, to the sixteenth and seventeenth centuries, and drew inspiration from early architecture, folk traditions, and rural crafts. Embroideries, manuscripts, and woodcarvings, in particular, provided a wealth of decorative motifs. In addition, motifs were revived from other non-western sources, including Turkish and Persian art.

Initially, three English brothers, Allan, Arthur, and Charles Bowes, directed the Moscow branch, but eventually Carl Fabergé's son Agathon assumed its control. Unlike in St. Petersburg, most of the hundred craftsmen and designers employed were Russian. Birbaum commented on the prevalence of the Russian folk style in the city, but rated the quality of Moscow's output as inferior to that of St. Petersburg. Although deploring "the absence of structured elegance and the archaic and deliberately crude execution" of the Moscow wares, he begrudgingly praised their "originality of conception and the absence of clichés in composition."[11] In addition to manufacturing tableware, the silver department produced presentation pieces reviving traditional forms, including several types of drinking vessels: *kovshi, bratini,* and tankards (cat. nos. 16 and 17). The Moscow branch also dealt in colorful enamelware that in shape and decoration recalled the enameled silver produced in the Kremlin Armory during the seventeenth century. It was a field in which the Fabergé firm faced stiff competition.[12] The leading rival, a silver factory opened by Pavel

Ovchinnikov in 1853, began to specialize in enamels in the late 1860s. A number of silversmiths followed, including Ivan Khlebnikov, Gavriil Grachev, A. M. Postnikov, and two women, Mariia Semenova and Mariia Adler. They employed various techniques: *champlevé*, in which the surface of the metal ground is cut out, creating receptacles for the enamel; *cloisonné*, which entails the use of thin strips of metal soldered to the base to separate the enamel colors in the firing process; and a distinctly Russian variant, *filigree*, in which twisted wires are substituted for the strips. The Fabergé branch in Moscow produced some of its own enamels, but more generally it relied on Feodor Rückert, who operated a workshop supplying a number of other firms. Perhaps the most gifted of the enamelers, he worked in a neo-Russian style incorporating elements of Art Nouveau.

In addition to the Moscow shop, Carl Fabergé opened other branches. On his letterhead, he sometimes listed his outlet at the great summer fair in 1896 held in Nijni-Novgorod, a town situated at the confluence of the Oká and Volga rivers, where over 8,000 booths and shops offered goods from across the Russian Empire ranging from oriental carpets, porcelains, furs, and leather to wines and soap. In Odessa, on the Black Sea, a branch was established in 1890 that eventually employed about twenty-five workmen who fabricated small pieces of jewelry, and between 1906 and 1910, a shop was also maintained in Kiev.

After his successes in Paris, in 1900 Fabergé determined to serve a broader foreign clientele, and three years later, with Arthur Bowes as a partner, he opened a modest office in the Berner's Hotel in London that dealt mostly in silver from the Moscow branch. In 1906, when the shop moved to its own quarters and was placed under the direction of Carl Fabergé's son Nicholas and Henry C. Bainbridge, the emphasis shifted to the wares created in St. Petersburg. The chief obstacle Fabergé encountered in London was a British law requiring that all silver or gold be hallmarked. As a consequence, he had to send his wares to England in an unfinished state to be stamped, a process that would have damaged the enamels, and then return them to St. Petersburg for completion. The use of "branch" in reference to the London office is dismissed by A. Kenneth Snowman, who described it in more exalted terms as an "eyrie" and as a "private salon for the personal convenience of the Royal Family and their immediate entourage."[13] However, not only did the London office cater to the British monarchy and aristocracy,

but it also served as the center for the firm's international trade. Nicholas Fabergé regularly visited Paris, especially before holidays, and every spring made the rounds of the Côte d'Azur, the haunt of both the French and Russian aristocracy. Twice a year, representatives were also sent to India and the Far East. Tsar Nicholas II's fellow monarch and friend, King Chulalongkorn of Thailand, patronized the House of Fabergé as did his successor, King Vajiravudh. Consisting largely of dark green nephrite objects (see *figure* 8), the Thai royal family's collection testifies both to the artistic genius of Fabergé in blending the Thai culture with European stylistic craftsmanship and the close diplomatic ties between Russia and Siam at that time—ties that enabled King Chulalongkorn to maintain his country's independence and promote its modernization. It is an interesting chapter in the history of both countries.

Justifiably, Fabergé's most celebrated creations are the Easter eggs that evoke the romance and tragedy of the Imperial family and represent consummate achievements of the goldsmith's art. During the reign of the Romanovs, however, the public was almost unaware of their existence. Apart from the few shown in Paris in 1900, they were displayed to the public on only one occasion, at a charity benefit exhibition held at the Baron von Dervis mansion in St. Petersburg for seven days in March 1902 (*figure 4*). In a photograph taken on that occasion, two of the eggs in the current exhibition (cat. nos. 21 and 22) can be discerned in a vitrine in the mansion's renowned Golden Drawing Room (see *figure* 10). Rarely were they mentioned in the press, the major exception being an article published in the Russian magazine *Town and Country* in 1916,[14] until Henry C. Bainbridge published his account in 1934.[15]

The opening of the Russian archives following the dissolution of the Soviet Union in 1991 has revealed new information regarding the eggs and their creation.[16] It is now known that Alexander III (1845–94), using his brother Grand Duke Vladimir Alexandrovich as an intermediary, commissioned the first egg for his wife, Empress Marie Fedorovna, in 1885, the year of their twentieth wedding anniversary. It was closely based on an early eighteenth-century gold egg in Rozenburg Castle in Copenhagen that would have been familiar to the empress, a former Danish princess. Like its prototype, Fabergé's egg was enameled white and opened to contain a surprise, a gold hen, which, in turn, concealed a ruby pendant suspended within a

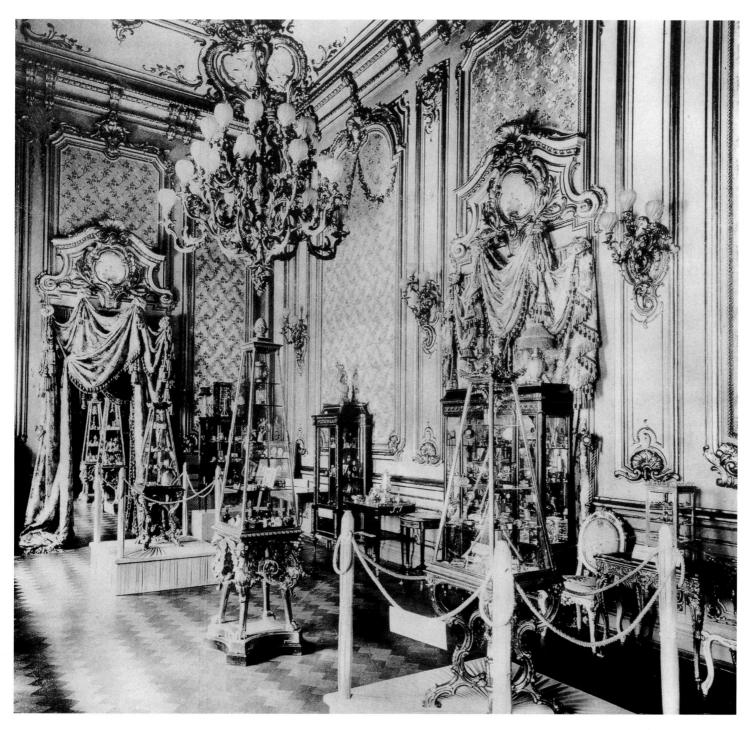

*Figure 4* Exhibition showing Fabergé Imperial Easter eggs in March 1902

*Figure 5* Tsar Nicholas II (1868–1918)

diamond-set crown (in the Danish egg, it was a ruby ring).

Subsequently, Fabergé's craftsmen would spend the following year working in absolute secrecy creating an egg for the next Easter. After his father's death in 1894, Nicholas II (*figure 5*) continued his father's practice until 1916, giving eggs to both his mother and his wife. Altogether fifty eggs were created, although none was produced in 1904 and 1905, the years of the disastrous Russo-Japanese War and civil unrest at home. The eggs and their surprises often referred to a topical subject, such as a cruise taken to the Far East on the cruiser battleship Pamiat Azova by Nicholas, then the tsarevich, with his ailing brother, Grand Duke George (1891); the Imperial coronation (1897); the

completion of the Trans-Siberian Railway (1900); the Imperial couple's trip to Moscow (1906); and the Tercentenary of the House of Romanov (1913). The increasing austerity in Russia following the outbreak of World War I is reflected in the Imperial eggs. The Order of St. George Egg of 1916 presented to Marie Fedorovna had a silver rather than gold shell, and the egg delivered to Alexandra Fedorovna that year ominously was made of steel and had a war theme. One of the eggs planned for 1917, but never completed, was to be of dark blue glass, and the other of Karelian birch wood.

The tradition of working in hardstones began in Russia in the early eighteenth century. To exploit the vast mineral deposits that were then being discovered, the Imperial government established lapidary works in Peterhof outside St. Petersburg (1725), Ekaterinburg in the Ural Mountains (1765), and Kolyvan in western Siberia (1802). From these sources came the malachite, lapis lazuli, porphyry, jasper, and other minerals so lavishly used in building and furnishing the palaces in St. Petersburg, particularly the Winter Palace. During the late 1880s, the Imperial Lapidary Works at Peterhof hired Fabergé to provide mounts and fittings for various decorative objects in stone, but he is not known to have employed the medium himself until 1891, when the tsar commissioned the jasper Pamiat Azova Easter Egg. The following year, the Golden Wedding Anniversary of the empress's parents, King Christian IX and Queen Louise of Denmark, Fabergé produced nephrite, jade, and topaz carvings of elephants, the animal that served as the insignia of the House of Denmark. Prior to 1908, Fabergé's production of carved *objets de fantaisie*, including animals, figures, and flowers, was limited, and he drew instead from other sources. Karl Woerffel's lapidary works on the Obvodny Canal in St. Petersburg supplied carved animals, as did the Haus Stern factory at Oberstein (now Idar-Oberstein), a German town near Metz renowned for its agate quarries and its stone-polishing works. In addition, carvings were imported from Ekaterinburg to be refinished in St. Petersburg.

Fabergé's lapidary works opened in 1908 and were eventually headed by a gifted gem-cutter, Petr M. Kremlev. Even though as many as twenty craftsmen were employed, the shop still could not fill all the orders, and sculptures continued to be supplied both by Woerffel, now controlled by Fabergé, and by Ekaterinberg, though in both instances they were refinished in

St. Petersburg. Fabergé's craftsmen, including most notably Petr M. Derbyshev, a sculptor who had trained at Oberstein and in Paris with the jeweler René Lalique, undertook the carving working from the models. Special attention was given to the selection of materials: obsidian, for example, with its distinctive chatoyancy, lent itself to suggesting a seal's lustrous fur, whereas polished nephrite proved particularly appropriate for conveying the moist skin of amphibians. The carvers did not sign their works, but when gold elements such as birds' feet were added, they bore the mark of the goldsmith, invariably Henrik Wigström.

The treatment of the subjects varied. Those works dating prior to 1908, which were usually supplied by the Oberstein or the Ekaterinberg works, tended to be the most consciously naturalistic. Drawing from a European *animalier* tradition that can be traced to sixteenth-century Germany, particularly to the casts of lizards and insects by the Nuremberg silversmith Wenzel Jamnitzer, the carvers rendered their subjects with a precision sometimes bordering on dryness. In other carvings that may more fully reflect the personal vision of Carl Fabergé, who is remembered for his wit, characteristic poses are captured, such as a cat arching its back (cat. no. 61), or certain aspects such as a pig's rotundity (cat. nos. 86 and 87), are exaggerated. A whimsical note is sometimes added by depicting young, ungainly animals rather than adults.

Similarities have been drawn between Fabergé's animals and Japanese netsuke. These were the small toggles, most often carved of wood, ivory, or horn, that were worn in Japan before western male dress was adopted. They were used to attach a cord to the *obi*, or belt sash, from which *inro* (compartmentalized lacquer boxes), tobacco pouches, or pipe cases were suspended. Often they were carved in the shapes of animals and were sculpted with attention to detail, but they were often stylized with exaggerated features comparable to those found in Fabergé's hardstone carvings. The similarities were not coincidental. Fabergé had a collection of over 500 netsuke, which was eventually transferred to the Hermitage Museum.[17]

With the outbreak of World War I in 1914, many of Fabergé's employees were called to arms, and the firm had to divert its production from *objets de fantaisie* to more mundane items like grenades and medical supplies. When the Bolsheviks seized his headquarters in 1918, Carl Fabergé merely requested

ten minutes to retrieve his hat and coat before walking away. He would live in exile for two years before dying in Lausanne, Switzerland, on 24 September 1920. The war, however, had forever eradicated the society and culture that had sustained his art. The Imperial Easter eggs, those exquisite hardstone creations masked as utilitarian objects such as bell pushes for summoning servants, ink pots, precious boxes, and the jeweled and enameled parasol handles evoke awe and admiration for their beauty, but they are inevitably regarded as relics of a vanquished past. The hardstone animals, however, convey a timeless appeal. Their refined craftsmanship and their sympathetic, yet at times humorous, interpretations of subject matter speak to today's viewers as vividly as when they were created.

NOTES
1 *The Mrs. Henry Walters Art Collection*, Parke-Bernet Galleries, Inc. (New York, n.d.), I, 104, no. 522 illus.
2 Accounts vary on the number of Imperial Easter eggs actually exhibited, but only three, the Lilies of the Valley, the Pamiat Azova, and the Pansy Eggs are cited in René Chanteclair's review, "La bijouterie étrangère à l'Exposition Universelle," *Revue de la Bijouterie, Joaillerie et Orfèverie*, 5 (October 1900): 61–74.
3 H. C. Bainbridge, *Peter Carl Fabergé, His Life and Work* (London, 1949), 11–12.
4 *The History of the House of Fabergé according to the Recollections of the Senior Master Craftsman of the Firm, Franz P. Birbaum* (St. Petersburg, T. F. Fabergé and V. V. Skurlov, 1992), 4.
5 A. K. Snowman, *Fabergé: Lost and Found, The Recently Discovered Jewelry Designs from the St. Petersburg Archives* (New York, 1993), 20.
6 *History of the House of Fabergé*, 4–5.
7 Ibid., 14–17.
8 *Golden Years of Fabergé, Drawings and Objects from the Wigström Workshop*, A La Vieille Russie (New York, 2000).
9 Snowman, *Fabergé: Lost and Found*.
10 Boris Ometov in G. von Habsburg and M. Lopato, *Fabergé, Imperial Jeweler* (New York, 1994), 136.
11 *History of the House of Fabergé*, 11.
12 A. Odom, *Russian Enamels, Kievan Rus to Fabergé* (London, The Walters Art Gallery, ex, cat., 1996).
13 A. K. Snowman, *Fabergé: Jeweler to Royalty* (New York, Cooper-Hewitt Museum, ex. cat., 1983), 10.
14 "Easter Eggs," *Town and Country, A Journal for Gracious Living*, St. Petersburg (1 April 1916): 3–7.
15 H. C. Bainbridge, "Russian Imperial Easter Gifts," *Connoisseur*, 93, no. 393 (May 1934 and June 1934): 384–89.
16 T. F. Fabergé, L. G. Proler, and V. V. Skurlov, *The Fabergé Imperial Easter Eggs* (London, 1997).
17 A. von Solodkoff, *The Art of Carl Fabergé* (New York, 1988), 75.

*Figure* 6   Carl Fabergé sorting gemstones in his workshop

# Fabergé: His Hardstone Creations and His Clients

MARILYN PFEIFER SWEZEY

The delicacy and beauty of Fabergé objects has charmed viewers for over a century. From whimsical animal creations to elegant parasol handles and the famed Imperial Easter eggs, Carl Fabergé's works of art have appealed to the aristocracy and the general public alike. His use of hardstone in combination with precious materials is one of the defining features of his style. Hardstone carvings had become a popular tradition in Russian decorative art by the middle of the nineteenth century, but they were almost exclusively produced in the stone-cutting factories of Siberia, Kolyvan, and St. Petersburg. Fabergé was one of the few goldsmith-jewelers in Russia in the late nineteenth–early twentieth century to produce decorative art objects of carved hardstone, often combined with *en plein* enameling and settings of gold or precious gems.

Educated as a traditional jeweler and goldsmith, Fabergé became an expert gemologist and was often called upon to assess gemstones for the Hermitage Museum. For many years, he personally selected all of the stones used in his firm's productions (*figure* 6). Fabergé described himself, however, as an "artist-jeweler," emphasizing that "an expensive thing interests me little if the value is only in many diamonds or pearls."[1]

He valued the natural beauty of hardstone mineral compounds and saw the great artistic potential in the colorful variety of the nephrite, rhodonite, agate, and other rich mineral resources of Russia. Under his direction, designers and modelers created small hardstone works of art accented with precious gems. Diamonds, sapphires, and rubies were used sparingly, and always within the artistic design. It was this formula that brought Fabergé international fame.

In a rare interview, published in 1914 in the St. Petersburg periodical *Town and Country*, Fabergé talked about some of the lesser-known, semiprecious stones he prized: "Look at these surprisingly beautiful stones! . . . Pyrope, for example—why is it not valued here? The play of light is remarkable and it is a significantly harder stone than pearl. . . ."[2] Pyrope is a

magnesium aluminum silicate in the garnet family ranging in color from deep red to near black. Some of the finest deposits were found in the Bohemian region of the Czech Republic, where the garnet-cutting industry reached its peak in the nineteenth century. Fabergé would certainly have been aware of this valuable source of material, although he lamented the lack of creativity he perceived in the cutting process. "Pyrope," he explains further, "is the finest grade of garnet—distinguishable only to an experienced eye. There is 'more life' in pyrope. In cutting garnet into delicate shapes, it is possible to obtain remarkable nuances, from light pink to the color of old Burgundy wine, smoky red. In former times," he concludes, "they knew how to cut the stone very artistically. But now jewelers only imitate the old ways."

Another little-known stone Carl Fabergé discussed in this interview is tiger's-eye. "There is soft tiger's eye and there is the hard stone—the real tiger's eye," he explains. "The real stone is a hundred times more expensive than the soft, though they are equally beautiful. Catherine II loved tiger's eye, and she had a complete set of jewelry in these stones to match the color of a dress." Catherine the Great (1729–96) also made extensive use of Russian hardstone in the decoration of her palace rooms, one of the most notable examples being the Agate Pavilion in the Tsarskoe Selo Palace outside of St. Petersburg, created for her by the Scottish architect Charles Cameron.

Hardstone from Siberia and the Urals was used in the Fabergé firm's production almost from the beginning, when small, practical objects such as cane and parasol handles, picture frames, clocks, bell pushes, and hand seals began to be made in the early 1890s. Many of these little objects were made of hardstone in combination with settings of gold, silver, enamel work, or even precious stones. The stone-cutting work was contracted out to factories such as that of Karl Woerffel in St. Petersburg or the Stern lapidary works in the stone-cutting center at Oberstein in Germany. Fabergé also had active

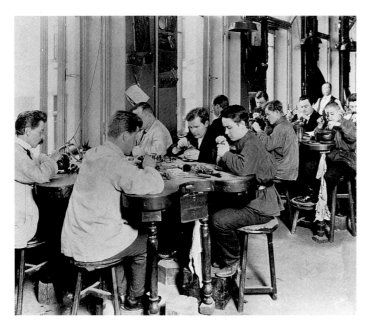

*Figure 7* Fabergé workshop in St. Petersburg

working relationships with the Russian lapidary factories at Peterhof and Ekaterinberg. The objects would then be completed in the Fabergé jewelry, silver, or gold workshops of Perkhin—and later Wigström—Holmström, Rappoport, and others (*figure 8*).[3]

The first sculptured Fabergé figures in Russian hardstone—animals, flowers, and people—were made around 1890. It was from the selection of animals available in the St. Petersburg shop in 1900 that Henry Walters purchased a jasper anteater, a nephrite hippopotamus, an agate chimpanzee, and other animals (see cat. nos. 74, 101, and 109) on his summer visit. Most likely, these were made in Oberstein, where the first animals were thought to have been carved. These figures would then have been sent to the Fabergé workshops in St. Petersburg to be fitted with tiny jeweled eyes. Despite the range of these early objects, according to the memoirs of Franz Birbaum, Fabergé's chief designer from 1895–1917, stone carving was only "of secondary interest in the work of the firm before 1908," when Fabergé bought the Woerffel lapidary works in St. Petersburg and opened his own workshop.[4] In addition to animals, sculpted figures of

people—many of them Russian national types—flowers, fruit, and some mosaics became popular Fabergé hardstone specialties.

The most common stones used for the animal carvings were nephrite, obsidian, rhodonite, chalcedony, agate, rock crystal, and topaz. The stones were generally selected to match the appearance of the animal. Agate was one of the most frequently used stones for dogs, rabbits, mice, and rare birds. Jasper and lapis-lazuli were also utilized together with many other unusual stones, "even pebbles from the beach and simple stones—if the color patterns were of particular interest."[5] The sandstone rhinoceros match striker in Art Nouveau style is one such example (cat. no. 106).

Nephrite was the most frequently used stone, according to Birbaum, because of its "qualities and appearance."[6] One of the variants in the jade family, nephrite is a calcium magnesium aluminum silicate containing variable amounts of iron and is considered the toughest of all gemstones. Its structure consists of a mass of minute, interlocking fibers, which gives it a strength tougher than steel. Nephrite has long been used in many cultures for delicate carvings. It was not until about 1850, however, that nephrite was found in Siberia, near Irkutsk, and became popular with Russian craftsmen.

The basic green color comes in many shades, ranging from translucent dark green to a lighter hue that is mottled and fissured, used for such elements as the leaves on a basket of lilies of the valley made for Empress Alexandra Fedorovna in 1896. The exquisite basket, presented to the empress by the Nijny-Novgorod merchants as a coronation gift, is a masterpiece of gold work, jewels, and hardstone carving. Nine gold stems of lilies of the valley with pearl flowers and tiny diamond stamens are seen "growing" in a gold wicker basket filled with green gold wire moss. Transparent nephrite was used to form the leaves, finely carved on both sides to simulate their natural look. Lilies of the valley were the favorite flower of the empress and, according to Carl Fabergé, the basket "always stood on her desk" in her room at the Alexander Palace.[7]

A darker and more solid shade of green was used for the nephrite leaves of the Imperial Orange Tree Egg (cat. no. 24) made for Empress Marie Fedorovna and now in the Forbes Magazine Collection. There are other varieties of nephrite as well, in shades of gray, white, and blue, but these were not used in the Fabergé objects.

One of the most spectacular of the nephrite stone carvings is the Buddha that was made for the personal worship of the Thai Royal family (*figure 8*). Carved from a single, large piece of nephrite, the sculpture is over a foot high and weighs around twenty pounds. Although it is unsigned by the artist, the name of *Fabergé* in Latin letters is carved into the base along with the year *1914*. It is the only one of its kind in existence and remains today in the court chapel in Bangkok, unseen by the general

*Figure 9*  Diamond Trellis Imperial Easter Egg

public and largely unknown to Fabergé enthusiasts.

Rhodonite was the second most frequently used stone, though it was best for small objects such as a tiny elephant now in the collection of John Traina, Jr. (cat. no. 90). The cracks and markings in this bright pink stone made it less suitable for larger figures. Nevertheless, one of the largest of the sculpted stone works associated with Fabergé must have been the rhodonite iconostasis (icon screen separating the altar from the nave) made for the Church of the Saviour on the Blood in St. Petersburg, the memorial church built on the site of the assassination of Alexander II in 1881.[8] Designed by Fabergé and carved at the Ekaterinburg lapidary factory, the iconostasis is a marvel of the art of the stone cutter. The whole interior of the Russian revival style church, completed in 1907, was decorated with mosaic iconography and carved stone work in Byzantine revival style. After nearly thirty years of slow restoration, the church is now open as a museum, and the remarkable Fabergé iconostasis can once again be seen.

Hardstones were also primary materials in some of the jeweler's most famous creations, the Imperial Easter eggs. The pale green jadeite Diamond Trellis Egg (*figure 9*), made for

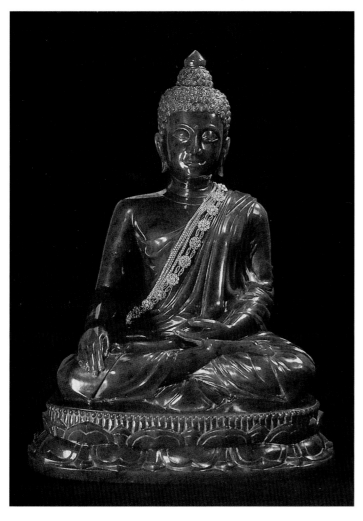

*Figure 8*  Nephrite statue entitled *Buddha Calling the Earth to Witness* made for the Thai royal family, 1914

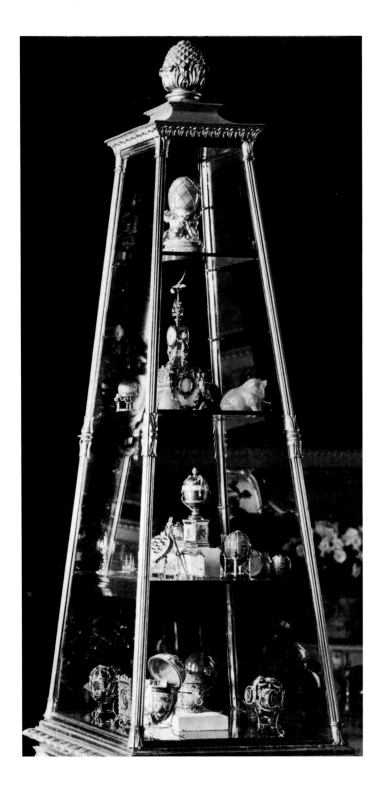

Empress Marie Fedorovna in 1892, is a striking example of the Fabergé style and is one of thirteen surviving Imperial Easter eggs made from hardstone (the agate Renaissance Egg and the nephrite Orange Tree Egg are on view in the exhibition, cat. nos. 21 and 24). The egg is enclosed in a graceful trellis network of tiny rose-cut diamonds and can be seen at the top of the empress' pyramid case in the photographs of the 1902 exhibition at the von Dervis mansion (*figure 10*). Now in a private collection, it is unfortunately never publicly exhibited.

One of the most spectacular of the Imperial eggs is the rock crystal Winter Egg of 1913, also given to Empress Marie Fedorovna. Designed by Alma Pihl, a young Finnish designer discovered in the jewelry workshop of her uncle, Albert Holmström, the egg simulates the winter frost of ice crystals on a window. These are formed of rose-cut diamonds set in platinum. The egg sits on a rock crystal base in the form of a block of melting ice also set with rose-cut diamonds. The surprise, suspended on a hook inside the egg, is a small diamond basket filled with white quartz snowdrops set on gold stems with stamens of green demantoid garnets. The leaves are carved of nephrite and set into a bed of gold wire moss. The egg was sold recently by Christie's to a private collector for a record-breaking price of $9.6 million. Unfortunately, this egg, too, is almost never on public view.

Unlike the Fabergé workmasters, whose hallmarks appear on gold and silver objects, the stone modelers did not sign their work, so it is almost impossible to determine the author of a particular piece. When Fabergé opened his own lapidary workshop in 1908, he gathered a small group of talented stone carvers. Petr Kremlev, who had trained at the Ekaterinberg Art School, was appointed to manage the workshop and also executed a number of the animal carvings himself. Birbaum records that by 1912 there were twenty artisans in the workshop—including a woman, Eugenia Ilyinskaya-Andreoletti, a Russian-Italian, who also specialized in animal carvings. However, between 1912 and 1914 there was such "intensive

*Figure 10* Exhibition in 1902 featuring the Imperial Easter eggs, including the Diamond Trellis Egg (top shelf), the Gatchina Palace Egg (bottom shelf, front left corner), and the Renaissance Egg (bottom shelf, center), as well as a hardstone boar (second shelf, right corner)

activity" that the stone carving workshop was unable to meet demand, and "some of the more ordinary commissions were therefore sent to the Ekaterinburg workshops."[9]

Birbaum mentions another talented stone carver whose "original personality deserves special mention."[10] The story of Petr Derbyshev from Ekaterinberg is a colorful Russian tale worth recounting in Birbaum's own words.

> I got to know him in 1908 when he came to St. Petersburg looking for work. He actually walked most of the way, working in various places as a loader or gardener, to keep body and soul together. He arrived in Petersburg very ragged and in bast shoes. We immediately recognized a businessman and a talented worker, and the firm made haste to provide him with clothes and shoes. As the workshop was only planned at that time, he was sent to the Woerffel factory, where he worked for a year and made some money. With a recommendation from us he went to Oberstein and from there he soon went to Paris, where he worked with the artist and engraver Lalique, who was delighted with him and wanted to make him his successor by marrying him to his daughter. But fate decided otherwise. Homesickness and perhaps fear of marriage forced him to return to Russia at the beginning of 1914. He was called up in the first months of the war and died at the taking of Lvov. . . .[11]

One of the most prominent artists who worked on the hardstone figures was the sculptor Boris Froedman-Cluzel. Born and raised in St. Petersburg of Swedish and French parents, he was well educated, having attended the famous art school of Baron Stieglitz. Like Carl Fabergé himself, Froedman-Cluzel completed his art education in Europe, attending the Royal Academy of Art in Stockholm and then the Academy of Fine Arts in Paris. He became a well-known sculptor in St. Petersburg between 1910 and 1917. Among his remarkable accomplishments are some sixty statuettes of ballet artists, including Anna Pavlova, Mathilde Kschessinska, and Tamara Karsavina. His mold of the foot of Anna Pavlova, cast in bronze, is now in The British Museum. He also modeled a bust of Prime Minister Peter Stolypin following the leader's assassination in 1911, and, in 1915, he crafted a sculpture portrait of the twenty-one-year-old Prince Igor Konstantinovich, who would be murdered by the Bolsheviks just a few years later along with other members of the Romanov family at Perm in 1918. Froedman-Cluzel managed to leave Russia following the revolution and, after a few years in Paris, went to Cairo, where he spent his last years as a professor of sculpture at the art academy there. He is thought to have died in Cairo in about 1952.

Boris Froedman-Cluzel came to the attention of Fabergé sometime around 1906, through his models of horses and other military subjects for the Imperial regiments. When Fabergé received a commission to immortalize in hardstone animals on the British royal family's Sandringham estate in 1907, Froedman-Cluzel seemed to be the logical choice to head the team of modelers to go to London. The artists lived at Sandringham and worked on wax models of animals, following a list prepared by King Edward VII. At the same time, they were treated as guests and would sometimes be invited to hunt and to the Royal breakfast afterwards.

Froedman-Cluzel wrote a charming description of the atmosphere in which he lived and worked in a letter of 24 December 1907, written on Sandringham stationery:

> I have an accommodation here in the hall and work hard under the personal supervision and appraisal of my high customer. My zoological assortment has been increased by 20 new models performed here. There are some things which I've managed to make rather well. But what is most precious to me is that praise which is generously splashed on me by this amiable and rare King! As you know, I have done a lot of work for the King in St. Petersburg, and then, one fine day, received an invitation to leave for England immediately so that I could be personally presented to His Majesty and to fulfill his wish to sculpture his pets and my four-legged friends on the spot.[12]

Froedman-Cluzel also did the fine model of the king's prize race horse, Persimmon, which was cast in silver in the Moscow workshop, the only one of the Sandringham animals not carved in stone. It should be noted that the artist did only the wax models for Fabergé. The stone carving was actually done in St. Petersburg by Kremlev, Derbyshev, and others.

This commission became the most celebrated collection of animal portraits in Fabergé's history and demonstrates how

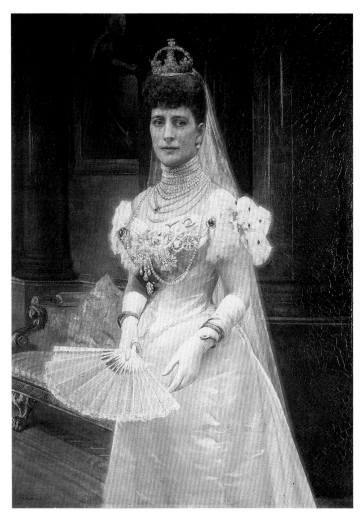

*Figure 11* Queen Alexandra (1844–1925)

sculpted flowers and animals. By 1902, Queen Alexandra already had a significant collection of these objects, a fact noted by one American visitor, Consuelo Vanderbilt, who mentioned in her memoirs the queen's "unique collection, " which she saw that year on a visit to the estate.[14]

Edward liked the idea of replicating the Sandringham animals so much that he commissioned Carl Fabergé to prepare wax models of all of the domestic and farmyard animals, from the small earth worms to the large draft horses. More than a hundred different figures—the king had specified that there were to be no duplicates—were modeled from life. Many of the animals were actual portraits of specific dogs, cats, or parrots.[15] The most famous of the royal pet portraits is "Caesar," King Edward VII's Norfolk terrier. He is a lively looking creature carved of beige chalcedony with ruby eyes and is portrayed wearing a brown enameled collar with a little gold bell and a gold plaque on which are written the words "I belong to the King." The personality of Caesar, who is remembered in various memoirs of the time for his active interest in trouser legs and furniture, seems evident in the work of the modeler. Queen Alexandra's two favorite Pekinese dogs were also modeled and carved in stone—light blue beryl for one and cream-colored chalcedony for the other, both with diamond eyes.

The wax models were presented by the king to Queen Alexandra on her sixty-fifth birthday, 1 December 1907, in the presence of the modelers—Caesar was also in attendance. Having met with the king's enthusiastic approval, the wax models were taken back to St. Petersburg to be carved in the appropriate Russian hardstone. They were brought to London the following year, and the king purchased them all.

The animals in the British Royal Collection today number over 350—each one unique. It is the largest Fabergé collection in the world, with more than 550 pieces. Queen Elizabeth is known personally to be very fond of her Fabergé animals, which can be seen from time to time when they go on exhibit at the Queen's Gallery at Buckingham Palace.

Fabergé's hardstone animal carvings were favorites among many of his elite clientele. As Birbaum noted, "Many highly placed people collected these figures, and others knew that additions would be well received."[16] Dmitry Ivanov, Director of the Armoury Museum of the Moscow Kremlin, wrote in a 1922 publication that "the Grand Duchesses originated the fashion for

important the relationship was between the jeweler's hardstone creations and his elite aristocratic clientele, whom he believed had "long tired of diamonds and pearls."[13] It was Mrs. George Keppel, a close confidante of the king's, who encouraged the idea of having sculptures made of some of the animals at Sandringham, as a gift to Queen Alexandra (*figure 11*). The Queen, who was gradually becoming deaf, found increasing consolation in the company of animals and in her passion for flowers. Through the gifts given to her by her sister, Russian empress Marie Fedorovna, she became a real devotee of Fabergé's

collections of hardstone figures of animals and birds. It became fashionable to do 'hardstone portraits' of beloved domestic pets." Dowager Empress Marie Fedorovna had a collection of over one hundred Fabergé animal figures, many of which were kept in her Blue Salon in the Anitchkoff Palace in St. Petersburg. One of her animals can be seen in the pyramid case in the photographs of the 1902 exhibition at the von Dervis mansion in St. Petersburg (*figure* 10). It is similar to the honey-colored chalcedony boar with cabochon ruby eyes now in the British Royal Collection. She took most of the animals with her when she left Russia in 1919. Many remain part of her estate today, scattered among her descendents, but some were sold and are now in American museum collections. The small pink carnelian rabbit with diamond eyes, on loan to this exhibition from the Forbes Magazine Collection, was originally in her collection, as was the opal elephant bell push with ruby eyes and gold feet, on loan from the Cleveland Museum of Art (cat. nos. 70 and 98).

Prince Yussoupoff was known to have a large collection of Fabergé animals in his St. Petersburg residence. Elisabeth Balletta, actress of the Imperial Michael Theatre, also had a well-documented collection of Fabergé animals and flowers, including a model of her favorite bulldog, perhaps similar to the amethyst bulldog in this exhibition (cat. no. 55). Many of these were gifts from Grand Duke Alexis Alexandrovich, one of the favorite clients of the Fabergé firm and a devoted admirer of the actress. These pieces are now dispersed among collections all over the world. The small nephrite and enameled watering can in the present exhibition (cat. no. 39) was originally hers.

Grand Duchess Xenia, sister of Nicholas II, and her husband, Grand Duke Alexander Mikhailovich, purchased animals from Fabergé every Christmas for each of their seven children. They all would receive the same animal, each made from a different hardstone.

The tumult of the Russian Revolution in 1917 ended the hardstone production of the firm, whose workshops were taken over by the Bolsheviks in 1918. Many of Faberge's imperial clientele were killed or forced to flee the country. These small surviving treasures, however, continue to provide pleasure to the viewer and attest to the lasting legacy of Fabergé's technical perfection and artistic standard of elegant simplicity.

NOTES

[1] *Town and Country, A Journal for Gracious Living*, St. Petersburg, no. 2 (1914): 14.

[2] Ibid.

[3] See essays by William Johnston and Marianna Chistyakova in this volume.

[4] *The History of the House of Fabergé according to the Recollections of the Senior Master Craftsman of the Firm, Franz. P. Birbaum* (St. Petersburg: T. F. Fabergé and V. V. Skurlov, 1992), 28.

[5] Ibid., 41.

[6] Ibid., 39.

[7] It is not known where the stone carving was done, but the work was completed in the workshop of Mikhail Perkhin, whose marks appear on the basket. Today, the piece is in the collection of Matilda Geddings Grey at the New Orleans Museum of Art.

[8] V. V. Skurlov, *Jewelers and Stonecutters of the Urals* (St. Petersburg, 2001), 128.

[9] Skurlov in T. Fabergé, A. Gorinya, and V. V. Skurlov, *Fabergé and the Petersburg Jewelers* (St. Petersburg, 1997).

[10] *History of the House of Fabergé*, 46.

[11] Ibid., 46.

[12] Skurlov in *Carl Fabergé, Goldsmith to the Tsar*, E. Welander-Berggren, ed. (Stockholm, 1997), 34–35.

[13] *Town and Country*, 14.

[14] *Fabergé* (London: The Queen's Gallery, Buckingham Palace, 1995), 14.

[15] Ibid., 4.

[16] Skurlov in Fabergé, Gorinya, and Skurlov.

*Figure 12* Ivan Shishkin, *Woodland Scene*, 1876, oil on canvas, courtesy of A La Vieille Russie, New York. Shishkin dedicated his career to recording the Russian landscape realistically. It is among such settings that local peasants would hunt for deposits of gems and hardstones.

# Gemstones and Jewelry Arts of Russia in the Seventeenth–Nineteenth Centuries

Marianna B. Chistyakova

The enormous treasures of the Russian grand princes and later tsars—the Asiatic opulence of their palaces, the abundance of gemstones that adorned their ceremonial robes, their decorated gold and silver tableware, their ornate ecclesiastical vessels, and even their furniture—were astonishing to foreigners traveling to Russia as early as the fifteenth and sixteenth centuries. However, Russia had not yet discovered its own sources of precious stones.[1] At that time, gems were purchased mostly from eastern merchants traveling along the Great Silk Road that stretched from China and India through Central Asia into the Mediterranean.

Not until 1668 did the first reliable information about finds of rock crystal, topazes, amethysts, tourmalines, and beryls in the Ural Mountains become available. But this merely indicated the abundant treasures waiting to be discovered underground. The wealth was not to be obtained easily. It was only in the 1730s that quarrying and processing of hard rocks were regularly undertaken.

The mining industry developed rapidly during the late seventeenth century and early eighteenth century as a result of Peter the Great's innovative reforms. Expeditions to find various metal ores essential for domestic industries were dispatched throughout Russia on the tsar's direct orders. As early as the end of the seventeenth century, the first copper foundries were established in the Middle Ural Mountains. Consequently, the Russians discovered that malachite was not merely a byproduct of copper ore mining, but a magnificent decorative stone and a treasure in its own right. It was mined in the Urals in the form of enormous slabs, and eventually gained worldwide recognition for its unsurpassed intensity of color and the beauty of its pattern. However, truly artistic working of malachite did not start until the eighteenth century. Large quantities of malachite were exported to the West, where it was used extensively in the production of pigments, as mosaic particles, and, occasionally, in small decorative objects. It was not until the first decades of the nineteenth century, however, that malachite became the dominant stone in artistic production.

Peter the Great's successors continued the quest for mineral treasures. In the second half of the eighteenth century, during the reigns of Elizabeth I (1709–62) and Catherine the Great (1729–96), there was a tremendous surge of interest in minerals in general, and precious stone in particular. As the President of Mines Colleges (Mines Authority) put it: "Mineralogy became a common disease shared by many."

Private collections began to be established everywhere and demonstrated a growing interest not only in beautiful and precious stones but also in all sorts of mineralogical curiosities and samplings of metal ores. Fashionable rings began to be set both with traditional gemstones and with enormous crystals contaminated with various natural inclusions. Even though such design novelties did diminish the overall value of the stone and were considered less visually appealing, they were thought to provide evidence for the refined taste and sophistication of the jewelry's owner.

Russian empresses Catherine the Great and later her daughter-in-law Marie Fedorovna were passionately preoccupied with lapidary art and were skillful practitioners of the craft themselves. They searched for and acquired extensive European collections of gemstones, and cameos in particular. "Gem fever" became fashionable and a sign of good taste.

Demand for beautiful jewels rapidly increased. Gem finds still remained sporadic and were mostly made by locals who happened to stumble across them. The search for ornamental and precious stones became a subject of the stately interests during the second half of the eighteenth century. Numerous decrees encouraging the populace to look for, collect, and deliver to the court all the rare specimens were sent throughout the empire and widely publicized. In 1765, the first state-sponsored expeditions to the Ural Mountains and Siberia were dispatched. Hundreds of prospectors explored thousands of

square miles, and more than two hundred new finds of high-grade marble and other decorative minerals were made.

Between 1771 and 1773, extensive deposits of previously unknown hardstone were discovered near the village Maloe Sedel'nikovo. Distinguished by its bright pink color, it became known as rhodonite. Together with malachite and the highly acclaimed jaspers from this region, rhodonite became one of the most popular and frequently used ornamental stones in Russian decorative art. The unsurpassed quality and abundant forms of the stones allowed Russia to retain a virtual monopoly on quarrying and processing of these and many other varieties of hardstones for years.

The mineral wealth of the vast lands of Siberia began to be explored in the eighteenth century as well. The first quarter of the century was marked with important discoveries of aqua-marines, beryls, tourmalines, and topazes, all located east of Lake Baikal in the vicinity of the city of Nerchinsk (on the mountain Sherlovaia, Borschevochnyi mountain ridge). By mid-century, despite the remoteness of these mines from major markets, active quarrying and processing of stones had begun through the combined efforts of the newly built mill-factories and the large number of prospectors. Stone was processed here until about 1820, when the mines began slowly to decline; production was finally abandoned all together, although restarted again in the early twentieth century.

The middle of eighteenth century also brought another significant find. Deposits of lapis lazuli were first located in the valley of the river Sluidianka, and later along the river Malaya Bystraya near Lake Baikal. The remarkable discovery of this intensely beautiful stone was the result of a long geological inquiry initiated by the Russian court. Unlike Europeans, who mostly favored lightly colored stones, Russian aristocracy adored this stone precisely for its rich, heavenly color and its strong associations with oriental opulence. Unfortunately, the first specimens of lapis lazuli left the Russian Mines Authorities disappointed. Domestic lapis was much paler and of softer hues than the vivid and rich-colored stone that for years had been imported from Afghanistan. Consequently, the native stone was pronounced unworthy, and its quarrying came to an end. Only around the 1850s, when the demand for lapis lazuli greatly intensified, did old quarries reopen and undertake large, industrial-scale production.

Catherine the Great, throughout her reign, consistently demonstrated a preference for Russian ornamental stones, and she insisted on using native minerals and stones for palace construction and the decoration of interiors. She initiated further expeditions to remote areas of the Altai Mountains in southern Siberia. Several parties exploring the canyons of the river Korgon in 1786 came across one of the richest deposits of multicolored porphyries, including the red variety similar to the one found in Egypt and praised since antiquity. Simultaneously, specimens of various kinds of jasper from this region were collected, and a thorough mapping of these deposits in the Altai region was completed.

The following century saw a continuation of the exploration of the rich mineral assets of the eastern part of the country. Around 1850, new beds of jasper were located on the southern edge of the Urals. In 1831, merely by accident, under the roots of a fallen tree, local peasants found what turned out to be emeralds. Shortly thereafter, deposits of phenacite and alexandrite were discovered in the area. Many of these minerals continue to be mined from these same deposits, such as the Emerald gorge in the Middle Urals. Later, a garnet-demantoid of a remarkable quality was found along the small local river, the Bobrovka. Garnets from that find came in a vast variety of colors, from golden yellow to brilliant green, and had a remarkable clarity. That single find produced stones of such extraordinary quality that even today they remain unsurpassed. As if the mineral resources of the Urals were inexhaustible, the same small area in the Middle Urals produced great quantities of high-grade topaz, beryl, amethyst, and tourmaline, which continued to be mined throughout the nineteenth century. In addition to these riches, initial deposits of nephrite were found along the river Onot in the Sayan Mountains of Siberia.

It was in the early eighteenth century, under the reign of Peter the Great, that the first Imperial lapidary was founded. In 1703, the tsar moved the capital from Moscow to the new city of St. Petersburg, which was being built on land only recently reclaimed from the swamps of the Neva River and was still periodically plagued by disastrous floods. Growth in the number of public and private building projects within the city steadily increased demand for both construction and ornamental stone, creating the need for grinding plants closer to the capital. The Imperial lapidary factory was built in Peterhof, on the outskirts

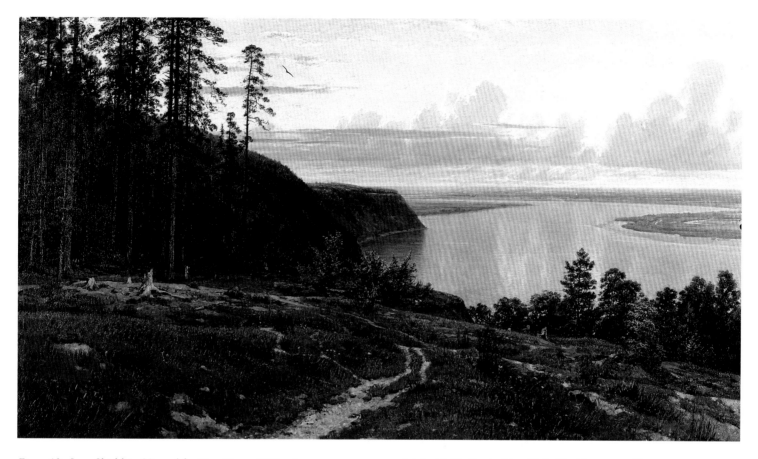

*Figure 13* Ivan Shishkin, *View of the River Kama*, 1882, oil on canvas, courtesy of A La Vieille Russie, New York. Shishkin, one of Russia's most influential landscape painters during the second half ot the nineteenth century, was born in the town of Yelabuyga on the Kama River. This waterway flows through the Ural Mountains, a major source of Russia's mineral wealth. It also links Siberia and the Urals in the West.

of St. Petersburg, replacing an existing small, outdated grinding mill. At the beginning merely a polishing facility for stone and commercial glass, by mid-century it was transformed into a well-equipped factory where a host of different artistic products were turned out. In addition to working with hardstones, the factory mastered the process of cutting gemstones and making jewelry. An attempt was made to learn the techniques of the Florentine mosaic using a variety of native stones, such as lapis lazuli, malachite, and marble, recently discovered in the desolate regions of the country.

Within a short period, the artisans of the factory mastered the unique process known as Russian mosaic, used to create large-scale objects made of lapis lazuli and malachite.[2] Such articles made for the Imperial court in the second half of the nineteenth century remain some of the most remarkable examples ever produced. From 1850 on, the finest works from the Peterhof lapidary factory began to gain international acclaim and were favorably compared with Italian mosaics, the model works in the field. Peterhof pieces were awarded honorary prizes at the International Expositions in London in 1862 and in Paris in 1867, and received the highest award at the 1893 Columbian Exposition in Chicago.

The nineteenth century also saw a surge in demand for the faceted gemstones. Factories were engulfed with orders from

royalty, jewelry firms, and private clientele. The Peterhof lapidary factory worked almost entirely on commissions from the Imperial court, making objects for personal needs, presentations, gifts, international exhibitions, etc. Objects in a multitude of sizes and functions were produced—from small, elegant trinkets adorned with jewels and made of precious metals to enormous sarcophagi cut entirely from solid blocks of rhodonite and jasper. Intricate stone carving was usually done by a special group of highly trained native and foreign masters, the latter being invited for specific projects. Whenever finished products required the addition of metal mounts, they were subcontracted to different, independent manufactures outside the factory. Factory Director Andrei Gun, a trained architect and a professor at the St. Petersburg Academy of Arts, provided artistic leadership and original design sketches for the firms of Verfel, Fabergé, Ovchinnikov, Bolin, Bekhli, and Khlebnikov, which collaborated with the factory, producing artistic mountings and accessories.

The tradition of artistic stone carving in the Ural Mountains predated the establishment of the Imperial Lapidary Works in Peterhof, albeit on a modest scale. Initially practiced by individual, self-taught craftsmen or in small, home-based workshops, stone-carving techniques advanced greatly due to the growing commissions from the capital. Together with architects, sculptors, and bricklayers, stone carvers were enlisted to work on building projects in St. Petersburg. Whereas initially artisans in the Ural areas primarily supplied semi-finished products or made simple, utilitarian items, by 1720, more artistic production had begun. The most frequently used materials were various kinds of chalcedony, like carnelian and agate. Typical products were cameos, bracelets, clasps, decorative pins, earrings, chess sets, coffee cups, clock cases, snuffboxes, and many other commonly used items. Ornaments made of faceted topaz, quartz, and carnelian were in great demand.

Later, local artisans began producing unusual stone mosaics, which were widely praised for their original designs and artistic execution. By the late nineteenth–early twentieth century, they mastered the technique of creating three-dimensional compositions in the shape of fruits, berries, and various foliage, which were used as centerpieces on the top of boxes, paperweights, and many other objets d'art. On occasion, these clusters of fruit were attached to a stem made of natural crystal, which made the final product incredibly realistic and unusual. Made with remarkable

naturalism and technical precision, these compositions became extremely popular and were in great demand.

The incredible abundance of form and rich variety of hardstones in the Urals and Siberia, and the substantial distance separating the mines from Peterhof, forced the establishment of two other famous Imperial lapidary works—one in Ekaterinburg in the Urals and the other in Kolyvan in the Altai Mountains. In 1721, the Director of Metallurgy Works in the Urals had suggested the building of a lapidary factory in Ekaterinburg, which, among other things, would cut decorative and precious stones. The stone-carving craft, although traditional to the area, was practiced by a limited number of artisans. Around 1726, the first small lapidary workshop was established, and, after several expansions, was turned into a factory in 1751. Early on, the factory's production was limited to slabs of cut and polished stone that were shipped to St. Petersburg, where the final touches could be applied. Modest attempts to manufacture finished products were made in 1752, when the first snuffboxes from local agate and small vases and buttons from carnelian and agate were produced. Building on its initial success, the factory converted entirely to the production of completely finished objects in 1782. In addition to small-scale pieces, the factory began to make large, complex works of jasper, malachite, and rhodonite, which were popular with the aristocracy.

By the end of the century, ornamental objects made from Ural stones were considered essential to the decoration of palace interiors. Leading Russian artists and architects of the time, such as A. Voronikhin, A. Zakharov, K. Rossi, V. Stasov, I. Gol'berg, K. Ton, and A. Shtakenshneider, designed factory-made pieces. For less important commissions, drawings by local draftsmen and trained artists were frequently used. The heyday of artistic stone cutting came in the early–mid-nineteenth century. Factory products were continuously awarded major prizes at the international exhibitions of industrial arts and were displayed among the prized possessions of the museums and palaces in St. Petersburg and other European capitals.

Both the Peterhof and Ekaterinburg factories became world centers of lapidary production, mastering the secrets of working with such challenging materials as malachite and lapis lazuli. For almost two centuries, these factories successfully maintained a monopoly on the unique technique of stone veneer, which required the application of small, thin pieces tightly fitted over

the base form. This approach, virtually unknown anywhere else in the world, made it possible to create gigantic columns, ornamental vases reaching to over 6 ½ feet (2 meters) tall, candelabra, tables, and other exquisite objects that were made with a technical virtuosity unsurpassed even today.

Other stones, like rhodonite, found in nature in the form of large slates, were transformed into monolithic objects remarkable for their large scale. Jasper was also among the frequently used stones. Ever since ancient times, this hardstone has been used to carve small figurines and ornaments. However, not until the eighteenth century did the technology become available to tame this stubborn stone for larger decorative projects. To some extent, it was the working of jasper that became the real testing ground for the techniques and advancements of the Russian lapidary art in general.

Large deposits of jasper, quartzite, and porphyry in the Altai mountains dictated the founding of yet another lapidary center. At first, already existing copper-smelting works were used for a limited number of stone-cutting projects. By the 1800s, the Imperial Kolyvan factory was established and was solely dedicated to lapidary production. In time, the site became famous for manufacturing enormous objects, columns, pedestals, fireplaces, and monumental vases, all made of assorted local stones. The most famous examples are a colossal oval vase on a pedestal made of jasper. It reaches over 8 ½ feet (2.6 meters) in height and weighs approximately 10 tons. The unique vase took almost twenty-two years to make.  It was named "Tsarina of all vases" and remains one of a kind.

As noted earlier, the opulence of the Imperial court was astonishing to foreign travelers and adversaries. Innumerable treasures were kept in the palaces, churches, and numerous monasteries. But who were the ingenious masters who created stupendous works of applied art as early as sixteenth century? And what kind of precious jewelry and ornaments were valued most in Russia at that time?

The art of jewelry making dates back to the ancient period of Russian history, before the Mongol invasion. Its development was influenced both from the East, where most luxury goods came from, and the Byzantine Empire, especially after Russia adopted Christianity in 988. The traditional decorative motifs used in wood and clay works, and the metalwork made in many local artistic centers in Russia, provided an extensive ornamental

vocabulary for the emerging jewelry art from the beginning. One of the characteristics of this Russian art was a predilection for intensely colored gemstones. Used sparsely at first, they began to be incorporated into the overall ornamentation of the object more frequently shortly after gemstones became readily available. They soon came to dominate completely over any other decorative devices employed in luxury wares.

Many Russian towns were centers of jewelry making long before the seventeenth century. After the consolidation of many small Russian principalities and the subjugation of its rivals in the sixteenth century, Moscow rose to prominence as an artistic center of the utmost importance. Artisans from every corner of the country were brought there to work at the Kremlin Armory, which produced the tsar's ceremonial robes, presentational arms and armor, ecclesiastical objects, table wares, furniture, and so forth. The shapes, as well as the ornamentation, of those objects were traditional and followed strictly the canons of the religious art of the earlier period. Such was the case with icon and Gospel coverings, chalices, and princely wares decorated mostly with biblical scenes within exuberant foliage ornamentation.

The seventeenth century continued the preference for lavish embellishment and a profusion of colorful gemstones. With time, religious scenes began to be supplemented with secular subjects, scenes of nature, and domestic details. Silver and Gold Chambers, the workshops on the Moscow Kremlin grounds, produced most of the gold and silver articles needed by the Russian court. Cutting and setting gemstones into decorative objects was apparently done in the Diamond Chamber, a separate workshop within the Kremlin Armory.

In addition to the native artisans brought to the capital, a small number of foreign silversmiths and goldsmiths were invited from the West as well. They were most likely the source of a few western motifs that began to appear on many objects at that time. In general though, western influence remained limited, and Russian decorative art continued to maintain its integral national character based on the centuries-old traditions. Bright, intense-colored gemstones continued to be used as accents throughout the century. Emeralds, sapphires, rubies, and pearls were among the favorite jewels of the period. On occasion, faceted stones made their appearance amidst the lavish ornamentation, but cabochon stones, often irregular in shape, and characteristic of an earlier period, remained the most

commonly used. Diamonds played a modest role, overshadowed by the colorful combinations of other precious stones and bright enamels. New technological advancements allowing facets to be cut in the natural diamond advanced this stone in the hierarchy of gemstones.

By the end of the seventeenth century, the monochrome palette only occasionally punctuated with a burst of colored stones became prevalent in decorative objects and jewelry. In the effort to demonstrate opulence, these ornate pieces were often overloaded with stones and unrestrained decorative details. Clarity of design and harmonious balance of all the elements was often sacrificed to the luxurious appearance and magnificent splendor of the objects.

The eighteenth century brought about significant changes in the social and cultural structure of Imperial Russia, alterations that affected jewelry art. During the 1730s, a rivalry developed between the French and Russian courts, and astronomical amounts of money were designated for the luxury items that demonstrated the wealth and splendor of each court. Jewelry making became one of the most important branches of the applied arts. Ladies and gentlemen adorned themselves with glittering stones from head to toe. Considerable improvement in cutting techniques set the stage for a real mania for diamonds. It was during this time that all of the main forms of stone cutting still in use today were introduced. Cut diamonds soon became an essential part of all decorations. Colored stones remained popular, and occasionally diamonds were backed with colored foils, so as to give these rather cold stones a light shimmer of color. By the 1750s, colored stones went out of style, and diamonds came solely to dominate the world of jewelry.

The eighteenth century was truly considered the age of jewelry. Never before or since has jewelry enjoyed such popularity and been imbued with such meaning. Its importance rose greatly from simple personal adornments and tokens of gratitude to official awards for service. A special gift fund was established at the Imperial court, and thousands of snuffboxes, watches, rings, bracelets, chatelaines, necklaces, and gold boxes were kept for presentation purposes.

Increasing requests from the court and orders from a wealthy clientele stimulated the rapid expansion of the industry and its workforce. In addition to the Russian jewelers working primarily in the traditional style, more and more foreign masters began to

be drawn to the business opportunities offered in Russia. They introduced distinctly European influences and many important stylistic changes.

The rococo style that dominated the 1730s, which was characterized by capricious scrolls, shell and diaper motifs, and fluid asymmetrical forms, started to wane by the end of the century. It was replaced by Neoclassicism, which favored classical models and simple, spare decoration. In jewelry, this stylistic change manifested itself in simpler forms and increased use of a monochrome palette.

Hundreds of goldsmiths worked in St. Petersburg at this time. These were mostly European masters looking for new professional opportunities. Not all of them were recent immigrants; many goldsmiths had, in fact, been born in St. Petersburg and remained foreigners only by origin. Among them were a few truly exceptional goldsmiths who were well known in Russia as well as in Europe: Gravero, Ieremie Pauzié, L. Pfisterer, Jean-Pierre Ador, Jean Duc, Johann Gothlieb Scharff, and Louis David Duval. Closely associated with the Imperial court, they manufactured many highly artistic works, from jewelry sets to the Imperial Regalia.

Clearly, the Imperial court played an important role as trendsetter and, therefore, a part in stylistic developments of the period, but the influence of these leading court jewelers on their craft in general cannot be overestimated. At the same time, it is readily apparent that the work of these foreign masters was strongly impacted by Russian national and historic traditions.

Classicism remained prevalent during the early nineteenth century in Russia. Images of military warriors, eagles, trophies, classical emblems, and mythological figures were popular and formed the artistic background to the Napoleonic war, which brought glory to Russia for its defeat of the French emperor. Historical and genre scenes, idyllic and pastoral subjects, and ethnographic types were also favored and were among the predominant styles of decoration.

A passion for antiquities also made cameos and intaglios widely popular. Mounted in gold and framed with diamonds and pearls, they frequently were fashioned into tiaras, clasps, necklaces, belts, and hair combs. Many colored gemstones—rubies, sapphires, emeralds, alexandrites, amethysts, aquamarines, and topazes—were among the preferred native stones. In addition to the color, great value was now put on the stone's

size, clarity, and fire, as well as the precision of the cut. Greater attention was often paid to semiprecious stones, such as agates, carnelians, onyxes, corals, and garnets. Great symbolism was attached to these stones, and they often were put together so that the initials of their names spelled another name or a saying.

Growing demands for silver and gold articles encouraged the rapid growth of jewelry firms and workshops. The large firms of P. Ovchinnikov, I. Khlebnikov, P. Sazikov, O. Kurlyukov, and the Bolin family expanded their production and became industry leaders. These firms received numerous commissions from the Imperial court and laid the foundations for Russia's fame in jewelry making and applied arts. Well represented at all major Russian and international exhibitions, these firms gained enormous popularity and acclaim, and won the highest awards and prizes.

Amidst the large number of extraordinary silversmiths active during that period, the one firm that received the most attention and universal recognition was that of Carl Fabergé. The history of its modest beginning, its rise to prominence, and its eventual disappearance is documented in the essay by William Johnston in this volume and need not be retold here. Eighty years after the firm's closure, public fascination with Carl Fabergé and his creations is stronger than ever. Fabergé objects continue to be the most intriguing and sought after items at international exhibitions. This sustained importance is hardly a surprise, considering that the House of Fabergé was a unique establishment, and a phenomenon even for Russia, where jewelry art at the beginning of the twentieth century reached unprecedented heights.

NOTES

[1] Ancient Roman historians Tacitus and Pliny the Elder (1st century A.D.) wrote about emeralds and rough diamonds apparently being brought from "Rifeiskii," i.e. the Ural Mountains. Even if these reports were true, the exact location of the gem sites had long been forgotten.
[2] The technique is characterized by a very thin veneer of decorative stone being applied in a rhythmic and complicated pattern over the base form.

# Catalogue of the Exhibition

*Figure 14* Large lapis lazuli urn set with ormolu mounts in the Nicholas Hall of the Winter Palace, St. Petersburg

# The Precursors

After his family had moved from St. Petersburg to Dresden in 1861, Carl Fabergé toured western Europe, visiting London, Paris, Milan, and Frankfurt-am-Main. In the course of these travels, he briefly apprenticed with a goldsmith, Joseph Friedmann of Frankfurt, and familiarized himself with the major developments in European luxury arts. Especially significant for his subsequent career were visits to the Grünes Gewölbe, the Dresden museum founded by Augustus the Strong in 1723/24 to house the state treasures of Saxony. Among its holdings were bowls and other utensils carved from rare stones by seventeenth-century Italian and South German lapidary artisans, statuettes by German seventeenth-century ivory workers, and masterworks by the eighteenth-century goldsmiths Balthasar Permoser, Johann Heinrich Köhler, and von Ferbecq. Most importantly, the Grünes Gewölbe housed the principal works of Johann Melchior Dinglinger (1664–1731), the court jeweler who together with his brothers Georg Friederich and Georg Christoph, an enameler and jeweler respectively, was responsible for some of the most fanciful figurative works in the history of European jewelry (cat. no. 1).

The St. Petersburg to which Carl Fabergé returned in 1865 was scarcely 158 years old, but it was already a city in which the fine and decorative arts flourished. Peter the Great and his successors, particularly Elizabeth I, Catherine II, and Nicholas I, had attracted to the new capital many eminent artists from France, England, and various German cities. Also, local craftsmen had been trained in western rococo, neoclassical, and empire styles. Such important goldsmiths and jewelers as Carl-Edward Bolin, Ignaty P. Sazikov, W. Kämmerer, Ivan Keibel, A. E. Tillander, and Ivan Y. Morosov had already established businesses in the capital before Fabergé joined his family firm. An advantage that Russian craftsmen had over their western counterparts was access to the vast mineral wealth of the Russian Empire. In the course of the eighteenth century, quarries had been opened in the Urals and in the Altai Mountains of northwestern Mongolia. Rich deposits of lapis lazuli were discovered in the Sluidianka River valley in southeastern Siberia and malachite was mined in the Urals. Among the other minerals that became available were various colored porphyries and jaspers, eosite, bowenite, rhodonite, and unlimited supplies of quartzes and chalcedonies. Initially, these resources were used for small decorative pieces such as snuffboxes, but by the early nineteenth century they were being employed on a grand scale for furnishing the palaces of St. Petersburg. Those stones that were particularly friable, including malachite and lapis lazuli, were usually used as a veneer in a technique known as "Russian mosaic" (see the essay by Chistyakova in this volume, p. 29).

1

## Ceremonial Cup, ca. 1720

*Johann Melchior Dinglinger*
*German (Dresden), 1664–1731*
*Agate, enamel, silver-gilt, various stones, gold*
*H: 11 ⅜ in (29 cm)*
*Provenance: Grünes Gewölbe, Dresden, 1722–1924; Dr. F. Mannheimer,*
*Amsterdam; Muller sale, 14 October 1952, lot 213; Alastair Bradley*
*Martin, New York; John Hunt, Dublin*
*The Walters Art Museum, acquired by partial exchange, 1971, 57.1994*

This ceremonial cup with a rearing Polish horse mounted on a translucent agate bowl is rich in state symbols. The horse wears a diamond-studded harness and an enameled saddle cover emblazoned with the Polish eagle. From beneath the saddle protrude the sword of investiture of the Order of the White Eagle and the ceremonial sword of Poland. An enameled oval medallion on the back of the bowl displaying a horseman painted in white on a rose ground represents the arms of Lithuania, then a grand duchy united with Poland. Set into the stem of the cup is a Polish crown resting on an enameled cushion supported by a white eagle. The stem is otherwise composed of entwined ribbon and

leaf scroll motifs in enameled silver. A star-shaped white-and-gold pendant of the badge of the Order of the White Eagle of Poland countercharged with the arms of Saxony is suspended from a gold lion's mask. Among the scrollwork are such naturalistic elements as a salamander, a pair of hounds, and other creatures. On the oval base are interlaced double A's, the monogram of Augustus the Strong. This cup is one of a pair commissioned by Augustus the Strong (Frederick-Augustus I, Elector of Saxony, and also King Augustus II of Poland) and was first displayed in the Grünes Gewölbe (Green Vaults) in Dresden on 2 February 1722. The companion piece, showing a trotting horse, has remained in Dresden.

Johann Melchior Dinglinger was appointed jeweler to the court in 1698. Working together with his brothers Georg Friedrich, an enameler, and Georg Christoph, a jeweler, he drew upon Saxony's rich mineral resources to keep alive the Renaissance goldsmith's tradition in which semiprecious stones and enamels were used in conjunction with metal. His international reputation was such that Peter the Great of Russia stayed as his houseguest in 1712.

Carl Fabergé had access to the Grünes Gewölbe when he joined his father in Dresden in 1861, and he undoubtedly was profoundly influenced by Dinglinger's works, such as his masterpiece, the Court of Aurangzeb (1707), in which 165 enameled gold figures pay homage to a Mughal emperor. He would also have seen pieces by Dinglinger in the collection of gems and ornaments in the Hermitage Museum.

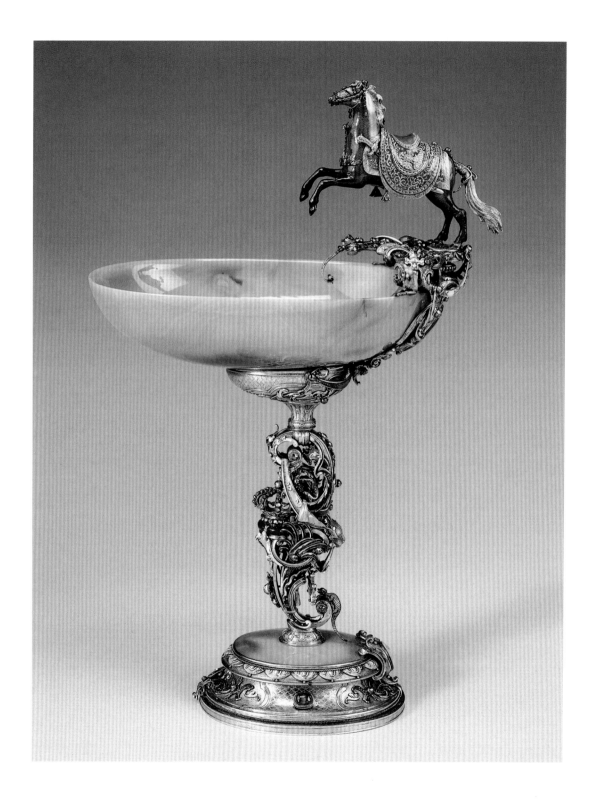

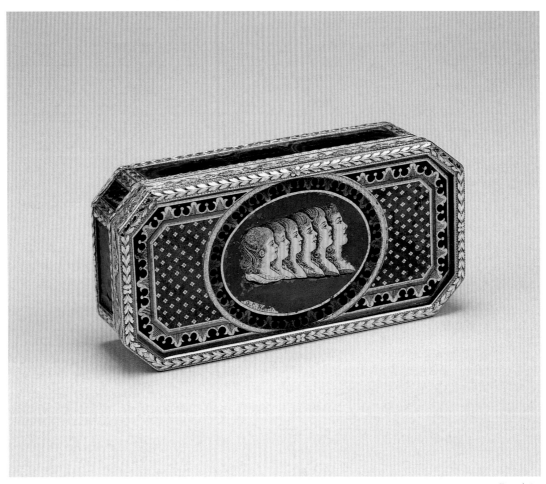

*Actual size*

2

*Box with Profile Images of the*
*Six Children of Tsar Paul I*

*St. Petersburg, ca. 1795*
*Goldsmith: Ditmar Kahrs (Norwegian) (marked with his initials)*
*Gold, malachite,* verre églomisé
*H: 1 in (2.5 cm); L: 3 ⅞ in (9.9 cm); W: 1 ⅞ in (4.7 cm)*
*Provenance: Henry Walters from Alexandre Poloutsoff, Paris, 1929*
*The Walters Art Museum, acquired by Henry Walters, 1929, 57.45*

This rectangular tobacco box with chamfered corners is faced with sheets of malachite. Set in the lid is a panel of *verre églomisé*, a decorative technique in which a design is worked onto the reverse side of a sheet of glass that has been gilded, silvered, or painted—gold and black being the most common color combinations. In Russia, it was a popular art form not only for small items, but also for large pieces of furniture. Although much *verre églomisé* was produced at the Imperial Glass Factory in St. Petersburg, individuals, including Grand Duchess Marie Fedorovna, also practiced this technique.

Represented in profile are the six older children of Paul I (1754–1801) and his second wife, Marie Fedorovna (1759–1828). The portraits replicate an aquatint by James Walker (1748–1808[?]), an English artist appointed engraver to the Court of Catherine II in 1785. His print, in turn, is based on a miniature by Marie Fedorovna dated 1790, which she presented to her husband on 19 September of that year. The subjects are Grand Dukes and Duchesses Alexander (later Alexander I), Constantine, Alexandra, Elena, Maria, and Catherine.

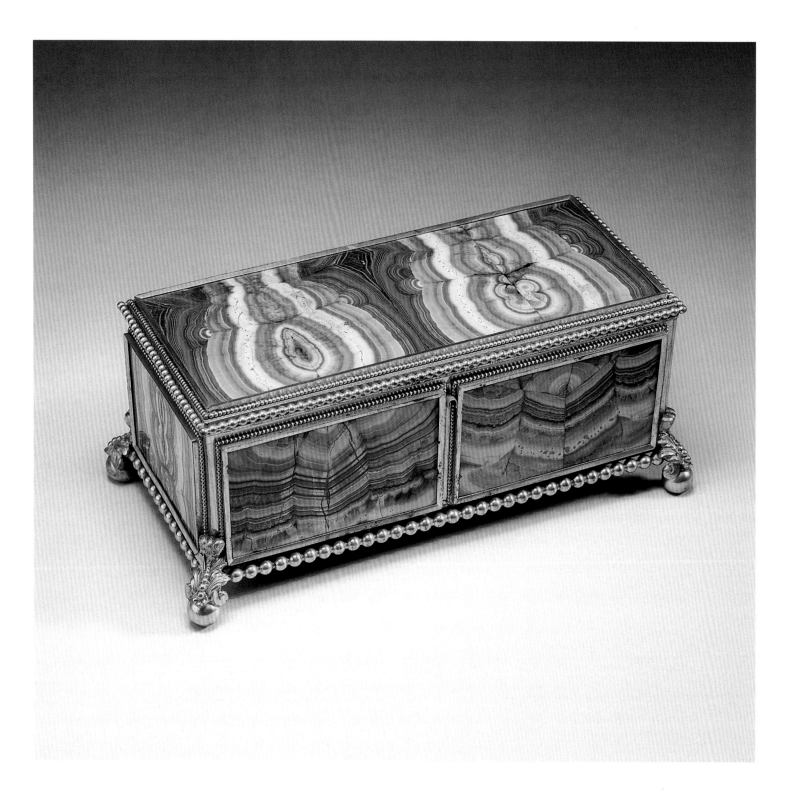

3

## Jewel Casket

*Russian, early 19th century*
*Gilded bronze, malachite*
*H: 4 in (10 cm); W: 9 ¾ in (24.8 cm)*
*Provenance: Henry Walters*
*The Walters Art Museum, acquired by Henry Walters, 57.1597*

This gilded bronze casket with a hinged lid rests on spherical feet surmounted by scrolls. Its frame is decorated with both large- and small-scale beading, and the sides and top are faced with thin sheets of malachite.

4

## Flower Basin

*Russian, late 18th or early 19th century*
*Gilded bronze, amethyst, agate, jasper, petrified wood, carnelians, marble*
*H: 6 ⅞ in (17.3 cm); D: 19 ¼ in (48.8 cm)*
*Provenance: Henry Walters from Alexandre Poloutsoff, Paris, 1929*
*The Walters Art Museum, acquired by Henry Walters, 1929, 54.1909*

The tradition of mounting specimen stones can be traced to sixteenth-century Florentine *pietra dura* work. In the late 1700s, techniques for slicing and polishing stones were perfected, allowing lapidaries, most notably the Dresden goldsmith Johann Christian Neuber (1736–1808), to produce masterpieces in which concentric, radiating patterns of specimen hardstones were set in lids of snuffboxes and circular tabletops.

In this Russian, Empire-style work, the skeleton of the container is in gilded bronze with Roman motifs including scroll patterns, *paterae* (or saucer-shaped appliqués), and paw feet. The body is lined with sheets of pink amethyst with traces of fluorite, and the rim is decorated with alternating carnelians and foil-backed amethysts. Set in the frame are sheets of dark brown agate, light brown spotted petrified wood, tan agate, pink agate, and white marble. The paterae have centers of banded agate and borders of jasper.

*5*

## Bowl on Tripod Feet

*Russian, early 19th century*
*Lapis lazuli, gilded bronze*
*H: 21 ¼ in (54 cm)*
*Provenance: Henry Walters*
*The Walters Art Museum, acquired by Henry Walters, 41.239*

In addition to the French Empire style, other neoclassical trends emanating from England, Germany, and Italy inevitably influenced the development of the decorative arts in St. Petersburg in the early nineteenth century. This vessel, both in its form—derived from an ancient Roman incense burner—and in its decorative motifs, exemplifies the Russian style *à l'antique* of this period. The classical decoration includes, from top to bottom, an egg and dart band, Roman *paterae* (or saucer-shaped appliqués), a circular support with chased Greek key decoration, a finial, and hairy paw feet.

This piece has been veneered using a technique known in Russia as "Roman mosaic." It entails the use of very thin sheets of mineral that are cemented to a metal or stone base. Any interstices left uncovered are filled with a paste of pulverized mineral and cement, and the surfaces are then polished. This technique lent itself especially to lapis lazuli and malachite, minerals that were both too costly and too brittle for large-scale carving. The three major centers of production were the Peterhof stone-cutting factory outside St. Petersburg, a factory in Ekaterinburg in the Ural Mountains, and one in Kolyvan in Siberia.

For this bowl on tripod feet, lapis lazuli has been applied over a bronze base. The mineral was originally imported from Badakshan, Afghanistan, but, in 1785, rich deposits were also discovered in the valley of the Sluidianka River in southeastern Siberia. The lapis lazuli's intense blue color is highlighted by the addition of the gilded bronze classical ornaments. A similar piece, veneered in malachite, is preserved in the State Hermitage Museum in St. Petersburg. Perfume burners, small round tables known as *guéridons*, and ornamental works of this form were popular in the early nineteenth century, as is demonstrated by glass examples produced at the Imperial Glass Factory.[1]

[1] A. Chenevière, *Russian Furniture, the Golden Age, 1780–1840* (New York, 1988), 163, figs. 161 and 162.

*6*

## Tazza

*Russian, mid-19th century*
*Marble*
*H: 13 ⅞ in (35 cm)*
*Provenance: William T. or Henry Walters*
*The Walters Art Museum, acquired by William T. or Henry Walters, 41.267*

This fluted, kylix-shaped basin is decorated with two carved acanthus leaves and a pair of leonine satyr's masks. It stands on a mottled green marble base.

7

# Tazza

*Russian, mid-19th century*
*Malachite, ormolu, slate, gilded bronze*
*H: 9 ⅝ in (24.5 cm); D: 9 ³⁄₁₆ in (23.3 cm)*
*Provenance: Mrs. Marjorie Merriweather Post*
*Hillwood Museum and Gardens, 21.100*

On this tazza, thin sheets of malachite, a stalagmitic form of carbon carbonate, have been cemented to a stone base. In about 1840, L. Leopold Joffrian perfected a machine with brass rotary saw blades that facilitated the very fine slicing of the mineral. Craftsmen could now apply these slices over a slate base, exploiting the concentric veins naturally occurring in the stone to create varicolored patterns. On the stem, however, the veneer is applied irregularly. The tazza has been mounted with a gilded bronze rim and base, the latter being chased with acanthus leaf motifs.

Inset in the bowl in ormolu is a prince's crown and, in Cyrillic, the name *Demidov*. The founder of the Demidov dynasty, Nikita Demidov, was a blacksmith ennobled in 1720 after manufacturing weapons and establishing an iron foundry for the government of Peter the Great. During the eighteenth century, the Demidovs augmented their wealth by operating ironworks and gold, silver, and copper mines. By the second quarter of the nineteenth century, they owned vast deposits of malachite, mostly near Nizhnii Tagil on the Siberian side of the Ural Mountains, north of Ekaterinburg. The Demidovs operated their own lapidary works in St. Petersburg and were largely responsible for the popularity of malachite work in the mid-nineteenth century. This tazza and its mate, also at Hillwood, are thought to have been Demidov presentation pieces.

## Table

*Russian, ca. 1860*
*Malachite, ormolu, slate*
*H: 30 ½ in (77.5 cm); D: 20 ⅜ in (51.7 cm)*
*Provenance: Mrs. Marjorie Merriweather Post*
*Hillwood Museum and Gardens, 32.20*

During the third quarter of the nineteenth century, Russian furniture designers worked in an eclectic style utilizing Renaissance and Baroque motifs. The top of this table is veneered in the "Roman mosaic" technique, with thin sheets of malachite cemented concentrically over the surface so as to exploit the decorative quality of the mineral's veins. The supports include a central baluster pedestal and three scrolled legs bearing Renaissance-style female caryatid figures, all in ormolu. The caryatids wear cuirasses with animal masks and terminate in acanthus leaves.

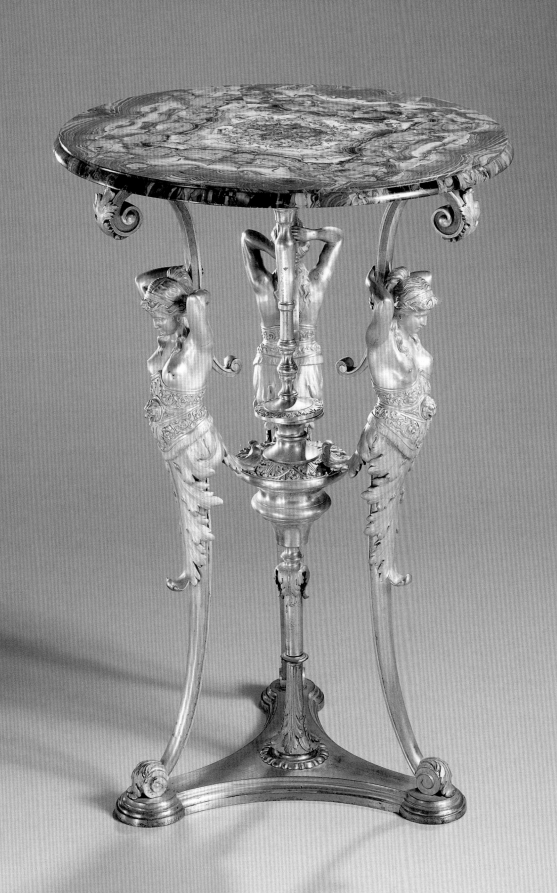

*9*

## Bowl

*Russian, late 19th century, possibly the firm of Carl Fabergé*
*Nephrite*
*D: 5 ⅟₁₆ in (12.9 cm)*
*Provenance: Henry Walters*
*The Walters Art Museum, acquired by Henry Walters, 42.561*

This nephrite bowl is a tour de force in the art of the lapidary. It is so thinly cut and so finely polished that it appears translucent against the light. For decorative purposes, Fabergé much more frequently used nephrite, a dark green mineral species of jade found in Siberia, than the more rare jadeite.

*Actual size*

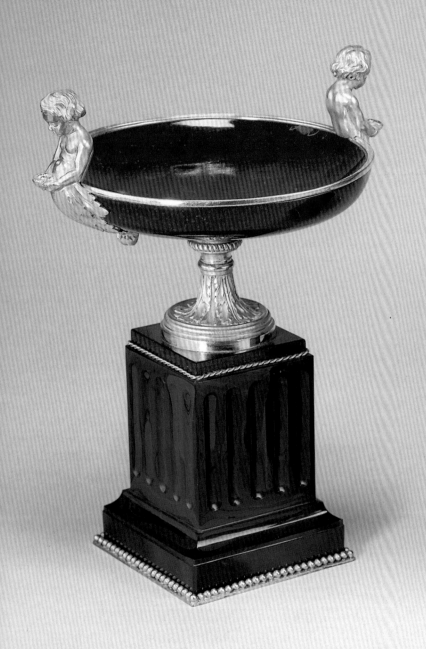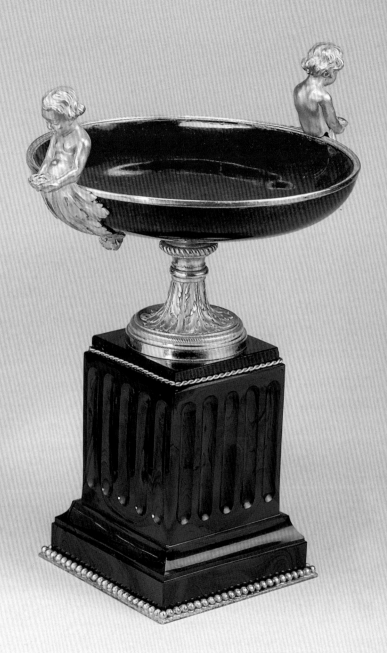

*10*

## Pair of Tazzas

*St. Petersburg, late 19th century*
*Imperial Glassworks*
*Purpurine, gilded bronze, colored glass*
*H: 9 ½ in (24 cm)*
*Provenance: Henry Walters from Alexandre Poloutsoff, Paris, 1930*
*The Walters Art Museum, acquired by Henry Walters, 1930, 47.415 and 47.416*

These kylix-shaped bowls are mounted with gilded bronze handles in the form of *putti* and are borne on feet decorated with acanthus leaves of the same metal. Gilded bronze beading has also been applied to the fluted bases of the gray-blue glass.

The most outstanding feature of these tazzas is the intense, *sang de boeuf* red of the bowls. The material is purpurine, a dense lead-potash glass containing crystals of cuprous oxide in a clear matrix. It is named after *porporino*, a red glass that had been developed by Alessio Matteoli in the Vatican mosaic workshop during the eighteenth century. Leopold Bonafede, one of two Italian brothers called to Russia in the mid-1850s by Tsar Nicholas I, produced purpurine at the Imperial Glassworks in St. Petersburg. The earliest documented use of this product was for five of the Imperial Glassworks' six entries at the Paris Exposition Universelle in 1867. After Bonafede's death in 1878, purpurine continued to be made at the factory under the direction of the chief chemist, S. P. Petuchov. The Imperial Glassworks supplied Fabergé with purpurine, though the jewelry firm developed its own purpurine of a slightly different chemical composition after 1880.

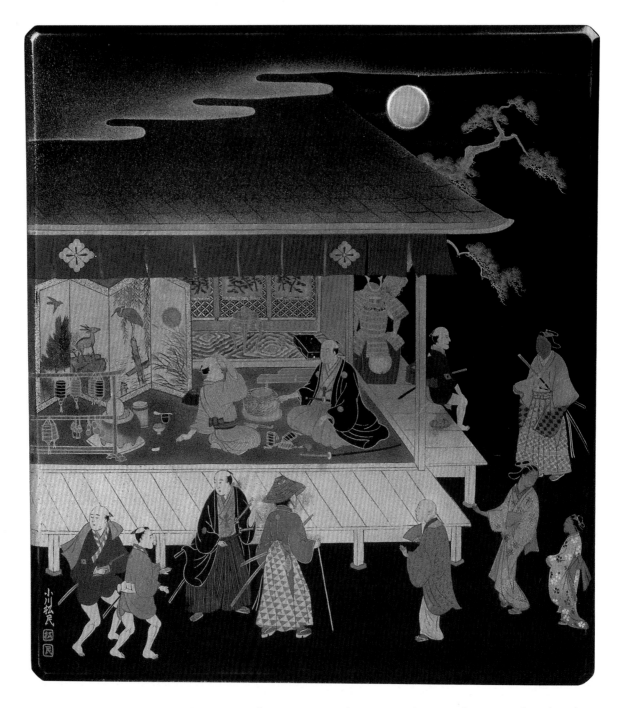

*Figure 15*  Ogawa Shōmin, box for writing implements, Japanese, late nineteenth century, lacquer, mother-of-pearl, silver, the Walters Art Museum, 67.162. This box depicts a shop selling inro. The man in the straw hat (bottom center) is wearing an inro with a netsuke attached

# Netsuke

As early as the sixteenth century, netsukes were adopted by the Japanese in their dress as a means of suspending personal belongings, known as *sagemono,* from their *obi,* or the sash worn around their waists. A cord was threaded through two openings in the netsuke and tied, and the loop was then inserted under the *obi* with the netsuke serving as a toggle to prevent the cord from slipping off. For a garment without pockets, netsukes were highly utilitarian devices that permitted wearers to carry on their persons such *sagemono* as purses, medicine, or seal cases (*inro*), and, especially after a ban on the cultivation of tobacco was repealed in 1716, tobacco pouches (*tabakoire*).[1]

Initially, netsukes were made from roots, shells, gourds, and wood, but by the mid-seventeenth century, they had evolved into flattened, buttoned-shaped products. During the eighteenth century, the *netsuke-shi* had emerged as a class of artists who specialized in the production of netsukes as a form of miniature sculpture using a wide range of materials including ivory, lacquer, various woods, coral, metal, and enamel. The *netsuke-shi* is particularly associated with miniature sculptures of deities, legendary figures from Japanese folklore, animals, plants, and human utensils. In terms of quantity, the production of netsuke reached its apogee during the second quarter of the nineteenth century. In the later netsukes, the carvers tended to strive for extreme realism, whereas previously their works were more stylized. Following the opening of their country to the West in 1867, the Japanese gradually adopted European dress, and the need for netsukes declined. However, they continued to be produced as independent works of art and sold abroad.

The appeal that netsukes held for westerners was but one manifestation of the *japonisme* movement that permeated European and American tastes and design during the later nineteenth century and the early years of the twentieth century. Important collections were assembled in Europe and America, and netsukes were often adapted to modern purposes such as cane-handle pommels and knobs on container lids. According to one estimate, Carl Fabergé had formed a collection of over 500 netsuke.[2] Undoubtedly, he saw in these miniature carvings a technical excellence, originality of design, and subtlety of humor that approximated the qualities of so many of his firm's hardstone works. Often, specific Japanese prototypes can be traced for Fabergé's carvings, but that the influence of the *netsuke-shi* was even more pervasive can be discerned in such values as tactile appeal and compactness of design that were shared by both schools of sculpture.

[1] The writer has drawn extensively from L. A. Edwards and M. M. Krebs, *Netsuke, The Collection of the Peabody Museum of Salem* (Salem, MA, 1980).

[2] A. K. Snowman, *The Art of Carl Fabergé* (London, 1952), 44–45.

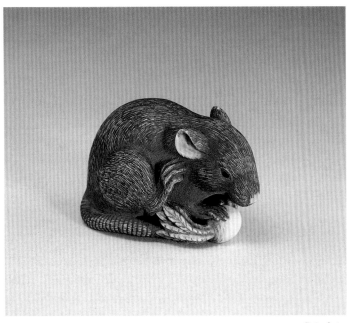

*Actual size*

*Actual size*

| |                                          | | 2

## Netsuke in the Form of a Rat

*Yamaguchi Okatomo (signed)*
*Japanese, active late 18th century*
*Ivory, coral*
*L: 1 ⅞ in (4.8 cm)*
*Provenance: William T. Walters*
*The Walters Art Museum, acquired by William T. Walters, 71.936*

The rat is portrayed with one rear leg raised to his ear and holding a
*daikon*, or Japanese radish, in his front paws. It has been realistically
carved and tinted with considerable attention lavished on its finely
incised strands of fur. Black coral was used for the inlaid eyes. The rat,
which is the first animal in the Chinese and Japanese twelve-year cycle,
was the first to appear before the Buddha in an audience of animals. It
was a popular subject, especially for those born in its year. A similar rat
by Okatomo is preserved in The Peabody Museum of Salem.[1]

[1] L. A. Edwards and M. M. Krebs, *Netsuke, The Collection of the Peabody Museum of Salem*
(Salem, MA, 1980), 97, no. 37.

## Netsuke in the Form of a Dog

*Izumiya Tomotada*
*Japanese, active late 18th century*
*Ivory*
*L: 2 ⅛ in (5.3 cm)*
*Provenance: William T. Walters*
*The Walters Art Museum, acquired by William T. Walters, 71.1020*

Although Chinese folklore disparaged dogs, in Japan they came to be
regarded positively as dispellers of evil and portenders of easy childbirth.
They symbolize the eleventh year in the Chinese and Japanese twelve-
year cycle. In this example, the crouching animal wears a rope leash.
Tomotada, a gifted animal carver, was particularly noted for carvings of
oxen with rope halters. He attracted many pupils, who were permitted to
sign their own works as his.

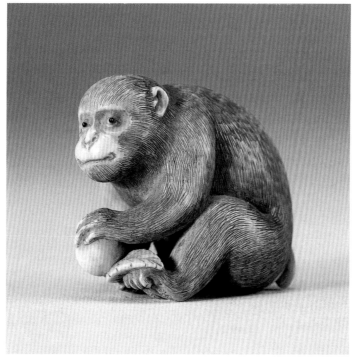

*Enlarged 200%*

13

## Netsuke in the Form of a Monkey

*Yamaguchi Okatomo (signed)*
*Japanese, active late 18th century*
*Ivory*
*H: 1 ³/₁₆ in (3 cm)*
*Provenance: William T. Walters*
*The Walters Art Museum, acquired by William T. Walters, 71.939*

Monkeys, which are native to Japan, symbolize the ninth year in the Chinese and Japanese twelve-year cycle. They were highly regarded as subjects for artists in all media. When holding a peach, as in this example, they are associated with longevity. Okatomo, together with Tomotada and Masanao, were the three major netsuke carvers in eighteenth-century Kyoto.

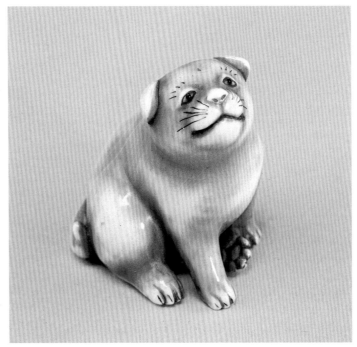

*Enlarged 200%*

*14*

*Netsuke in the Form of a Puppy*

*Ohara Mitsuhiro (signed)*
*Japanese, 1810–75*
*Sperm whale tooth*
*H: 1 ⅜ in (3.5 cm)*
*Provenance: William T. Walters*
*The Walters Art Museum, acquired by William T. Walters, 71.911*

The dog represented the eleventh year in the Chinese and Japanese twelve-year cycle and was popularly regarded as a dispeller of evil. It was frequently portrayed as a puppy. Ohara Mitsuhiro, one of the most versatile and highly regarded netsuke artists of the mid-nineteenth century, was born in Onamichi, near Hiroshima, and became an adherent of Zen Buddhism. In this example of his work, the smooth, rounded, subtly stained surface appeals to the viewer's tactile sense.

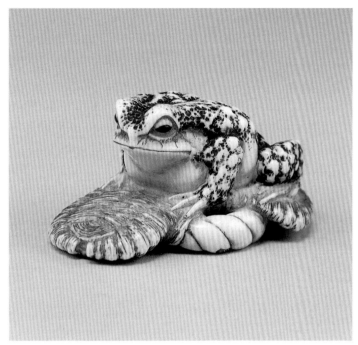

*Enlarged 200%*

15

## Netsuke in the Form of a Toad

*Suzuki Masakatsu*
*Japanese, active late 19th century*
*Ivory*
*H: ⅞ in (2.2 cm)*
*Provenance: William T. Walters*
*The Walters Art Museum, acquired by William T. Walters, 71.942*

As was characteristic for this period, the sculptor has striven for the maximum verisimilitude in rendering this toad seated on a straw sandal, carefully depicting the warty surface of its skin. He alternated between a black stain for the toad and a light brown tint for the sandal.

# Objets de Fantaisie

In the early 1880s, the House of Fabergé, which previously had been known for conservative enameled and diamond-set jewelry, focused increasingly on *objets de fantaisie*. These decorative pieces may sometimes have served a utilitarian purpose, but they were invariably intended to bring visual and tactile pleasure to the user. As was true of the miniature nephrite watering can presented to the ballet dancer Elisabeth Balletta (cat. no. 39), some simply served as delightful gifts. Those with an ostensible function included parasol handles and desktop objects such as letter openers, gum or glue pots, and stamp moisteners. Also popular were bell pushes, which replaced hand bells following the introduction of electricity, and picture frames, which were increasingly favored as painted portrait miniatures gave way to family photographs. Likewise, instead of snuffboxes, Fabergé produced the paraphernalia associated with smoking: cigarette boxes and holders, cigar cases, and match strikers. Most of these works were produced in the firm's St. Petersburg workshops under the artistic direction of the senior master craftsman—a position held by Franz P. Birbaum after the untimely death of Carl Fabergé's younger brother Agathon in 1895—and ultimately of Carl Fabergé himself. Meanwhile, a factory in Moscow opened in 1887, specializing in larger-scale silver objects, some of which were enameled in the Slavic revival style.

The St. Petersburg pieces tended to reflect the French rococo, neoclassical, and Empire revival styles then fashionable with wealthy clients internationally. On rare occasions, however, the firm explored the Art Nouveau movement popular in avant-garde circles and sometimes, in its simplified designs and bold color schemes, it seemed to anticipate the Art Deco style of the 1920s. Although they employed traditional techniques of goldsmithing and enameling, Fabergé's workmen perfected them, producing, for example, a range of enamel colors that far exceeded those of their eighteenth-century predecessors.

The consummate *objets de fantaisie* were the fifty Easter eggs commissioned for the Imperial family. A year, at least, was spent in creating each of these masterpieces, which drew upon all the resources and combined skills of Fabergé's craftsmen as well as upon his own lively imagination. Even in these lavish Imperial gifts, Fabergé exhibited an unusual restraint, relying less upon costly gems and materials for effect and more upon the artifice of his goldsmiths, lapidaries, enamelers, and other artists. It was the selection of various stones and gems and metals for their decorative effect rather than their monetary value that distinguished the House of Fabergé from its competitors both in Russia and in the West.

## 16

## U.S.S. Mayflower Bowl, ca. 1905

*Moscow, firm of Carl Fabergé*
*Marked in Cyrillic with K. FABERGE; Moscow assay mark for 1899–1908;*
*incised inventory no. 20320*
*Silver (84 zolotnik) and silver alloy, emeralds, amethysts, sapphires*
*H: 19 ¼ in (48.9 cm)*
*Provenance: U.S.S. Yacht Mayflower, 1905; transferred in 1929 to U.S.*
*Naval Academy, Annapolis, Maryland, where it served as a depository for*
*calling cards in the Superintendent's quarters until it was moved to the*
*Naval Academy Museum*
*U.S. Naval Academy Museum, 29.13*

Following the defeat of Russian forces in the Russo-Japanese War (1904–5), President Theodore Roosevelt persuaded the opponents to undertake negotiations in Portsmouth, New Hampshire, that resulted in the signing of a peace treaty on 9 September 1905. The U.S.S. Mayflower transported the president to Portsmouth, and it was on the yacht that the Russian and Japanese representatives first met. After the signing of the treaty, the Russian delegation, in gratitude, presented this ceremonial bowl to the officers of the wardroom mess of the Mayflower. The inscription, written in Cyrillic, translates: "To the hospitable Yacht Mayflower as a token from the Russian delegates to the peace conference at Portsmouth, August 1905 September." Three holes in the front of the bowl indicate the former presence of a gold Imperial crest that has been lost.

This presentation piece is composed of a bowl shaped as a *koush*, a drinking vessel that traced its origin to medieval wooden, boat-shaped utensils, and a handle in the form of a *bogatyr*, or medieval knight from Kiev. The figure, cast in silver alloy, carries a battle-axe and shield and wears a helmet and armor of chain mail. Stylized aquatic motifs adorn the exterior of the bowl. The surfaces are set with polished stones that impart a sense of richness to the appearance of the vessel.

Tatiana Fabergé and Valentin Skurlov noted that the firm of Carl Fabergé produced a similar kovsh with an almost identical bogatyr warrior in 1910 for a cost of 2,000 rubles as a gift from Nicholas II to the boy emperor of China, Hsüan T'ung (reigned 1909–11).[1]

Moscow was the center of Russia's Pan-Slavic Revival, an artistic movement that reached its apogee with the 300th anniversary of the Romanov Dynasty in 1913. Drawing on subjects from Russia's history and utilizing decorative motifs from the nation's medieval past, artists developed a style that paralleled the international Art Nouveau movement. At his Moscow branch, Fabergé employed over a hundred workmen, mostly of Russian nationality, who produced such items using traditional Russian forms and motifs.

[1] T. Fabergé and V. V. Skurlov, *Faberzhe i petersburgskie iuveliry: statei, arckhivnykh dokumentov po istorii russkogo iuvelirgnogo iskusstva* (St. Petersburg, 1977), 245.

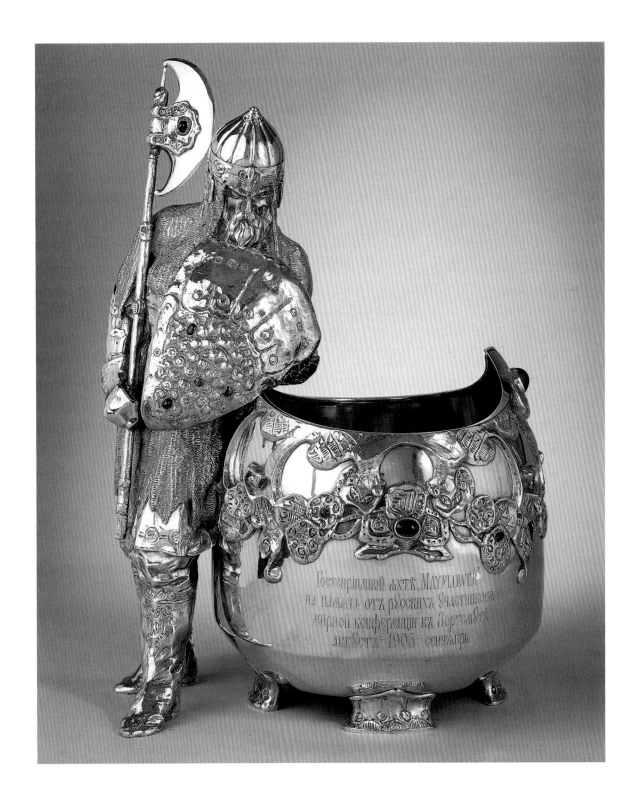

Гостепріимной яхтѣ „MAYFLOWER"
на память отъ русскихъ участниковъ
мирной конференціи въ Портсмутѣ
августъ 1905 сентябрь

*17*

## Kovsh

*Moscow, firm of Carl Fabergé*
*Marked in Cyrillic with the Imperial warrant and K. FABERGE; Moscow*
*assay mark for 1899–1908; incised inventory no. 13066; marked Shreve,*
*Crump & Low Co./6910/M*
*Silver (84 zolotnik), rubies, sapphires, emeralds, moonstones*
*H: 8 ½ in (21.6 cm); L: 17 ½ in (44.4 cm)*
*Provenance: The marks indicate that this kovsh was sold in the United*
*States through the Boston jewelry firm of Shreve, Crump & Low Co.;*
*Leroy Lipman, Baltimore*
*The Walters Art Museum, gift of Leroy Lipman, 1962, 57.1920*

This utensil is in the form of a kovsh, a boat-shaped drinking vessel.
Both the spout in the shape of a monstrous bat with spreading wings
and the handle terminating in a bust of a Kazan warrior have been cast
in silver. The border of interlace is studded with cabochon rubies,
sapphires, emeralds, and moonstones.

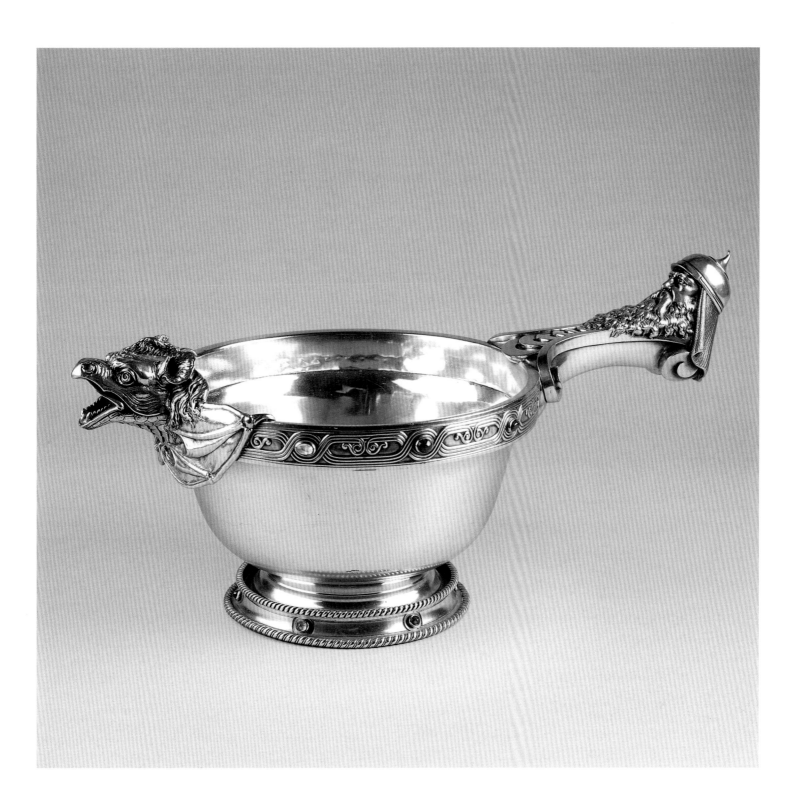

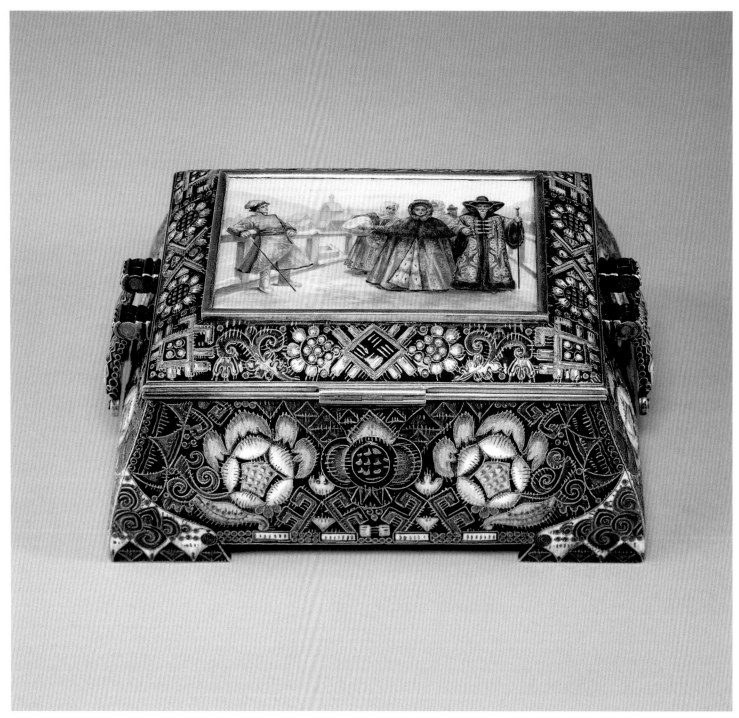

*Actual size*

*18*

## *Box with Miniature of* The Return from Church

*Moscow, firm of Carl Fabergé*
*Marked in Roman letters with CF; Moscow assay mark for 1908–17*
*Workmaster: Feodor Rückert*
*Silver (91 zolotnik), silver-gilt, enamel*
*H: 2 ¼ in (7 cm); L: 5 ⅞ in (15 cm)*
*Private Collection, Washington, D.C.*

Beginning in 1887, the independent workmaster Feodor Rückert began to supply painted enamels to Fabergé's Moscow branch. His wares, which were also produced for the rival firms of Ovchinnikov and Kurliukov, exemplify the Slavic Revival movement. In this movement, Russian artists, particularly those in Moscow, turned from western European styles, which had dominated their arts since the reign of Peter the Great, to re-examine their own national traditions. In his enamels, Rückert employed the Russian filigree technique, in which areas of opaque, painted enamel are separated by patterns of twisted wire soldered to a silver base. In addition, within the color fields, he used wire to create decorative motifs. After 1908, Rückert developed a distinctive palette combining greens, grays, browns, and dark blues, as in this example with abstract floral, scroll, and geometric decoration. The miniature scene on the lid showing Russians returning from church is based on a watercolor by Sergei Solomko entitled *XVIIth Century*, which was exhibited in 1910 in the 39th Exhibition of the Society of Russian Watercolorists in St. Petersburg. It is painted in matte enamel, an effect achieved by treating the final transparent enamel surface with hydrofloride acid. The use of silver at 91 zolotniks and the Roman initials "CF" confirm that this box was intended for export to the British market.

*19*

## Bust of Alexander III, 1912

*St. Petersburg, firm of Carl Fabergé*
*Assay mark for 1908–17*
*Workmaster: Henrik Wigström*
*Smoky quartz, nephrite, gold (56 zolotnik), diamonds, enamel*
*H: 3 ¾ in (10 cm)*
*Original fitted case made from hollywood, lining stamped in black*
*in Cyrillic with the Imperial warrant and* Fabergé, St. Petersburg,
Moscow, London
*Provenance: Sir Charles Clore; Christie's, Geneva, 13 November 1985,*
*lot 61; Christie's, New York, 16 April 1999, lot 89*
*The Forbes Magazine Collection, New York*

This smoky quartz bust of Alexander III (1845–94) wearing the order of
St. George is mounted on a nephrite column set in rose-cut diamonds
with the tsar's crown and cipher. Both the pedestal for the bust and the
base of the column are enameled in white over gold and set with
diamonds. Illustrated in the Wigström album of works completed
between 1911 and 1916 is a detailed watercolor drawing of this bust
and column with inventory number *12819* and the date *13.IX.1912*
*(figure 16).*[1] Ulla Tillander-Godenheim lists the bust as a "semi-official"
commission from the Office of His Imperial Majesty for a gift from the
Imperial family to a friend or relative.[2] A similar though larger bust of the
tsar is in the Royal Collection.[3]

[1] *Golden Years of Fabergé, Drawings and Objects from the Wigström Workshop* (New York, 2000),
77.
[2] Ibid., 46–47.
[3] *Fabergé from the Royal Collection* (London, 1985), no. 340.

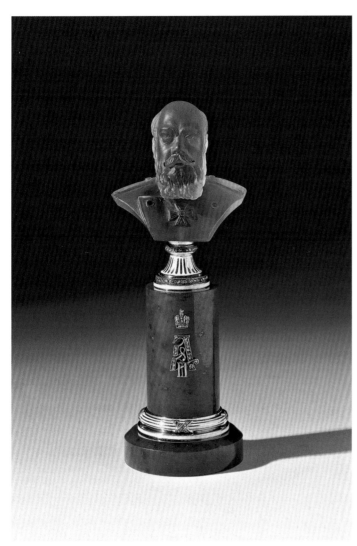

Actual size

Figure 16

## Imperial Cameo Box

*St. Petersburg, firm of Carl Fabergé*
*Marked on bezel with* FABERGE
*Workmaster: Henrik Wigström (marked with his initials)*
*Agate, enamel, gold (72 zolotnik), rubies, diamonds*
*L: 3 9/16 in (9 cm)*
*The Forbes Magazine Collection, New York*

This agate box has a stippled gold bezel with enameled green leaves and
red and white drops. An oval cameo on the face of the box shows
overlapping profiles of Tsar Nicholas II (1868–1918) and his wife,
Alexandra Fedorovna (1872–1918). A frame of white enamel with gold
bow ties encircles the cameo, which, in turn, is enclosed within a wreath
of leaves tied with a blue enameled bow. A crown set with diamonds
and rubies surmounts the cameo.

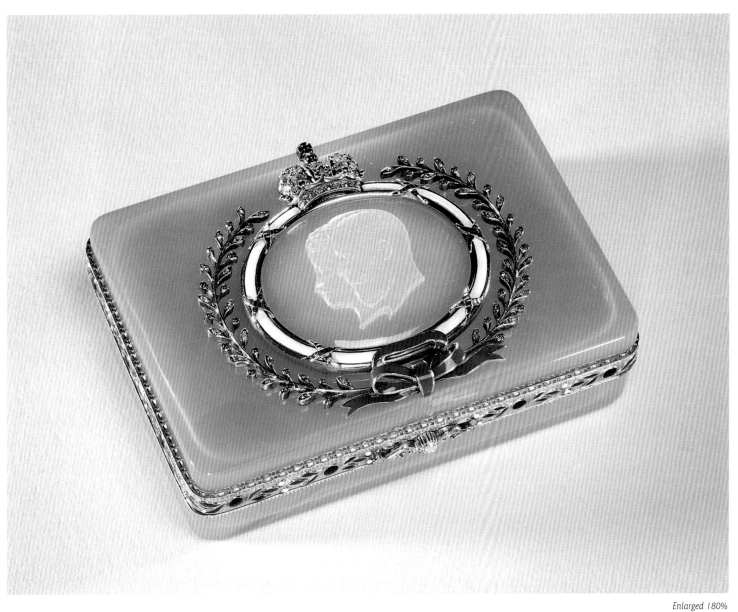

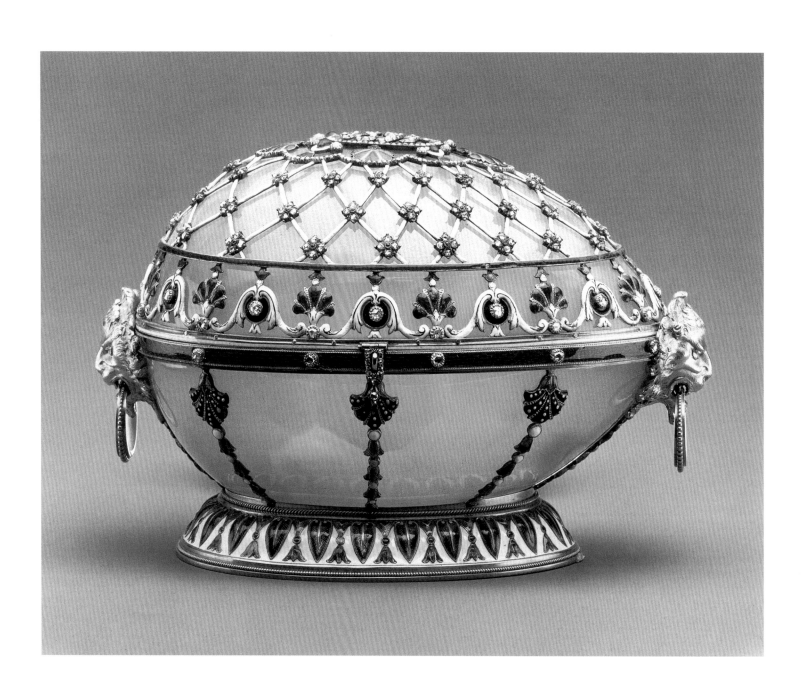

## 21

### Renaissance Egg, 1894

*St. Petersburg, firm of Carl Fabergé*
*Marked in Cyrillic with FABERGE*
*Workmaster: Mikhail Perkhin (marked with his initials)*
*White agate, gold (56 zolotnik), enamel, diamonds, rubies*
*L: 5 ¼ in (13.3 cm)*
*Original fitted case, velvet lining stamped in gold is obscured*
*Provenance: Tsar Alexander III to Tsarina Marie Fedorovna, 17 April*
*(Easter) 1894; sold by the Antikvariat of the Soviet Union, 1930; Armand*
*Hammer, New York; Mr. and Mrs. Henry Talbot de Vere Clifton, England;*
*Mr. and Mrs. Jack Linsky, New York; A La Vieille Russie, New York*
*The Forbes Magazine Collection, New York*

This was the last egg that Alexander III (1845–94) presented to his wife, Marie Fedorovna, before his death on 1 November 1894. It is based on a Renaissance-style, chalcedony casket by the Amsterdam jeweler LeRoy dating from ca. 1700 in the Grünes Gewölbe, Dresden (*figure 17*). Set in the top is the year "1894" rendered in diamonds on a red enamel ground enclosed by a border of enameled scallops alternating with palmette motifs. A jeweled and enameled trellis of scallops, lattice, and floral motifs has been applied over the milky white agate shell of the upper half. At each intersection of this trellis is a blossom composed of a cabochon ruby encircled by four diamonds. The lower half of the agate shell is rimmed with a red band of guilloché enamel, over gold. Eight straps composed of blue, green, and white scallops and green and white enamel palmette and circular motifs applied over gold divide the lower half into segments. The foot of the egg is decorated in green, red, and white enameled vegetal motifs. The gold handles are shaped as lion's masks holding swing handles. The Renaissance Egg originally contained a "surprise" that has been lost. Fabergé's invoice for the egg listed a cost of 4,750 rubles.

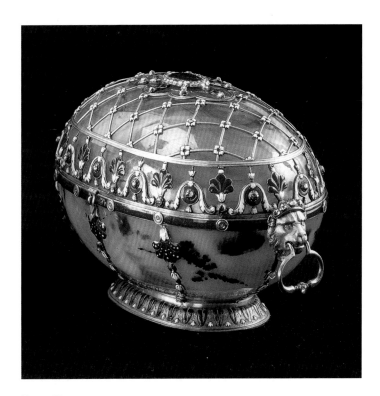

*Figure 17*

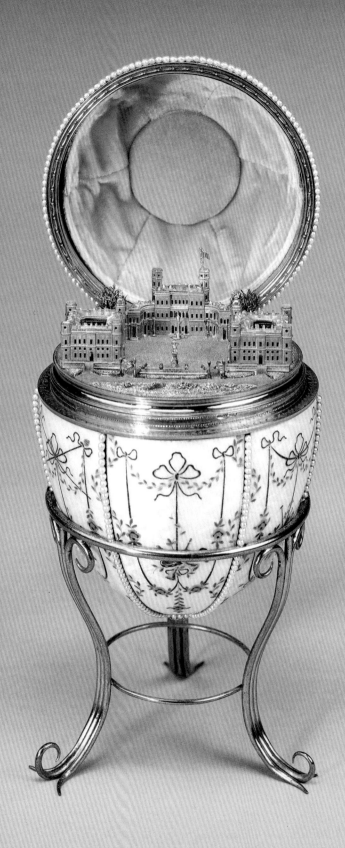

## 22

## Gatchina Palace Egg, 1901

St. Petersburg, firm of Carl Fabergé
Workmaster: Mikhail Perkhin
Gold, enamel, seed pearls, diamonds, rock crystal
H: 5 in (12.7 cm)
The stand is modern
Provenance: Tsar Nicholas II to Dowager Empress Marie Fedorovna, 1 April
(Easter) 1901; retained in the Anichkov Palace until 1917; Henry Walters
from Alexandre Poloutsoff, Paris, 1930
The Walters Art Museum, acquired by Henry Walters, 1930, 44.500

This Imperial Easter egg, produced under the direction of the workmaster Mikhail Perkhin for a cost of 5,000 rubles, is generally ranked among the Fabergé firm's finest creations. The surface of both the upper and lower halves has been divided into panels by rows of seed pearls. Over a red gold guilloché ground resembling in appearance moiré silk, multiple layers of translucent white enamel have been applied. Red ribbons tied in bows and leafy garlands support roses and alternating eighteenth-century-style trophies of the arts and sciences.

The egg opens to reveal a finely detailed miniature replica of the palace at Gatchina executed in colored gold. The palace, located about thirty miles southwest of St. Petersburg, was designed in the neo-classical style by the Italian architect Antonio Rinaldi (1709–90) for Catherine II's favorite, Count Grigorii Orlov, and erected between 1766 and 1788. After Orlov's death, Catherine bought the palace for her son, Paul Petrovich, the future Paul I. During Paul I's reign, the architect Vincenzo Brenna added a second story to the galleries extending beyond the main block. By the end of the nineteenth century, the palace had been considerably expanded and became the winter residence of Alexander III. Despite the palace's miniature scale on this egg, it is possible to discern such details as the statue of Paul I by Mikhail Klodt von Jurgensburg standing in the courtyard, the cannons, the flag, and details of the landscape including the parterres and the trees. The palace's windows are of rock crystal.

The Gatchina Palace Egg was included in a charity exhibition of Fabergé artifacts, antique miniatures, and snuffboxes held under the patronage of Dowager Empress Alexandra Fedorovna in the von Dervis mansion in St. Petersburg from 9 to 15 March 1902. The egg appears in a photograph published in the journal Niva in 1902 (see figure 10).[1] Very similar to the Gatchina Palace Egg in its external appearance is the Bonbonnière Egg produced under the direction of Mikhail Perkhin in 1903. It was one of seven Fabergé eggs presented by the Russian industrialist Aleksander Kelkh to his wife Varara.[2]

In 1908, Fabergé produced another Imperial Easter egg containing an architectural model, the Alexander Palace Egg, presented by Nicholas II to his mother. This nephrite egg contains a detailed miniature of the Alexander Palace, the Imperial family's favorite residence at Tsarskoe Selo, executed in gold, silver, enamel, and rock crystal.[3]

[1] Niva, 12 (1902), 233.
[2] T. Fabergé, L. G. Proler, V. V. Skurlov, The Fabergé Imperial Easter Eggs (London, 1997), 75.
[3] Ibid., 182–85.

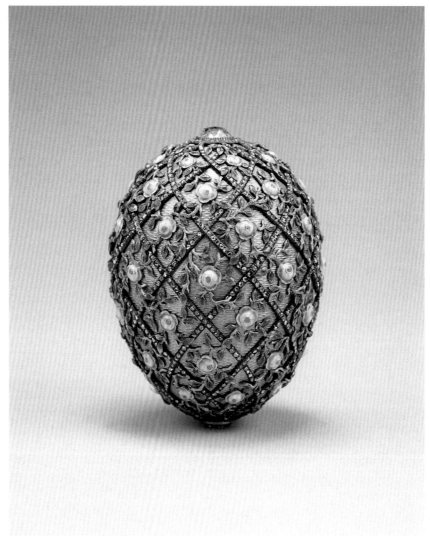

*Actual size*

23

*Rose Trellis Egg, 1907*

*St. Petersburg, firm of Carl Fabergé*
*Workmaster: Henrik Wigström (marked with his initials)*
*Gold, enamel, diamonds*
*H: 3 ³⁄₁₆ in (7.8 cm)*
*Provenance: Tsar Nicholas II to Tsarina Alexandra Fedorovna, 22 April*
*(Easter) 1907; transferred by the Kerensky government from the Anichkov*
*Palace to the Kremlin Armory in 1917; Henry Walters from Alexandre*
*Poloutsoff, Paris, 1930*
*The Walters Art Museum, acquired by Henry Walters, 1930, 44.501*

This egg is of translucent, pale green enamel over an engine-turned gold ground. It is covered with a latticework of crisscrossing rows of rose-cut diamonds. These support the gold rose bush of opaque enameled pink blossoms and green translucent enameled leaves. Beneath the large diamond at the apex of the egg is the date "1907." This diamond is mounted in gold and encircled by smaller diamonds.

Because of the 1904 Russo-Japanese War and the subsequent turmoil in Russia the following year, this Imperial Easter egg commemorating the birth of Tsarevich Alexei Nicholaievich (1904) was not presented until 1907. Fabergé's invoice for the egg, dated 21 April of that year, valued the egg at 8,300 rubles and cited the surprise as a diamond necklace with an ivory miniature framed in diamond brilliants of His Imperial Highness Grand Duke Tsarevich Alexei Nikolaievich (since lost). Because of its association with her son, the tsarina particularly treasured this egg and displayed it on the bottom shelf of a case in her study in the private quarters of the Winter Palace in St. Petersburg. It originally stood on a stand of "silver gilt wire."

In discussing the design of this egg, Fabergé acknowledged that the heir to the throne was from birth the commander of the army's rifle regiments, and, in jest, suggested that this rank be acknowledged in the design. He added, "we'll have to represent his soiled swaddling clothes, since for the time being they are the only results of his rifle practice."

*24*

## Orange Tree Egg (Bay Tree Egg), 1911

*St. Petersburg, firm of Carl Fabergé*
*Marked with FABERGE 1911*
*Workmaster: Henrik Wigström*
*Gold, nephrite, enamel, diamonds, citrines, amethysts, rubies, pearls, agate,*
*feathers; key in silver-gilt*
*H: 11 ¾ in (29.8 cm)*
*Provenance: Tsar Nicholas II to Dowager Empress Marie Fedorovna on*
*10 April (Easter) 1911; Moscow Kremlin Armory, 1917; Sotheby's, London,*
*10 July 1947, Wartski, London; A. G. Hughes, England; Arthur E. Bradshaw;*
*W. Magalow; Maurice Sandoz, Switzerland; A La Vieille Russie, New York;*
*Mildred Kaplan, New York, until 1966*
*The Forbes Magazine Collection, New York*

Tsar Nicholas II presented this egg to his mother, Dowager Empress Marie Fedorovna, on 10 April (Easter day) 1911. Although the egg was listed as being in the shape of a bay tree in Fabergé's invoice of 9 April 1911, it has subsequently been known as the Orange Tree Egg.[1] The gold tree stands in a white agate planter adorned with a gold trellis and enameled swags of laurel suspended from cabochon rubies. To suggest the coarseness of the soil, a technique known as *samorodok* (nugget) was employed, in which the near molten gold is suddenly cooled causing a wrinkled surface. The potted tree rests on a nephrite base with four nephrite posts mounted in gold and capped with pearl finials. The tree trunk is chased to resemble bark and bears 325 naturalistically veined, nephrite leaves, 110 opalescent, white enameled flowerets with diamond centers, and fruits of citrines, amethysts, rubies, and champagne diamonds. When triggered by touching one of the fruits, a mechanism hidden within the foliage causes a portion of the leaves to open and a feathered, gold nightingale to emerge; move its head, wings, and beak; and sing a melody. Fabergé's invoice lists the price of the egg as 12,800 rubles.

A possible prototype for the egg might have been an eighteenth-century orange tree in a trellised tub that was preserved in the *petit salon* at Hvidöre, Denmark, a residence shared by Marie Fedorovna and her sister, the widowed Queen Alexandra of Great Britain.[2] In the Earl of Roseberry's collection at Mentmore is a similar French topiary orange tree with a songbird mechanism dated 1757.

A drawing for a pendant in the form of a tree growing in a tub in the design book of Fabergé's workmaster Albert Holmstöm has been associated with the Orange Tree Egg.[3]

[1] T. Fabergé, L. G. Proler, V. V. Skurlov, *The Fabergé Imperial Easter Eggs* (London, 1997), 197–99.
[2] A. K. Snowman, *Fabergé, Jeweler to Royalty* (New York, 1983), 15.
[3] A. K. Snowman, *Fabergé: Lost and Found* (New York, 1993), 52.

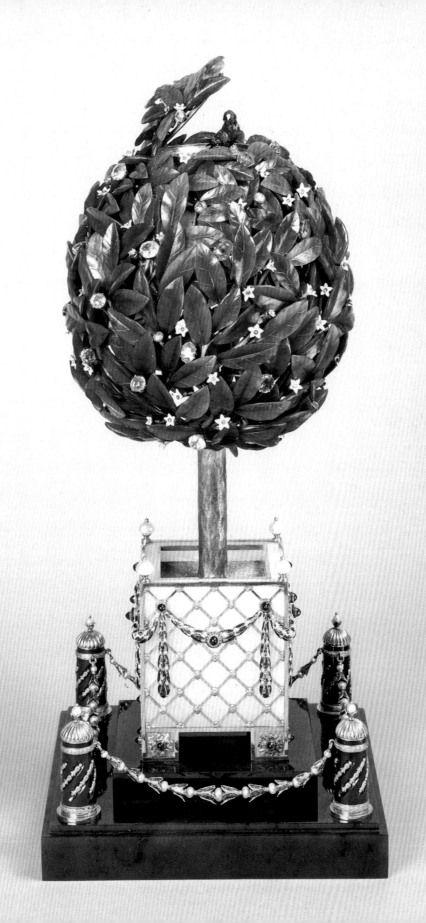

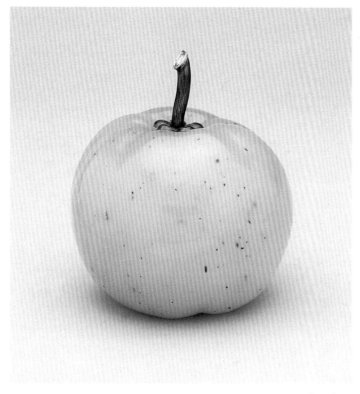

*Actual size*

25

*Apple Gum Pot*

*St. Petersburg, firm of Carl Fabergé*
*Mutton jade, gold (56 zolotnik), enamel, diamonds, sable hair*
*Original fitted case, lining stamped in gold with Imperial warrant and*
*K. Fabergé, St. Petersburg, Moscow*
*H: 2 ¾ in (6.9 cm)*
*Provenance: Christie's, Geneva, 9 May 1973, lot 229*
*The Forbes Magazine Collection, New York*

Gum pots contained glue or gum arabic used to affix postage stamps to letters. In this example, the mutton jade admirably suggests the color and texture of a green apple. Its diamond-studded stem, which is enameled brown and green, serves as the handle for the brush.

During Wigström's tenure as head workmaster, similar glue pots were produced marked with his initials. They include a glue pot in the shape of an apple in adventurine quartz, produced between 1898–1903, as well as two related pear-shaped pots made of bowenite with the St. Petersburg assay mark for 1899–1908.[1]

[1] G. von Habsburg, *Fabergé, Hofjuwelier der Zaren* (Munich, 1986), 160, no. 196; and op. cit., 160, no. 199; and G. von Habsburg et al., *Fabergé, Imperial Craftsman and his World* (London, 2000), 201, no. 456.

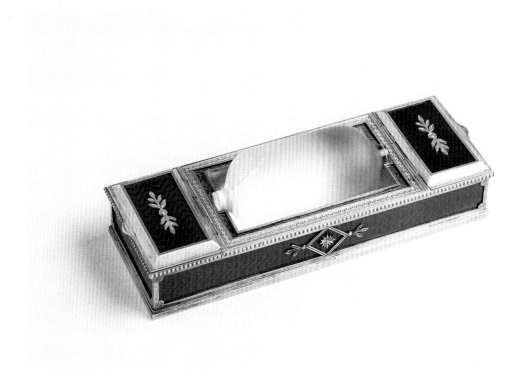

*Actual size*

26

## Stamp Box and Moistener

*Moscow, firm of Carl Fabergé*
*Marked with Imperial warrant and K. FABERGE; assay mark for*
*1899–1908; incised inventory no. 17484*
*Assay master: Ivan Lebedkin*
*Silver-gilt, glass, enamel*
*H: 4 ⅛ in (10.5 cm)*
*The Andre Ruzhnikov Collection*

This rectangular, silver-gilt stamp box has two compartments for stamps
and a central container for water fitted with a frosted glass roller that
serves as a moistener. The lids of the compartments and the sides of the
box are in blue guilloché enamel. Stylized laurel leaf appliqués have been
inserted in the two lids and on the sides of this work.

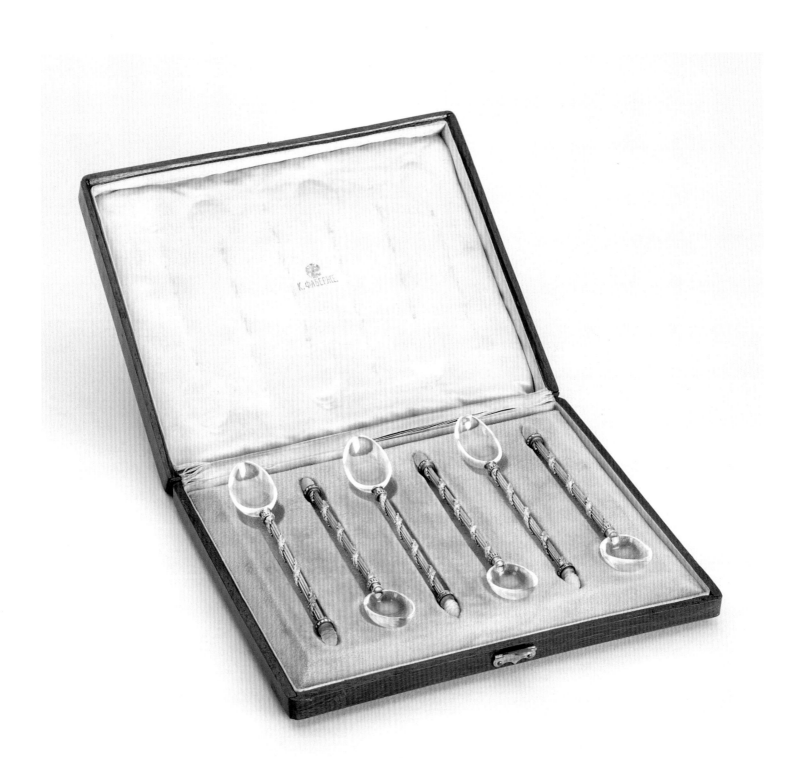

## 27

# Caviar Spoons

*St. Petersburg, firm of Carl Fabergé*
*Rock crystal, gold, diamonds*
*L: 4 ½ in (11.4 cm)*
*Original fitted case, lining stamped in black in Cyrilic with K. Fabergé*
*Provenance: Mrs. T. L. Goodwin (?), A La Vieille Russie, New York*
*The Forbes Magazine Collection, New York*

These Empire-style spoons have rock crystal bowls and finials shaped as pinecones. Their red gold fluted stems are entwined with ribbons of green gold laurel leaves. A. Kenneth Snowman published these spoons, or an identical set, as coffee spoons belonging to Mrs. T. L. Goodwin.[1] A caviar spoon similar to those in this set, but described as having bowls of smoky quartz, was published by Michel Y. Ghosn. It bore the initials of Fabergé's first chief workmaster, Erik Kollin, and was hallmarked St. Petersburg, before 1896.[2]

[1] A. K. Snowman, *The Art of Carl Fabergé* (London, 1952), fig. 155.
[2] M. Y. Ghosn, *Collection William Kazan, Objets de vertu par Fabergé* (Paris, ca. 1996), no. 75.

*28*

## Saltcellar and Spoon

*St. Petersburg, firm of Carl Fabergé*
*Marked in Cyrillic with FABERGE; assay mark for 1896–1908;*
*indistinct workmaster's mark*
*Jade, silver-gilt*
*Bowl: D: 1 ½ in (3.8 cm); Tray: D: 2 in (5.1 cm); Spoon: L: 2 in (5.1 cm)*
*Provenance: Sarah Hermann*
*Fine Arts Museums of San Francisco, gift of the estate of Sarah Hermann,*
*1996.145.8.1a–c*

The deep, rounded bowl of the saltcellar is of light jade with a silver-gilt
rim, and its small round tray and accompanying spoon are also of
silver-gilt.

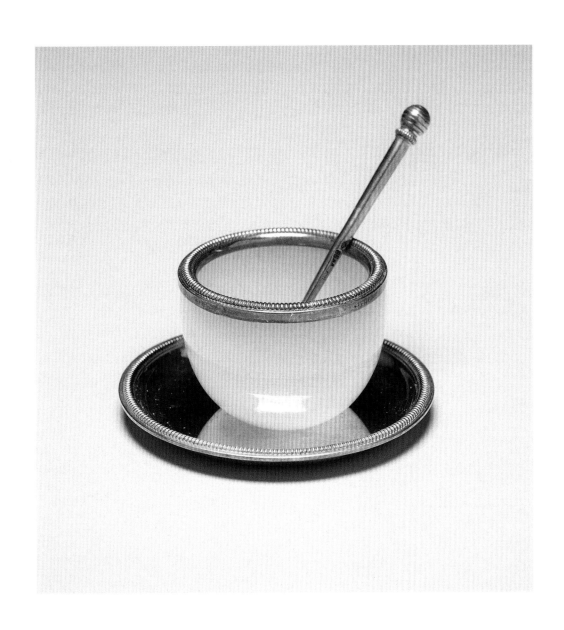

29

## Tray

*St. Petersburg, firm of Carl Fabergé*
*Assay mark for before 1899*
*Rhodonite, silver*
*H: 1 ¼ in (3.2 cm); L: 14 in (35.6 cm); W: 8 ⅜ in (21.3 cm)*
*Original fitted case, lining stamped in black in Cyrillic with Imperial*
*warrant and St. Petersburg, Moscow, Odessa, London*
*A La Vieille Russie, New York*

This oval tray is fitted with a silver rim of leaves and berries with ribbon
cross ties. The finest rhodonite, a member of the silicate group of minerals
that derives its name from its rose color, is mined in the Ural Mountains.

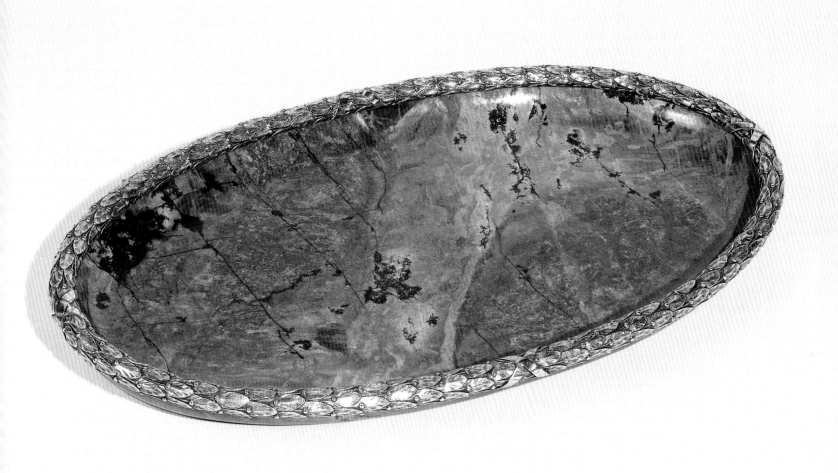

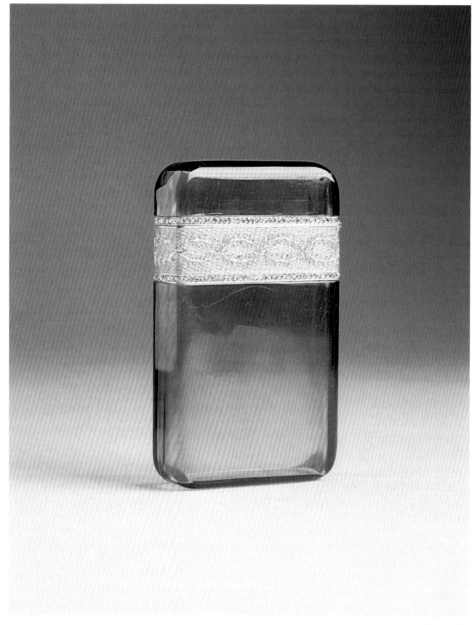

*Actual size*

30

## Cigarette Case

*St. Petersburg, firm of Carl Fabergé*
*Marked with FABERGE; assay mark for 1899–1908*
*Workmaster: Mikhail Perkhin (marked with his initials)*
*Assay master: Iakov Liapunov*
*Smoky quartz, gold (56 zolotnik), enamel, diamonds*
*L: 3 9/16 in (9 cm)*
*Original fitted case, lining stamped in Cyrillic with the Imperial warrant*
*and Fabergé, St. Petersburg, Moscow*
*The Andre Ruzhnikov Collection*

A gold band runs around the circumference of this case. It is bordered
with rows of rose-cut diamonds and is enameled in a peach color with a
guilloché pattern. Intertwined vines of laurel extend around it. Each laurel
leaf is set with a rose-cut diamond.

*31*

## Note-Paper Case and Pencil

*St. Petersburg, firm of Carl Fabergé*
*Assay mark for 1899–1908*
*Workmaster: Julius Rappoport (marked with his initials)*
*Bowenite, silver, pencil*
*H: 5 ⅞ in (14.9 cm)*
*Provenance: The John Traina, Jr., Collection*
*Fine Arts Museums of San Francisco, gift of John Traina, Jr., 1991.42 a–b*

A moss green bowenite plaque is set into a silver framework decorated with rococo "C" scrolls and rocaille and floral motifs. The borders are fluted and divided by leaves. Two pinecone-shaped finials flank the hinge at the top of the note case. Enclosed is a silver pencil.

At the silver factory he opened in 1883 at 65 Ekaterinski Canal in St. Petersburg, Julius Alexandrovich Rappoport (1864–1916) served as Fabergé's workmaster until 1908, specializing in small decorative works and metal mounts for large stone objects. Much of his work was produced in the French rococo style.

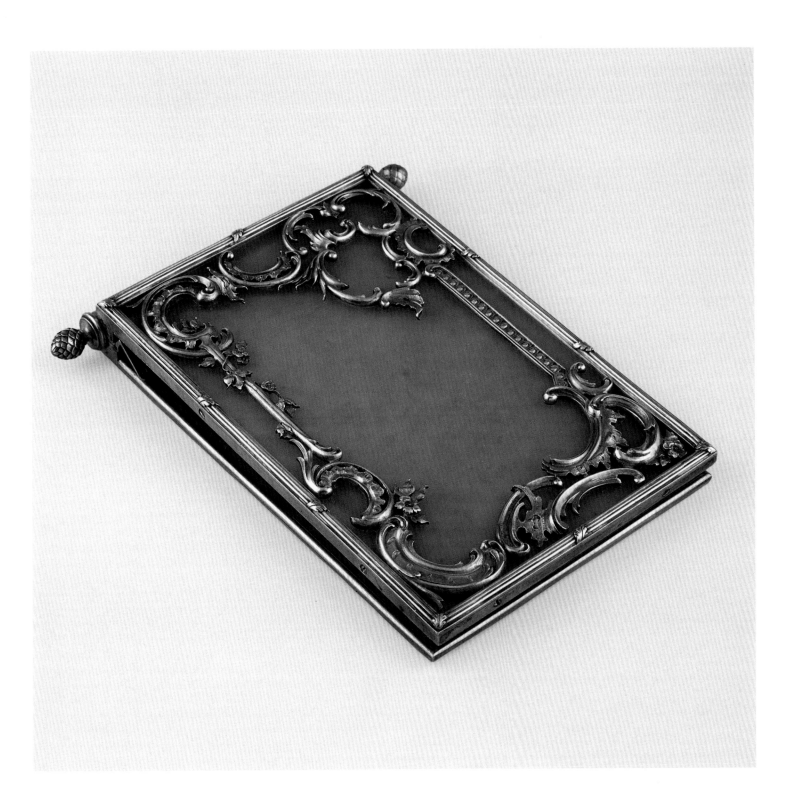

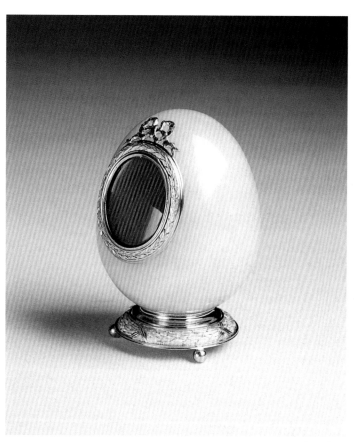

*Actual size*

32

## Egg-Shaped Frame

*St. Petersburg, firm of Carl Fabergé*
*Marked with FABERGE; assay mark for before 1899*
*Workmaster: Mikhail Perkhin (marked with his initials)*
*Bowenite, gold (56 zolotnik)*
*H: 2 ⅝ in (6.7 cm)*
*The Andre Ruzhnikov Collection*

This egg-shaped, bowenite frame stands on a circular, two-colored gold base supported by three ball feet. The oval opening is enframed by a laurel leaf border topped by a bow. Another oviform egg was produced by Mikhail Perkhin's workshop for Dowager Empress Marie Fedorovna.[1]

[1] G. von Habsburg, *Fabergé in America* (London, 1996), 46, fig. 21.

*33*

## Bonbonnière

*St. Petersburg, firm of Carl Fabergé*
*Incised inventory no. 50289*
*Bowenite, gold, enamel, diamonds*
*W: 2 ½ in (8 cm)*
*The Andre Ruzhnikov Collection*

A bonbonnière is a dish for sweets or candies. This triangular example with rounded sides has fleur-de-lys hinges and a clasp decorated in red guilloché enamel that are set with rose-cut diamonds.

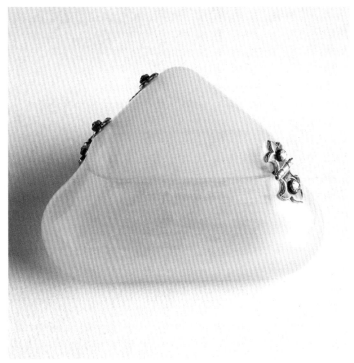

*Actual size*

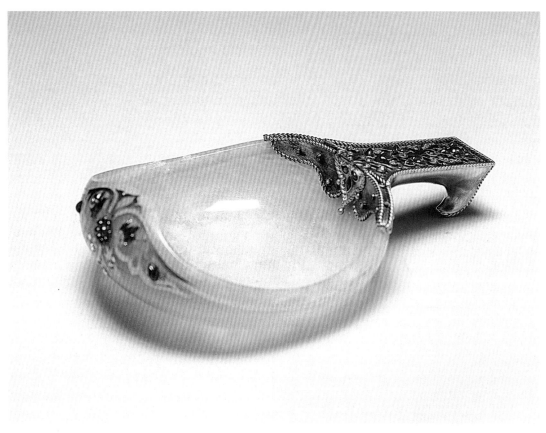

*Actual size*

34

## Kovsh

*Russian, late 19th–early 20th century*
*Jade, gold, rubies, sapphires, diamonds*
*L: 4 ½ in (11.4 cm)*
*Provenance: Sarah Hermann*
*Fine Arts Museums of San Francisco, gift of the estate of Sarah Hermann,*
*1996.145.5*

This modern, stylized form of the traditional kovsh, originally an ancient Slavic wooden vessel, is of light jade. The gilded handle is set with rubies, sapphires, and diamonds in a floral pattern, which is repeated on the front of the kovsh.

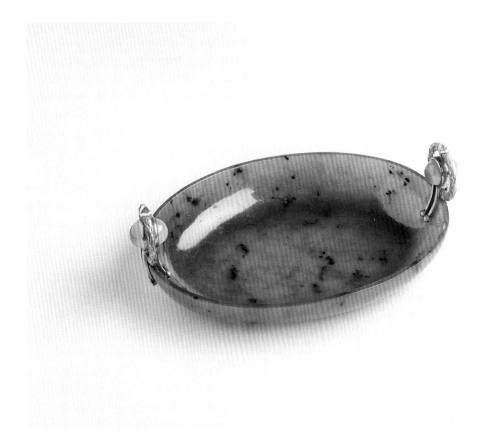

*35*

## Oval Dish

*St. Petersburg, firm of Carl Fabergé*
*Marked with FABERGE; assay mark for 1908–17*
*Workmaster: Henrik Wigström (marked with his initials)*
*Nephrite, gold (56 zolotnik), moonstones*
*L: 4 in (10.2 cm)*
*The Andre Ruzhnikov Collection*

The handles of this finely cut, oval, nephrite dish are set with
moonstones in openwork mounts chased with laurel leaves.

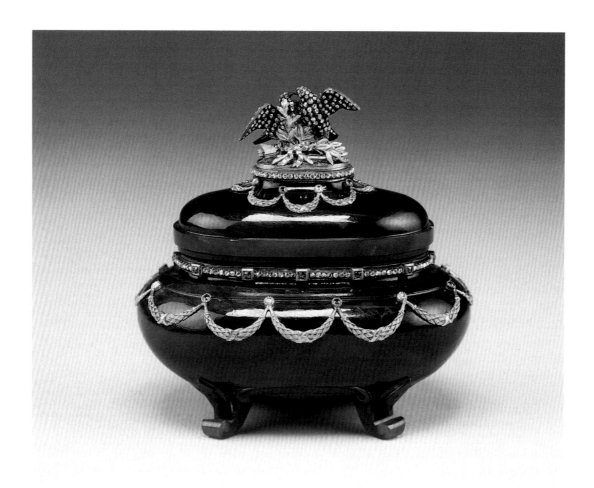

*Actual size*

36

## Urn with Cover

*St. Petersburg, firm of Carl Fabergé*
*Nephrite, gold, rubies, diamonds*
*H: 3 ⅝ in (9.3 cm)*
*Provenance: Probably purchased by Henry Walters from Alexandre*
*Poloutsoff, Paris, 1929/30*
*The Walters Art Museum, acquired by Henry Walters, 1929/30, 57.913*

This tureen-shaped urn is carved of nephrite, a green jade much favored by the Fabergé firm. Enormous nephrite boulders had been discovered along the Onot River in eastern Siberia in 1851. A pair of loving doves in pavé-set diamonds and a cupid's bow and arrows in green and red gold—both motifs associated with the French eighteenth-century master François Boucher—are mounted on the urn's cover. Suspended from alternating diamonds and rubies are yellow gold garlands with red gold ties. Rows of diamonds, interspersed at intervals with rubies, line the rim of the urn.

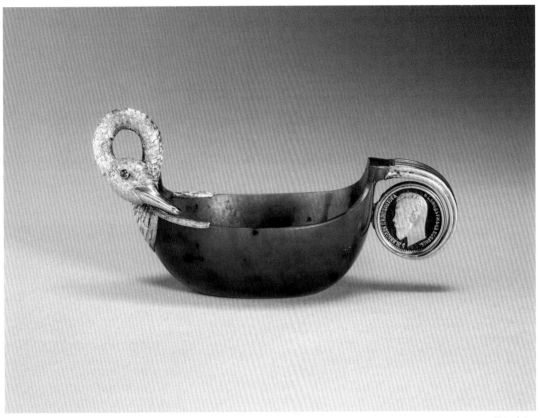

*Actual size*

37

## Swan Kovsh

*St. Petersburg, firm of Carl Fabergé*
*Workmaster: Henrik Wigström (marked with his initials)*
*Nephrite, gold (72 zolotnik), rubies, enamel*
*H: 1 ¾ in (4.5 cm); L: 4 in (10 cm)*
*Provenance: Sir Charles Clore; Sotheby's, London, 28 October 1985*
*Private Collection, Washington, D.C.*

Mounted on the thinly carved nephrite bowl is the swan's head and
long, sinuous neck. They are executed in red and green gold with
particular attention being given to the finely detailed chasing of the
feathers. Rubies have been set in the eyes. The tail, reeded in red and
green gold, serves as the kovsh's handle. It encircles a five-ruble coin
depicting Nicholas II from 1898, enameled translucent strawberry red.

*Actual size*

*38*

## Oval Box with Monogram of Nicholas II

*St. Petersburg, firm of Carl Fabergé*
*Marked with FABERGE*
*Workmaster: Henrik Wigström (marked with his initials)*
*Nephrite, gold (56 zolotnik), diamonds, enamel*
*H: 4 ⅞ in (12.3 cm)*
*Provenance: Henry Walters from Alexandre Poloutsoff, Paris, 1929/30*
*The Walters Art Museum, acquired by Henry Walters, 1929/30, 57.1047*

The monogram of Nicholas II, rendered in diamonds, is set in the lid of this presentation box. It is mounted in an opalescent white cartouche bordered by diamonds and surmounted by the Imperial crown, also in diamonds. The central cartouche is flanked by green gold wreaths and garlands and is enclosed within an oval border of rose-cut diamonds.

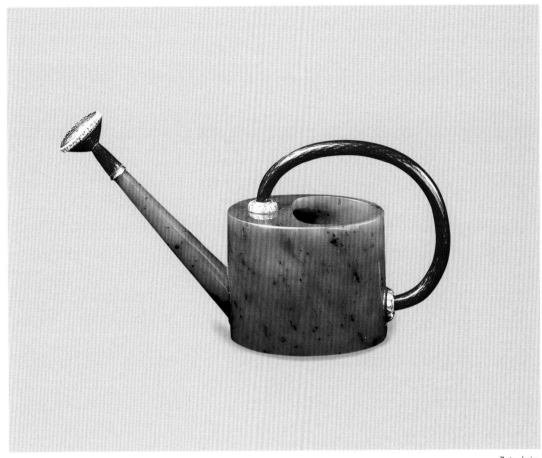

*Actual size*

*39*

## Miniature Watering Can

*St. Petersburg, firm of Carl Fabergé*
*Marked with FABERGE; incised inventory no. 4709*
*Original fitted case made from hollywood, lining stamped in gold with*
*Imperial warrant and K. Fabergé, St. Petersburg, Moscow*
*Nephrite, enamel, gold, diamonds*
*L: 4 ⅛ in (10.4 cm)*
*Provenance: Mme. Elisabeth Balletta, St. Petersburg; Lansdell K. Christie,*
*Long Island, New York; A La Vieille Russie, New York*
*The Forbes Magazine Collection, New York*

The gold spout and handle of this miniature nephrite watering can are enameled strawberry red. Rose-cut diamonds in crimped gold settings line the spout's circumference and mountings for the handle. This precious trinket was originally owned by Elisabeth Balletta, a favorite of Grand Duke Alexis Alexander, and a principal performer at the Imperial Michael Theater in St. Petersburg. It may have been intended for display with one of Fabergé's flower pieces. A similar watering can appeared in the King Farouk Sale.[1]

[1] King Farouk Sale, Sotheby's, Cairo, 1954, lot 149.

*Actual size*

## 40

## Case

*St. Petersburg, firm of Carl Fabergé*
*Workmaster: Henrik Wigström*
*Nephrite*
*L: 3 ¹⁵⁄₁₆ in (10 cm)*
*Provenance: Henrik Wigström*
*The John A. Traina, Jr., Collection*

This unfinished case comes from the workbench of Henrik Wigström (1862–1923), Fabergé's chief head workmaster from 1903 until 1918, when the new Bolshevik leadership in Russia nationalized the firm. The highly polished, dark nephrite case has two compartments with lids.

## 41

### Bookmark and Paperknife Combination

*St. Petersburg, firm of Carl Fabergé*
*Assay mark for 1908–17; incised inventory no. 20286*
*Workmaster: Vladimir Soloviev (marked with his initials)*
*Gold (56 zolotnik), nephrite, enamel*
*L: 3 ⅛ in (8 cm)*
*The Andre Ruzhnikov Collection*

This two-colored gold combination piece is decorated with a mauve guilloché enamel decorative band to which laurel leaf garlands have been applied. The egg-shaped finial is of nephrite.

Around 1913, Vladimir Soloviev took control of a workshop at 12 Malaya Morskaya that had formerly been operated by Philip Theodor Ringe and later by Anders Mickelson, both of whom were "outworkers" employed by the Fabergé firm. Soloviev is usually associated with the enameled, gold, or silver-gilt pencils that he supplied to the Fabergé firm.

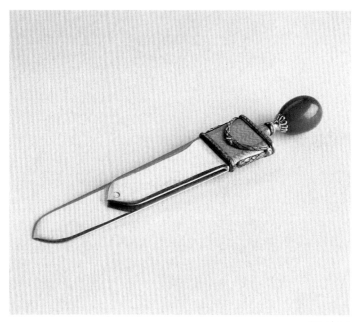

*Actual size*

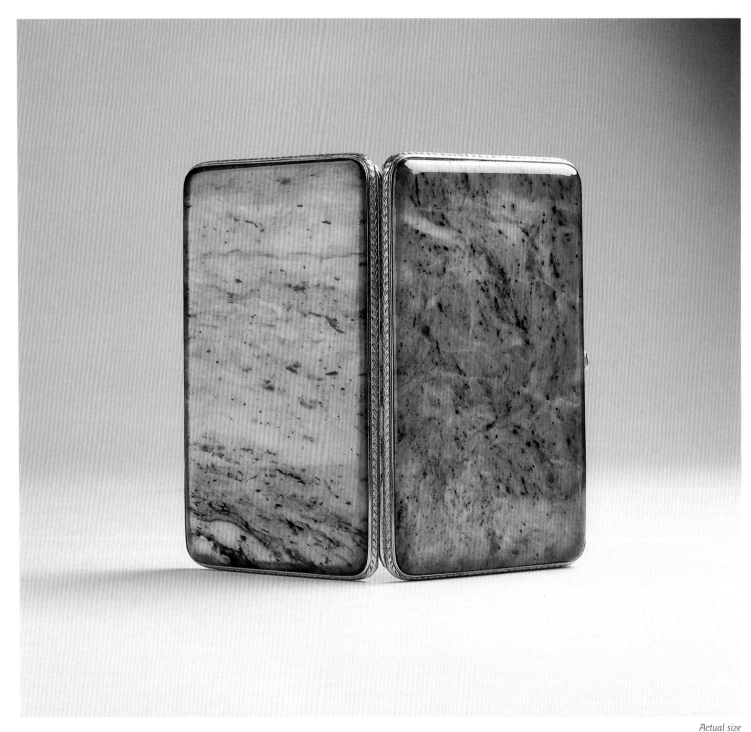

*Actual size*

*42*

## Cigarette Case

*St. Petersburg, firm of Carl Fabergé*
*Marked with FABERGE; assay mark for before 1899*
*Workmaster: Mikhail Perkhin (marked with his initials)*
*Nephrite, gold, moonstone*
*L: 4 ½ in (11.5 cm)*
*Provenance: Ambassador William Kazan*
*The Andre Ruzhnikov Collection*

Two-colored gold borders with a laurel-leaf pattern enframe the nephrite halves of the box. A cabochon moonstone is used as the push-piece.

## 43

## Cigarette Case

*St. Petersburg, firm of Carl Fabergé*
*Nephrite, diamonds, leather*
*L: 3 ¾ in (9.5 cm); W: 2 in (5.1 cm)*
*Provenance: Sarah Hermann*
*Fine Arts Museums of San Francisco, gift of the estate of Sarah Hermann,*
*1996.145.7a–b*

The case is of translucent green nephrite in cylinder shape with diamond-set hinges and clasp. So perfectly fitted is the opening in the cylinder body that it is almost invisible.

Beginning in the 1880s, cigarette cases were made in abundance in the Fabergé workshops, often of quite original design. At that time, smoking was very popular at all levels of society, and handsome cigarette cases from Fabergé bearing an appropriate inscription often served as fashionable wedding gifts for brides to give their husbands.

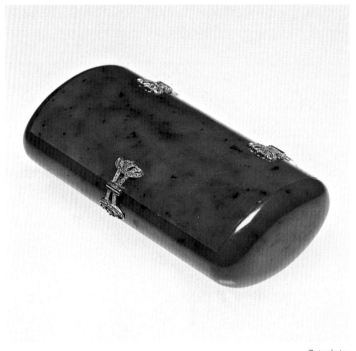

*Actual size*

*44*

## Case with Cigarette Holder

*St. Petersburg, firm of Carl Fabergé*
*Nephrite, diamonds, gold, amber*
*L: 3 in (7.6 cm)*
*The John A. Traina, Jr., Collection*

The cigarette holder has an amber mouthpiece and a nephrite collar banded with a row of diamond chips set in gold. This case, which is decorated with a band of rose-cut diamonds, is fitted to contain a nephrite cigarette holder, which is similarly banded. Its mouthpiece is of amber.

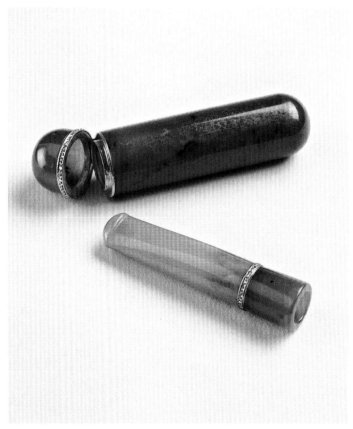

*Actual size*

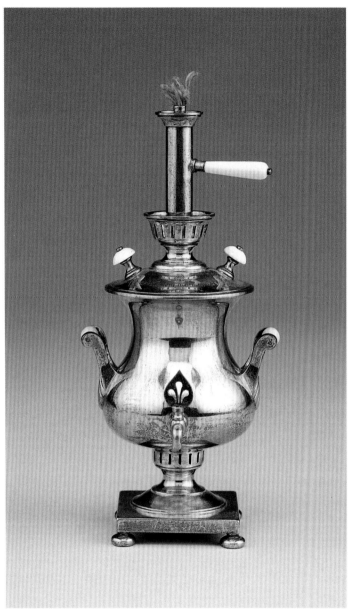

*Actual size*

*45*

## Spirit Lamp in the Form of a Samovar

*St. Petersburg, firm of Carl Fabergé*
*Marked in Cyrillic with the Imperial warrant and K. FABERGE,*
*Jeweler of the Court, St. Petersburg*
*Workmaster: Vladimir Soloviev (marked with his initials)*
*Silver-gilt (88 zolotnik), ivory*
*H: 5 in (12.7 cm)*
*Provenance: Dr. N. Dorin Ischlondsky*
*The Walters Art Museum, gift of Dr. N. Dorin Ischlondsky, 1961, 57.1911*

This spirit lamp is in the form of a samovar, an ornate urn traditionally used for making tea in Russia. A cotton wick extends beyond the inner tube that would have served as the heating element in a samovar. Impressed in the lid is an Imperial eagle and an inscription in Cyrillic that translates: "K. Fabergé, Jeweler of the Court / St. Petersburg." A similar spirit lamp with the St. Petersburg assay mark for 1908–17 was produced in gold under the direction of Henrik Wigström.

Vladimir Soloviev assumed control of an independent workshop that had been founded in St. Petersburg by Philipp Theodor Ringe (1824–82) and had subsequently been operated by Anders Mickelson (1839–1918). All of Soloviev's work dates from the last decade of the Fabergé firm's existence.

*Actual size*

*Actual size*

## 46

### *Square Bell Push*

*St. Petersburg, firm of Carl Fabergé*
*Marked in Cyrillic with FABERGE; assay mark for before 1899;*
*incised inventory no. 103t*
*Workmaster: Mikhail Perkhin (marked with his initials)*
*Bowenite, silver-gilt (88 zolotnik), moonstone, enamel*
*H: 2 ⅜ in (6.1 cm)*
*The Andre Ruzhnikov Collection*

This square bowenite bell push is mounted in a silver-gilt frame and
stands on four gadrooned (or oval fluted), spherical feet. Set in its upper
surface is a circular, mauve guilloché enameled panel that is decorated
with intertwined silver-gilt laurel leaf garlands. In turn, this panel is
applied over a white guilloché enameled square ground with silver-gilt
rosettes in each corner. A cabochon moonstone serves as the bell push.

## 47

### *Triangular Bell Push*

*St. Petersburg, firm of Carl Fabergé*
*Marked in Cyrillic with (FA)BERGE; assay mark for 1899–1906*
*Bowenite, gold (56 zolotnik), moonstone, enamel*
*W: 2 ³⁄₁₆ in (5.5 cm)*
*The Andre Ruzhnikov Collection*

This triangular bowenite bell push stands on three reeded ball feet and is
decorated on its sides with applied laurel-leaf sprays. On the upper
surface, a panel in pink guilloché enamel in a radiating design is
decorated with a laurel wreath trisected by three arrows pointing
outward.

*48*

## Sphinx Bell Push

*St. Petersburg, firm of Carl Fabergé*
*Marked in Cyrillic with K. FABERGE; assay mark for 1908–17*
*Workmaster: August Hollming*
*Lapis lazuli, gold, enamel, diamonds, rubies*
*Original fitted case, lining unstamped*
*L: 4 ⅜ in (11.1 cm)*
*Provenance: Dr. J. G. Wurfbain; Wartski, London*
*The Forbes Magazine Collection, New York*

The Egyptian sphinx of lapis lazuli rests on a gold ground that has been chased to suggest the texture of sand. The ground, in turn, is set in an oyster white enameled gold base with chased scrolling borders. On the sphinx's forehead is a *uraeus*, or sacred cobra, in rubies and a band of pavé-mounted diamonds.

August Frederik Hollming (1854–1913), a Finnish jeweler, opened his own workshop in St. Petersburg in 1880 and twenty years later moved into Fabergé's building at 24 Bolshaya Morskaya Street. His workshop specialized in cigarette cases, miniature Easter eggs, and jewelry.

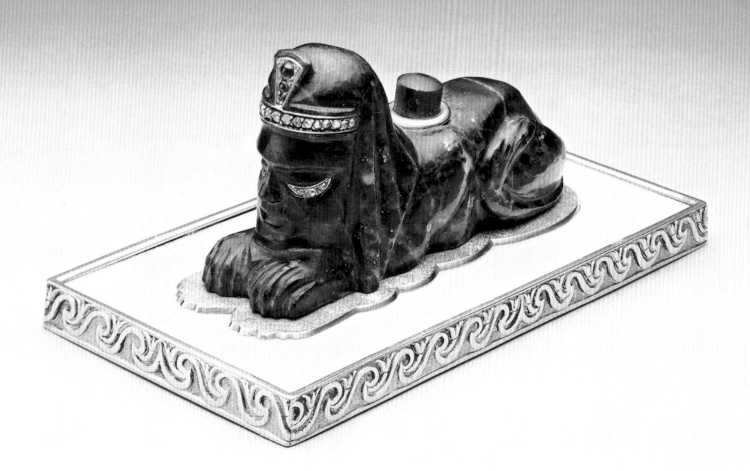

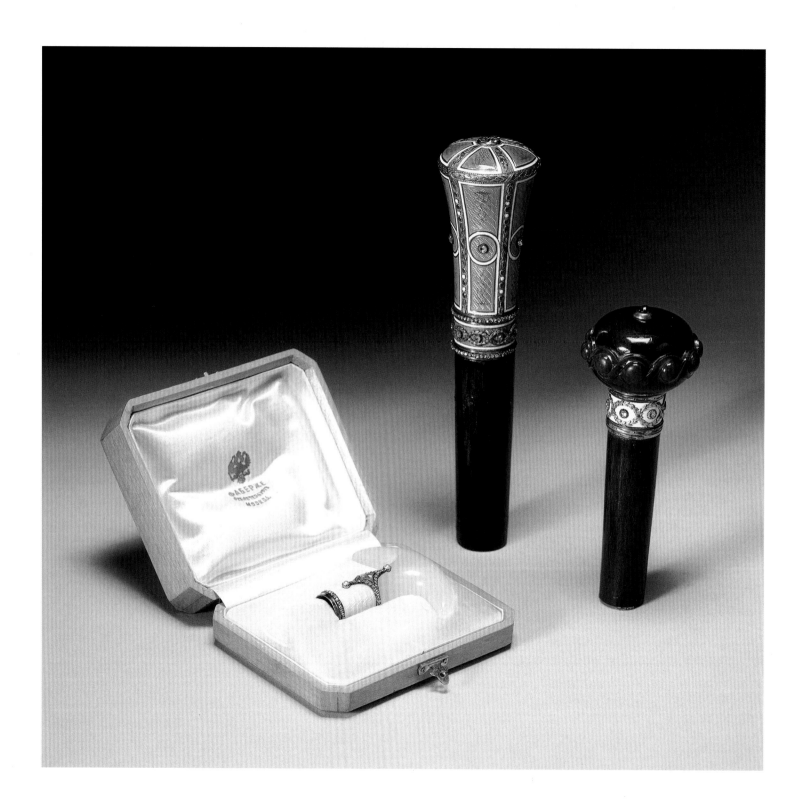

*49*

## Parasol Handle

*St. Petersburg, firm of Carl Fabergé*
*Assay mark for before 1899; incised inventory no. 14137*
*Workmaster: Mikhail Perkhin (marked with his initials)*
*L: 3 ⅛ in (8 cm)*
*Gold (72 zolotnik), enamel, diamonds*
*Provenance: Purchased by Henry Walters in St. Petersburg in 1900 as a*
*gift for his sister, Mrs. Warren Delano III; Laura F. Delano (Henry Walters'*
*niece), 1922*
*The Walters Art Museum, gift of Laura F. Delano, 1950, 44.621*

*50*

## Parasol Handle

*St. Petersburg, firm of Carl Fabergé*
*Assay mark for 1899–1908*
*Workmaster: Mikhail Perkhin (marked with his initials)*
*Jade, enamel, diamonds, pearls, gold*
*Original fitted case, lining stamped in gold in Cyrillic with the Imperial*
*warrant and Fabergé, St. Petersburg, Moscow*
*H: 2 in (5 cm)*
*Provenance: Purchased by Henry Walters in St. Petersburg in 1900 as a*
*gift for his niece, Mrs. Frederick B. Adams*
*The Walters Art Museum, gift of Mrs. Frederick B. Adams, 1956, 57.1862*

*51*

## Parasol Handle

*St. Petersburg, firm of Carl Fabergé*
*Assay mark for 1899–1908; incised inventory no. 3224*
*Workmaster: Mikhail Perkhin (marked with his initials)*
*Nephrite, diamonds, lapis lazuli, gold (56 zolotnik), enamel*
*L: 1 ¾ in (4.5 cm)*
*Provenance: Purchased by Henry Walters in St. Petersburg in 1900 as a gift*
*for his sister, Mrs. Warren Delano III; Laura F. Delano (Henry Walters' niece)*
*The Walters Art Museum, gift of Laura F. Delano, 1950, 57.1841*

These three parasol handles were purchased by Henry Walters during his trip to St. Petersburg in 1900 as gifts for his nieces.

The surface of the pink enamel parasol handle over guilloché gold is divided into panels by bands of red, white, and green foliate motifs. Each panel is decorated with dendritic (tree- or moss-like motifs resembling the patterns naturally found in moss agate) painted beneath the translucent enamel. The top, which is set with a diamond, unscrews to reveal a compact or compartment for cosmetics. Encircling the handle are intertwined bands of laurel leaves and two rows of small, rose-cut diamonds.

A parasol in pink enamel in the Virginia Museum of Fine Arts, also bearing Perkhin's mark, is nearly identical except for its collar, decorated with patterns of sprays of gold leaves radiating from diamonds.[1]

The highly polished, T-shaped, pale jadeite handle is fitted to an elaborate collar of white and apricot guilloché enamel over gold. Rows of rose-cut diamonds with inset half-pearls border the collar and divide the enameled areas.

A carved guilloché pattern set with polished lapis lazuli stones extends around the circumference of the nephrite pommel. Set at its apex is a cabochon sapphire mounted in gold. The collar is rimmed in red gold and decorated with entwined green gold garlands applied over an oyster white enamel ground. In each of the interstices, a rose-cut diamond has been mounted with a crimped flange.

[1] Virginia Museum of Fine Arts, Richmond, inv. no. 47.20.186.

## Cane Handle in the Form of an Elephant Head

*St. Petersburg, firm of Carl Fabergé*
*Assay mark for 1899–1908*
*Assay master: Iakov Liapunov*
*Workmaster: Mikhail Perkhin*
*Nephrite, gold (56 zolotnik), diamonds*
*H: 3 ⅜ in (8.6 cm)*
*Provenance: Richard Gabillet, Paris*
*The Forbes Magazine Collection, New York*

This elephant-head cane handle may have been commissioned for
a member of the royal house of Thailand, which had many nephrite
pieces made for them by the House of Fabergé during the early
twentieth century.

## 53

### Parasol Handle in the Form of a Swan Head

*St. Petersburg, firm of Carl Fabergé*
*Rock crystal, enamel, gold, pearls, emeralds*
*H: 4 7/16 in (11.2 cm): W: 15/16 in (5 cm); D: 9/16 in (1.5 cm)*
*Provenance: Princess Elizabeth (daughter of Prince Paul, Prince Regent of*
*Yugoslavia and a descendant of Catherine the Great)*
*The Terence Isakov Collection*

The crook-shaped parasol handle is in the form of an arched swan's neck
and head with naturalistically rendered plumage. The eyes are set with
emeralds. The gold collar is in pale blue guilloché enamel over gold set
with two rows of pearls.

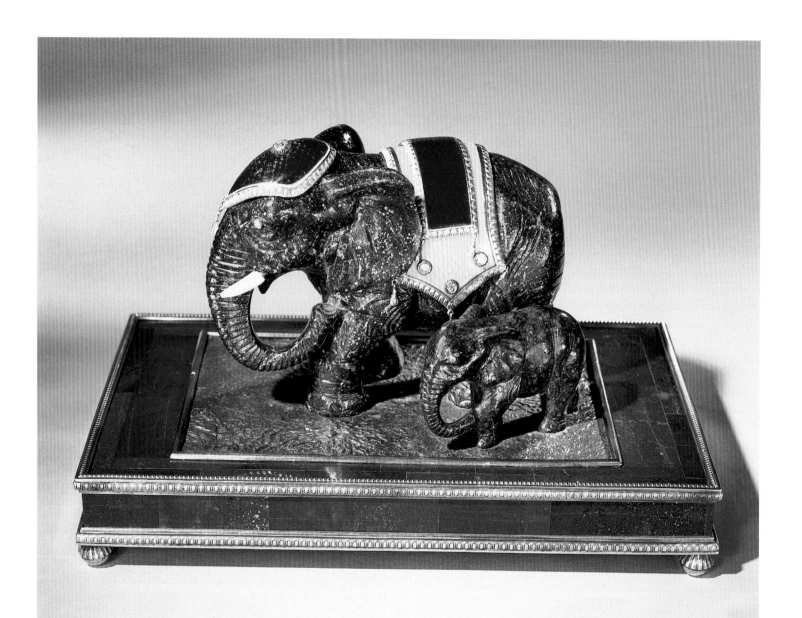

# Fabergé's Animals

*Figure 18*

Fabergé's earliest documented hardstone animals were three elephants on a jadeite bell push made in late 1891.[1] The following Easter, Alexander III commissioned for his wife, Empress Marie Fedorovna, the Diamond Trellis Egg (see *figure 9*). Carved of pale green bowenite, it opened to reveal a miniature ivory elephant surmounted by a tower, the insignia of the Danish royal family.[2] Four other elephants in various stones and sizes were ordered that year to commemorate the golden wedding anniversary of the empress' parents, King Christian IV and Queen Louisa of Denmark.

Prior to opening his own lapidary studio in 1908, Fabergé relied on outside sources for most of his hardstone carvings: Karl Woerffel's lapidary works in St. Petersburg; the Haus Stern factory in the German town of Idar-Oberstein; and the stone-carvers of Ekaterinburg in the Ural Mountains. The animal sculptures produced at these locations tended to exhibit a remarkable attention to realistic detail, sometimes to the point of appearing dry in execution. Aware of this failing, Fabergé frequently had them reworked in his St. Petersburg studio before offering them for sale. He again turned to the artisans of Idar-Oberstein in the years just prior to World War I, when they could no longer meet the demands for hardstone carvings as they had become so popular.

The production of carvings in St. Petersburg entailed the skills of both sculptors, who modeled the figures in wax, and carvers, who transformed the designs into stone. Franz P. Birbaum recalled twelve modelers and three "modelers/gemstone workers" in St. Petersburg, but, with the notable exception of Boris Oskarovich Froedman-Cluzel, who modeled the animals at Sandringham, their individual productions have yet to be identified.[3] Despite their anonymity, these craftsmen succeeded in imbuing their animals with distinctively individual, sometimes comical characteristics. Such traits as the ungainliness of a bear cub or a puppy, the contentment of a sow about to suckle her young, the vigilant stare of an owl, or the agility of an ermine were conveyed through caricature, exaggeration, and through the animals' poses.

The subjects most frequently depicted fall into several categories: pets and livestock, exotic creatures found in the wild or in zoos, and smaller species, including amphibians, fish, and insects. Rotund animals with short, sturdy limbs such as the elephant, rhinoceros, hippopotamus, and the pig proved to be ideal subjects: their bulky shapes offered an opportunity to exploit the visual appeal of the nephrite, rhodonite, chalcedony, or other stone being used. Elephants, which were particularly popular, were made according to several categories: those with their trunks curved outwards as in the Danish royal insignia or inwards as in Japanese netsukes. Contributing to the appeal of this subject may have been the living specimen that King Chulalongkorn of Thailand presented to Nicholas II during a state visit in 1897. It was kept in the park of the Alexander Palace in St. Petersburg along with two keepers also provided by the King (*figure 18*).

Fabergé's artists were also adept at producing portraits of specific animals, the most notable instance being the chalcedony statuette of Caesar, King Edward VII's Norfolk terrier, who was the king's constant companion, commissioned in 1907. Even when they did not represent individual animals, Fabergé's artists managed to convey distinctive features of the various species. For example, with dogs, they captured the distinctive traits of various breeds, whether they were schnauzers, bulldogs, dachshunds, or poodles.

[1] Marina Lopato in G. von Habsburg et al., *Fabergé, Imperial Craftsman and his World* (London, 2000), 300.

[2] For the Diamond Trellis Egg, see T. Fabergé, L. G. Proler, and V. V. Skurlov, *The Fabergé Imperial Easter Eggs* (London, 1997), 109–11.

[3] *The History of the House of Fabergé according to the Recollections of the senior master Craftsman of the Firm* (St. Petersburg, 1992), 21–22.

## 54

## *Bulldog Box*

*St. Petersburg, firm of Carl Fabergé*
*Assay mark before 1899; incised inventory no. 47416*
*Workmaster: Mikhail Perkhin (marked with his initials)*
*Agate, gold, enamel, diamonds*
*H: 2 in (5 cm)*
*Provenance: A La Vieille Russie, New York*
*The Forbes Magazine Collection, New York*

The dog's head is sculpted in a mottled brown agate with eyes and teeth set with diamonds. Its studded, buckled collar is of red gold. A similar Fabergé bulldog box, also carved of agate, formerly belonged to a relative of the Swedish oil magnate Emanuel Nobel.[1] Animal-shaped boxes carved of stone were produced in Dresden during the eighteenth century. A. Kenneth Snowman illustrates an agate snuffbox in the shape of a lion set with diamond eyes and teeth, a snuffbox with the lid carved of green jade in the form of a growling dog with Paris gold mounts dating from 1760, and an amethyst boar's-head box with ruby eyes dating from the mid-eighteenth century.[2] Fabergé's bulldog box also recalls English eighteenth-century dog-head snuffboxes and bonbonnières made of ceramics or enameled copper.

[1] *Carl Fabergé, Goldsmith to the Tsar* (Stockholm, 1997), 126–27, no. 72.
[2] A. K. Snowman, *Eighteenth Century Gold Boxes of Europe* (London, 1966), figs. 495, 497, and 515.

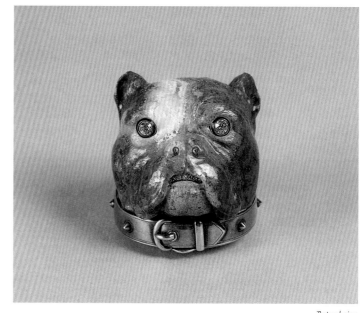

*Actual size*

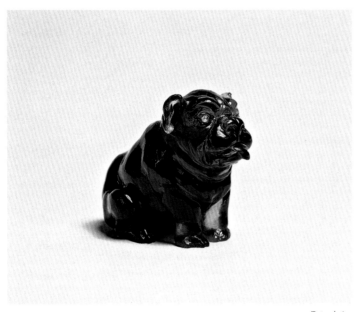

*Actual size*

## Bulldog

*St. Petersburg, firm of Carl Fabergé*
*Amethyst, diamonds*
*H: 1 ¹¹/₁₆ in (4.4 cm); L: 2 in (5.1 cm); 1 ⅜ in (3.5 cm)*
*Provenance: Said to have belonged to Grand Duchess Tatiana (1897–1918)*
*(daughter of Nicholas II), the Alexander Palace, Tsarskoe Selo;*
*India Early Minshall*
*The Cleveland Museum of Art, the India Early Minshall Collection,*
*1966.450*

Humor rather than strict realism appears to have been the intent of the carver of this seated puppy, which has a whimsical expression. It is carved of amethyst and has rose-cut diamond eyes. The compact, rounded shape of the bulldog invites comparisons with the netsuke in the form of a puppy (cat. no. 14).

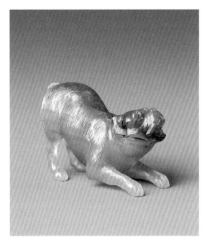

*Actual size*

56

## Barking Dog

*St. Petersburg, firm of Carl Fabergé*
*Agate, diamonds*
*H: 1 ⅛ in (2.9 cm); L: ⅝ in (1.6 cm); D: 1 ¹³⁄₁₆ in (4.6 cm)*
*Provenance: Helen B. Sanders*
*The Brooklyn Museum of Art, bequest of Helen B. Sanders, 78.129.5*

The excited, barking dog is portrayed in a defensive crouching position with its head raised. It is carved from a partially translucent, brownish golden agate and has eyes inset with rose-cut diamonds.

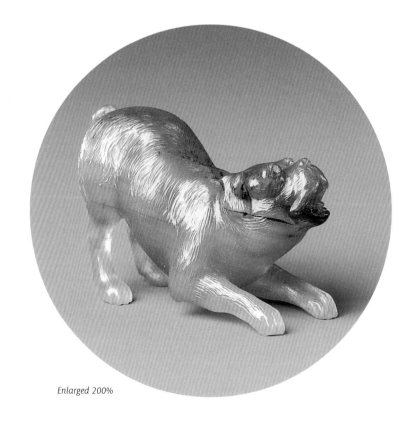

*Enlarged 200%*

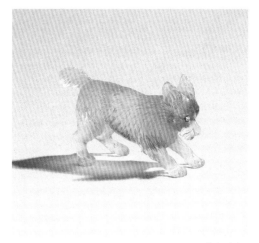

*Actual size*

## 57

### *Schnauzer*

*St. Petersburg, firm of Carl Fabergé*
*Citrine, diamonds*
*L: 1 ½ in (3.8 cm)*
*The Woolf Family Collection*

The dog is carved of citrine, a lemon-colored quartz, and has eyes of rose-cut diamonds. In this exceptionally realistic work, the schnauzer's distinctive wiry hair and thick mustache are carefully delineated. Despite the tiny scale of this statuette, the sculptor has conveyed a sense of both motion and sound by portraying the animal as he is about to leap and, presumably, bark.

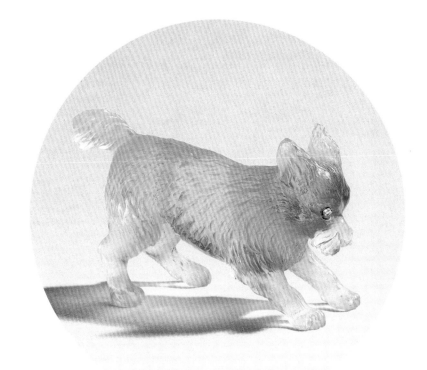

*Enlarged 200%*

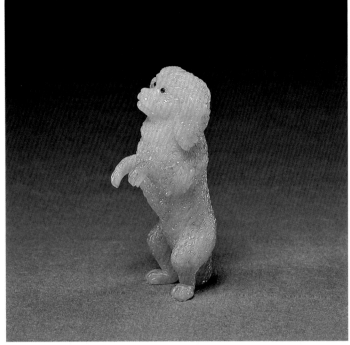

*Actual size*

58

## Begging Dog

*St. Petersburg, firm of Carl Fabergé*
*Agate, rubies*
*H: 2 ½ in (6.3 cm); L: 1 in (2.5 cm); D: ⅞ in (2.2 cm)*
*Provenance: India Early Minshall*
*The Cleveland Museum of Art, the India Early Minshall Collection,*
*1966.448*

The carver has admirably portrayed the curled fur and captured the stance and pleading expression of a creamy white poodle begging on its hind feet. Its eyes are set with cabochon rubies.

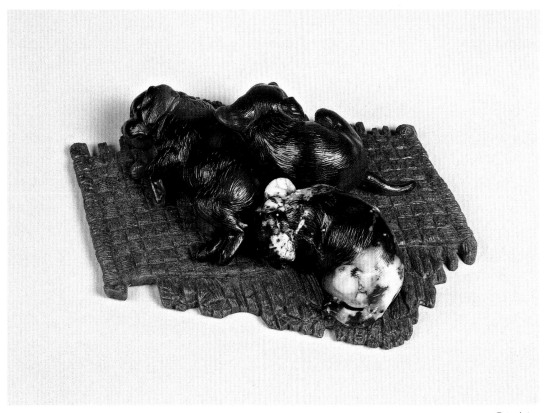

*Actual size*

*59*

## Three Puppies on a Mat

*St. Petersburg, firm of Carl Fabergé*
*Agate, chalcedony, marble*
*H: 1 ⅛ in (2.9 cm); L: 4 ⁹⁄₁₆ in (11.6 cm); D: 3 ⅞ in (9.8 cm)*
*Provenance: India Early Minshall*
*The Cleveland Museum of Art, the India Early Minshall Collection,*
*1966.451*

The carver has exploited a range of colored stones to attain a remarkably
naturalistic effect. In the Royal Collection, London, a similar approach
was adopted for a litter of pigs carved from various colored
chalcedonies.[1]

[1] *Fabergé*, The Queen's Gallery, Buckingham Palace (London, 1995), 22, fig. 3.

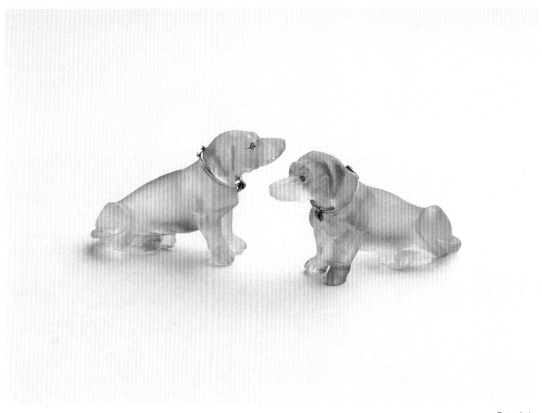

*Actual size*

## Pair of Dachshunds

*St. Petersburg, firm of Carl Fabergé*
*Quartz, gold, rubies, enamel*
*H: 1 ⅝ in (4.1 cm)*
*Provenance: Lady Manton, Houghton Hall, Yorkshire, England*
*The John A. Traina, Jr., Collection*

Fabergé's craftsmen were adept at producing realistic representations of
both specific animals and various breeds. This pair of seated dachshunds
may represent specific pets. They are made from quartz, set with ruby
eyes, and wear white enameled gold collars.

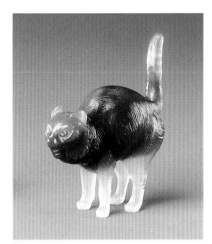

*Actual size*

61

## Cat

*St. Petersburg, firm of Carl Fabergé*
*Agate, diamonds*
*H: 1 ⅞ in (4.8 cm); L: ¾ in (1.9 cm); D: 1 ½ in (3.8 cm)*
*Provenance: A La Vieille Russie, New York; Helen B. Sanders*
*The Brooklyn Museum of Art, bequest of Helen B. Sanders, 78.129.4*

The sculptor portrays the cat in a characteristic pose, with its back
arched and its tail raised in a defensive position. It is executed in banded
agate and has rose-cut diamond eyes.

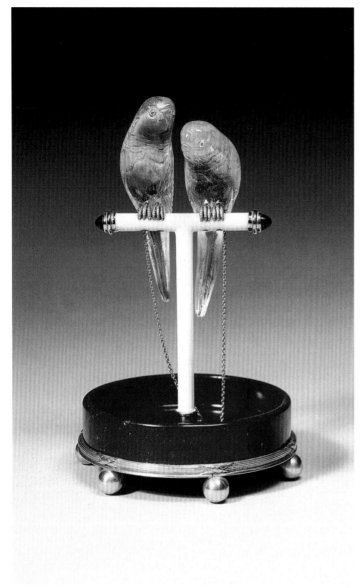

*Actual size*

62

## Pair of Parakeets

*St. Petersburg, firm of Carl Fabergé*
*Workmaster: Henrik Wigström (marked with his initials)*
*Topaz, ivory, purpurine, peridots, sapphires, gold (72 zolotnik)*
*H: 4 ⅜ in (10.9 cm)*
*Provenance: Dr. N. Dorin Ischlondsky*
*The Walters Art Museum, gift of Dr. N. Dorin Ischlondsky, 1961, 57.1912*

A pair of topaz parakeets with peridot eyes and gold feet is perched on a T-shaped ivory stand and connected by gold chains to the mount. The cross bar of the stand terminates in cabochon sapphires. The high rimmed, purpurine feeding tray rests on a fluted gold base supported by six gold balls.

*63*

## Pair of Cockatoos

*St. Petersburg, firm of Carl Fabergé*
*Topaz, tourmaline, ivory, diamonds, gold, enamel,*
*rubies, sapphires*
*H: 4 in (10.1 cm)*
*Provenance: Dr. N. Dorin Ischlondsky*
*The Walters Art Museum, gift of Dr. N. Dorin Ischlondsky, 1961, 57.1913*

Perched on a T-shaped ivory stand is a pair of topaz cockatoos with ruby
eyes and gold feet. They are connected by gold chains to a pink enamel
and gold mount set in a nephrite base supported by four gold ball feet.
A pair of amethyst lovebirds in a similar setting marked with the initials
of Henrik Wigström is in the Lillian Thomas Pratt Collection of the
Virginia Museum of Fine Arts.[1]

[1] P. Lesley, *Fabergé, A Catalog of the Lillian Thomas Pratt Collection of Russian Imperial Jewels*
(Richmond, 1976), 28, 31, and 34.

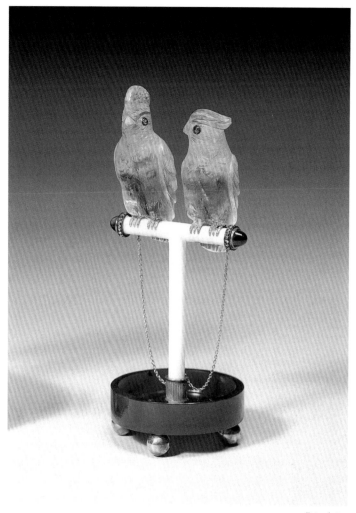

*Actual size*

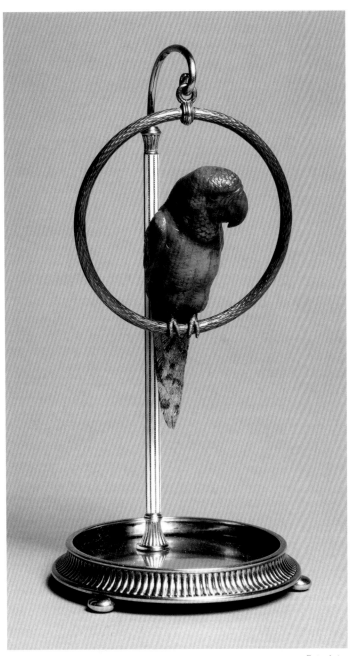

*Actual size*

## Parrot on a Perch

*St. Petersburg, firm of Carl Fabergé*
*Assay mark for 1899–1908*
*Assay master: Iakov Liapunov (marked with his initials)*
*Workmaster: Mikhail Perkhin (marked with his initials)*
*Silver (88 zolotnik), enamel, jasper, agate, emeralds*
*H: 6 in (15.2 cm); D: 2 ⅞ in (7.3 cm)*
*Provenance: Christie's, London, 25 November 1958, lot 152;*
*India Early Minshall*
*The Cleveland Museum of Art, the India Early Minshall Collection,*
*1966.447*

A parrot carved of jasper with emerald eyes rests on a guilloché enameled silver ring suspended from a stand decorated with white enamel. The fluted, circular base is supported on ball feet. Part of the parrot's tail was broken and replaced with agate between 1958 and 1960. In the Lillian Thomas Pratt Collection of the Virginia Museum of Fine Arts, there is a similar, though slightly larger, bird carved of agate with emerald eyes.[1]

[1] P. Lesley, *Fabergé, A Catalog of the Lillian Thomas Pratt Collection of Russian Imperial Jewels* (Richmond, 1976), 35, no. 45.

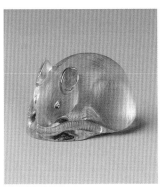

*Actual size*

65

## *Mouse*

*St. Petersburg, firm of Carl Fabergé*
*Citrine, diamonds*
*H: ¾ in (1.9 cm); L: 1 ⅛ in (2.8 cm); D: ¾ in (1.9 cm)*
*Provenance: A La Vieille Russie, New York; Helen B. Sanders*
*The Brooklyn Museum of Art, bequest of Helen B. Sanders, 78.129.7*

A mouse carved of citrine with inset diamond eyes rests against an overturned bowl. A type of Japanese netsuke that might have served as a prototype is illustrated by Geza von Habsburg.[1]

[1] G. von Habsburg, *Fabergé, Hofjuwelier der Zaren* (Munich, 1986), 307, no. 637.

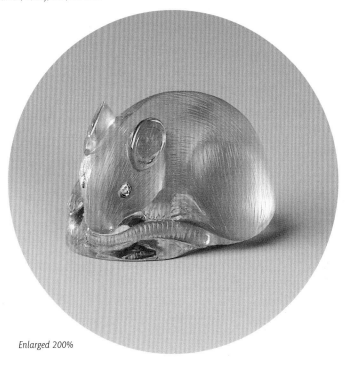

*Enlarged 200%*

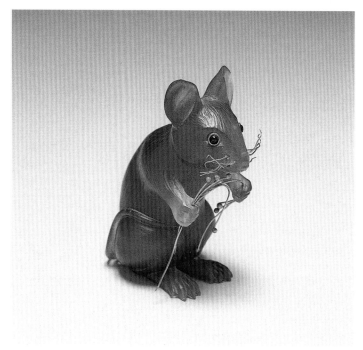

*Actual size*

66

*Mouse*

*St. Petersburg, firm of Carl Fabergé*
*Agate, diamonds, gold*
*H: 2 ½ in (6 cm); W: 1 ½ in (4 cm)*
*The Christian de Guigné Collection*

Commonplace rodents, including squirrels, rats, and mice, provided
Fabergé with beguiling subjects. This brownish agate mouse has
diamond inset eyes and gold whiskers. In the Royal Collection, London,
there is a dormouse, distinguished by its bushy rather than bald tail,
which is also posed erect, with platinum rather than gold whiskers.[1]

[1] *Fabergé, 1846–1920* (London, 1977), 15.

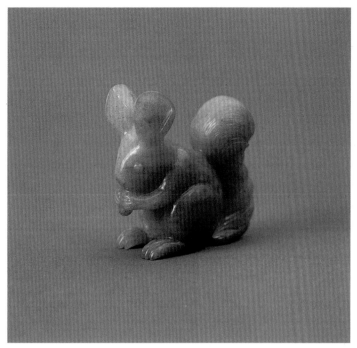

*Actual size*

*67*

## Squirrel

*St. Petersburg, firm of Carl Fabergé*
*Quartz*
*H: 1 ¾ in (4.6 cm); L: 1 ⅞ in (4.6 cm)*
*Provenance: Agathon Carlovitch Fabergé; Leo Wainstein*
*Private Collection, Finland*

A squirrel with exceptionally large ears, carved of light brown quartz, is portrayed chewing a nut. This squirrel originally belonged to Fabergé's second son, Agathon Carolovitch (1876–1951), who, as a gem expert, was employed by the Bolshevik government to assess the value of the Imperial treasures.

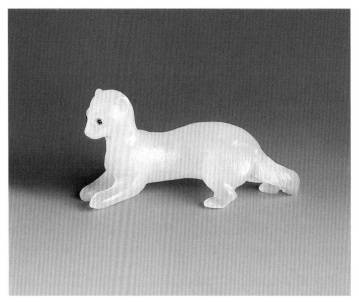

*Actual size*

68

## Ermine

*St. Petersburg, firm of Carl Fabergé*
*Bowenite, rubies*
*H: 1 ¼ in (3.2 cm); L: 2 ⅜ in (6 cm)*
*Private Collection, Finland*

The colorless bowenite ermine has eyes inset with rubies. Fabergé's artists
did not limit themselves to the most common rodents such as squirrels
and mice but also portrayed those less frequently encountered, including
porcupines, chinchillas, hamsters, and, in this instance, an ermine.

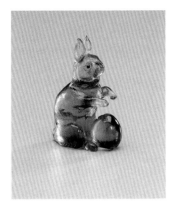

*Actual size*

*69*

## Rabbit and Egg

*St. Petersburg, firm of Carl Fabergé*
*Amethyst, rubies*
*H: 1 ⅛ in (2.9 cm)*
*Original fitted box, lining stamped with the Imperial warrant and*
*St. Petersburg, Moscow, Odessa*
*Provenance: Mr. and Mrs. Jack Linsky; Mrs. Marjorie Merriweather Post*
*Hillwood Museum and Gardens, 21.24*

The rabbit and egg are carved of a single piece of amethyst. Squatting on its hind legs, the animal extends his paws. Fine incisions in the stone suggest the animal's fur. Its eyes are inset with rubies.

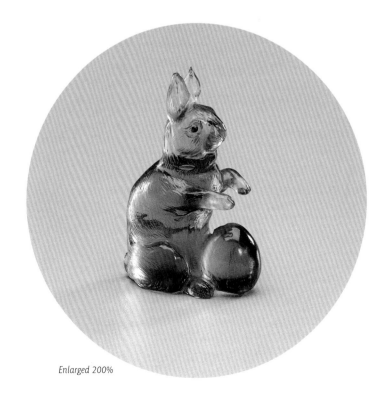

*Enlarged 200%*

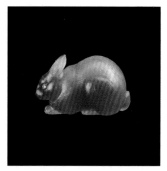

*Actual size*

70

## Pink Rabbit

*St. Petersburg, firm of Carl Fabergé*
*Carnelian, diamonds*
*L: 1 ⅛ in (2.8 cm)*
*Original fitted case, lining stamped in gold with the Imperial warrant and*
*Fabergé, St. Petersburg, Moscow*
*Provenance: Dowager Empress Marie Fedorovna; Grand Duchess Xenia*
*Alexandrovna (sister of Nicholas II), Windsor; Princess Andrew of Russia*
*(daughter-in-law of Xenia Alexandrovna); Sotheby Parke Bernet, Inc.,*
*London, 29 July 1965, lot 94*
*The Forbes Magazine Collection, New York*

This naturalistically rendered carnelian rabbit with finely incised fur and
minute diamond-set eyes originally belonged to Dowager Empress Marie
Fedorovna (1847–1928).

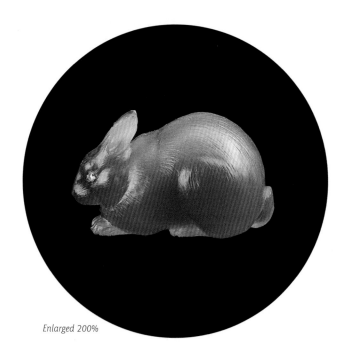

*Enlarged 200%*

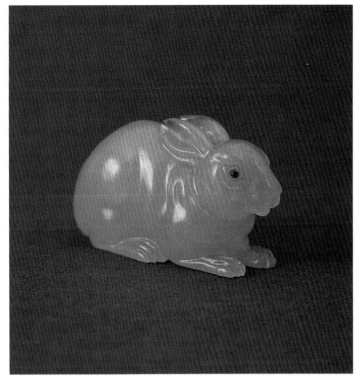

*Actual size*

71

## Rabbit

*St. Petersburg, firm of Carl Fabergé*
*Bowenite, rubies, gold*
*H: 1 ¼ in (3.1 cm), L: 2 ¼ in (5.9 cm)*
*Provenance: Agathon Carlovitch Fabergé; Leo Wainstein*
*Private Collection, Finland*

The pale green bowenite has been polished so as to suggest the smooth folds in the crouching rabbit's skin and fur. Its ruby eyes are inset in gold.

*Actual size*

72

## Rabbit

*St. Petersburg, firm of Carl Fabergé*
*Agate, diamonds*
*H: ⁷⁄₁₆ in (1.3 cm)*
*Original fitted case, lining stamped in black in Cyrillic with the Imperial*
*warrant and* Fabergé, St. Petersburg, Moscow, Odessa
*The Andre Ruzhnikov Collection*

The carver has lavished considerable attention to such details as the
animal's fur in this very diminutive agate rabbit with rose-cut diamond
eyes. Rabbits were particularly popular among Fabergé's clients.

*Enlarged 400%*

73

## Rabbit

*St. Petersburg, firm of Carl Fabergé*
*Obsidian, diamonds*
*H: 1 ¼ in (3.2 cm); L: 1 ¾ in (4.4 cm); D: ⅞ in (2.2 cm)*
*Original fitted case, lining stamped with the Imperial warrant and*
*St. Petersburg, Moscow*
*Provenance: A La Vielle Russie, New York; Helen B. Sanders*
*The Brooklyn Museum of Art, bequest of Helen B. Sanders, 78.129.8*

The obsidian rabbit with rose-cut diamond eyes has been carved to
resemble a Japanese ivory netsuke.

*Actual size*

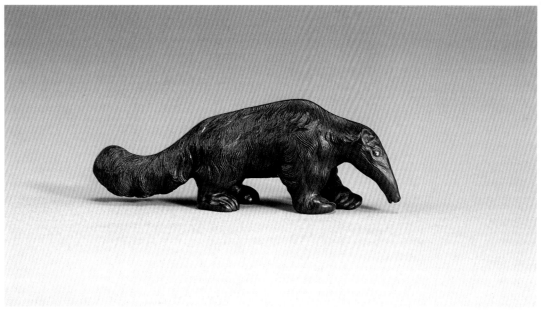

## 74

## *Anteater*

*St. Petersburg, firm of Carl Fabergé*
*Jasper, diamonds*
*H: 3 ½ in (8.7 cm)*
*Provenance: Henry Walters*
*The Walters Art Museum, acquired by Henry Walters, 1900, 42.354*

Represented is the great anteater of Central and South America, a mammal that can attain a length of eight feet. This exotic animal, with its distinctive, elongated head, occurs rarely in Fabergé's repertory, although several other examples are known, including one of bloodstone in Castle Howard and another of aventurine quartz illustrated by Geza von Habsburg.[1] The Walters' anteater, of red jasper with inset diamond eyes, was among the objects purchased by Henry Walters during his cruise to St. Petersburg in 1900. Curving striations have been used to indicate the animal's long, bushy tail.

[1] G. von Habsburg et al., *Fabergé, Imperial Craftsman and his World* (London, 2000), 303, no. 787, and G. von Habsburg, *Fabergé, Hofjuwelier der Zaren* (Munich, 1986), 194, no. 302.

*Actual size*

75

## South African Porcupine

*St. Petersburg, firm of Carl Fabergé*
*Ophi calcite, rubies*
*H: 1 ½ in (3.8 cm); L: 2 ¾ in (7 cm); D: 1 ¾ in (4.4 cm)*
*A La Vieille Russie, New York*

Exploiting the qualities of this stone, with its distinctive large crystals,
the carver has portrayed the rodent in a defensive position with its quills
erect. This was one of a series of animals modeled from examples in the
London Zoo, which housed animals found throughout the British Empire.
Another porcupine, made from brownish agate, is illustrated in *The Art
of Peter Carl Fabergé.*[1]

[1] *The Art of Peter Carl Fabergé*, A La Vieille Russie (New York, 1961), no. 52.

*Actual size*

76

## Hoopoe Bird

*St. Petersburg, firm of Carl Fabergé*
*Workmaster: Henrik Wigström (marked with his initials)*
*Agate, gold (72 zolotnik), diamonds*
*H: 2 in (5.1 cm)*
*Original fitted case, lining stamped with the Imperial warrant and* Fabergé,
St. Petersburg, Moscow, London
*The Castle Howard Collection, Yorkshire*

The hoopoe is carved of a reddish brown agate tinged with black,
approximating the bird's actual beige-buff color. Its eyes are inset with
rose-cut diamonds, and its feet and beak are of engraved gold. The
initials of the head workmaster, Wigström, indicate that his shop was
responsible for the gold fittings. This crested bird ranges over Africa and
India in the winter and reaches as far north as Siberia in the summer.

*Actual size*

## Perching Owl

*St. Petersburg, firm of Carl Fabergé*
*Incised inventory no. 7827*
*Agate, diamonds, chalcedony, gold, silver-gilt*
*H: 2 ⁹⁄₁₆ in (6.5 cm)*
*Provenance: Lord Ivar Mountbatten*
*The Terence Isakov Collection*

A horned owl carved of honey-colored agate with rose-cut diamond eyes
and gold feet rests on a silver-gilt perch set in a block of chalcedony. The
bird's tilted head imparts a sense of immediacy, and remarkable attention
has been given to indicating the bird's feathers. Similar in shape and in
detail is a great horned owl cast in silver as a hand-set by an
undocumented Fabergé workmaster with the initials AL.[1]

[1] Christie's, New York, 16 April 1999, lot 125.

## Owl Bell Push

*St. Petersburg, firm of Carl Fabergé*
*Assay mark for 1899–1908*
*Assay master: Iakov Liapunov*
*Workmaster: Mikhail Perkhin (marked with his initials)*
*Gold (56 zolotnik), nephrite, tiger's eye*
*L: 2 ¾ in (6.9 cm)*
*Provenance: The estate of Countess Monica Bismarck; Christie's, Geneva,*
*30 November 1982, lot 264; A La Vieille Russie, New York*
*The Forbes Magazine Collection, New York*

Fabergé's practice of producing items that were both utilitarian and
deluxe is demonstrated by his bell pushes. With the introduction of
electricity, hand bells were replaced by bell pushes as a means of
summoning servants. Pushing the owl's eyes activated the bell. The
tiger's eye, or rounded chrysoberyls, used for the bell push is a
gemstone found near Ekaterinberg. The model for this carving appears to
have served as the basis for a silver owl bell push (also with tiger's eye
pushes) produced by Julius Rappoport's workshop.[1]

[1] K. Farrington, *Fabergé* (San Diego, 1999), 83.

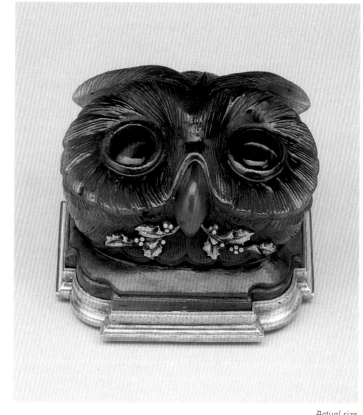

*Actual size*

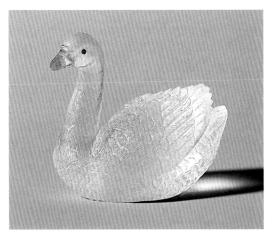

*Actual size*

# Swan

*St. Petersburg, firm of Carl Fabergé*
*Rock crystal*
*L: 1 ¹⁵/₁₆ in (5 cm)*
*Provenance: Lord Ivar Mountbatten*
*The Terence Isakov Collection*

A young swan or cygnet is portrayed as though it were swimming. The carefully detailed rendering of the plumage is comparable to that on a large carving of a goose in the Lillian Thomas Pratt Collection at the Virginia Museum of Fine Arts.[1]

[1] P. Lesley, *Fabergé, A Catalog of the Lillian Pratt Collection of Russian Imperial Jewels*, Virginia Museum, Richmond, 1960, 25, no. 29.

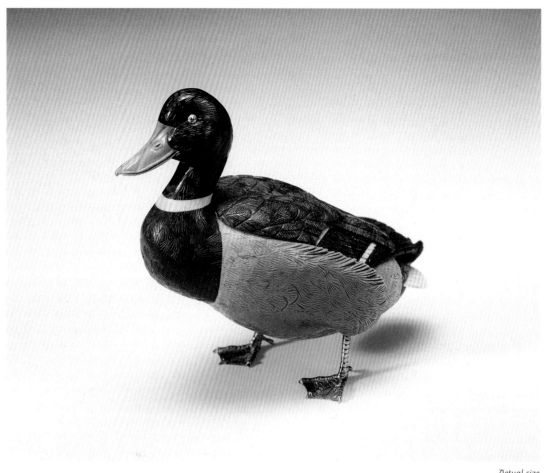

*Actual size*

80

## Duck

*St. Petersburg, attributed to firm of Carl Fabergé*
*Nephrite, chalcedony, lapis lazuli, diamonds, gold*
*H: 3 ½ in (9 cm); W: 3 ¼ in (8.5 cm)*
*The Christian de Guigné Collection*

Aiming for the maximum appearance of verisimilitude, Fabergé's
sculptors occasionally assembled their carvings from variously colored
stones, as in this mallard duck, which also has gold feet. A similar duck
is to be found in the Royal Collection, London.[1]

[1] *Fabergé,* The Queen's Gallery, Buckingham Palace (London, 1995), 20, fig. 4.

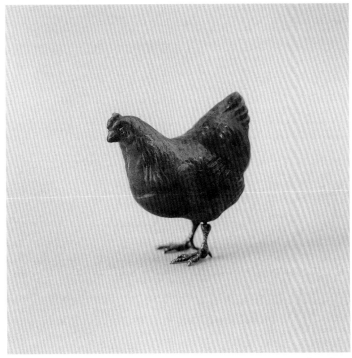

*Actual size*

81

## Hen

*St. Petersburg, firm of Carl Fabergé*
*Rhodonite, silver-gilt, peridots*
*H: 1 ¾ in (4.6 cm); L: 1 ¹¹/₁₆ in (4.3 cm)*
*Provenance: Agathon Carlovitch Fabergé; Leo Wainstein*
*Private Collection, Finland*

The hen is carved of rhodonite, a beautiful rose-red mineral with black veining that was mined at Syedelnikova near Ekaterinburg in the Urals. The feet are of silver-gilt and the eyes of peridot.

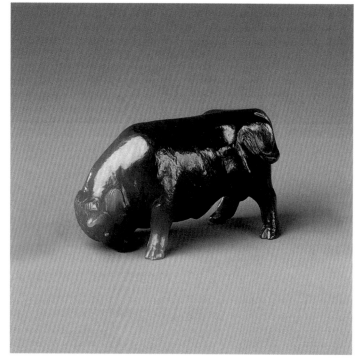

*Actual size*

## Bull

*St. Petersburg, firm of Carl Fabergé*
*Nephrite, diamonds*
*H: 1 ¼ in (3.2 cm); L: ¹⁵⁄₁₆ in (2.4 cm); D: 2 ¹⁵⁄₁₆ in (7.5 cm)*
*Original fitted box, lining stamped with the Imperial warrant and*
*Fabergé, St. Petersburg, Moscow*
*Provenance: A La Vieille Russie, New York; Helen B. Sanders*
*The Brooklyn Museum of Art, bequest of Helen B. Sanders, 78.129.3*

The stocky bull with well-defined musculature lowers its head to attack.
He is carved from nephrite and has eyes inset with rose-cut diamonds.

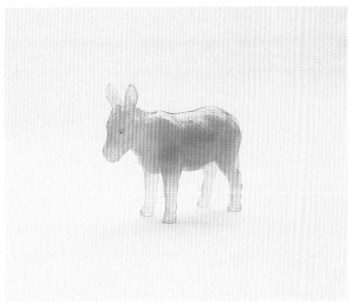

*Actual size*

## Donkey

*St. Petersburg, firm of Carl Fabergé*
*Agate, diamonds*
*H: 1 ⁹⁄₁₆ in (4 cm)*
*Provenance: Tsar Nicholas II; Sotheby's, Geneva, 27 May 1993, lot 427*
*The John A. Traina, Jr., Collection*

According to the Moscow State Archives, this agate donkey with rose-cut diamond eyes originally belonged to Tsar Nicholas II. It may have been modeled after the small donkey that King Umberto presented as a gift from his children to the tsar's children. With the exception of the animals modeled in 1907 at the royal farm at Sandringham, livestock and farm animals figured less prominently in Fabergé's production than did either domestic pets or wild creatures.

*Enlarged 200%*

## 84

### Equestrian Stickpin

*St. Petersburg, firm of Carl Fabergé*
*Workmaster: August Hollming (marked with his initials)*
*Gold (56 zolotnik), composition*
*L: 2 ½ in (6.4 cm)*
*Case in red morocco leather stamped in gold with Orecker & Co.,*
*560 Fifth Avenue, New York*
*Provenance: Sotheby's, New York, 16 December 1985, lot 102; Jonathan*
*Farkas, New York; presented to Christopher Forbes on the occasion of his*
*50th birthday by Mr. and Mrs. Paul Vartanian and their children, Nishan*
*and Annabel Vartanian*
*The Forbes Magazine Collection, New York*

The horse's head is made from a synthetic composition material; its bridle and the shaft of the pin are of gold. August Frederik Hollming (1854–1913), from Finland, became an apprentice in the St. Petersburg workshop in 1876 and a workmaster four years later. He specialized in jewelry and gold and silver functional pieces.

*85*

# Lamb

*St. Petersburg, firm of Carl Fabergé*
*Agate, rubies*
*H: ⅝ in (1.6 cm); L: 2 in (5.1 cm); D: 1 ⁵⁄₁₆ in (3.3 cm)*
*Provenance: A La Vieille Russie, New York; Helen B. Sanders*
*The Brooklyn Museum of Art, bequest of Helen B. Sanders, 78.129.9*

A seemingly newly born lamb carved of creamy white agate with ruby
eyes lies helpless on the ground.

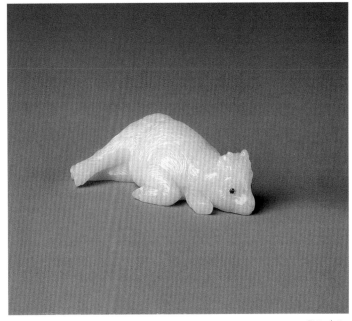

*Actual size*

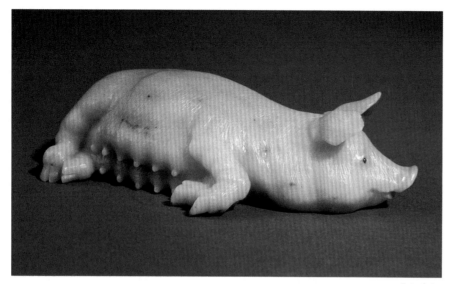 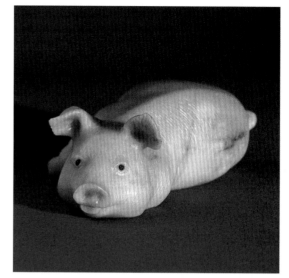

*Actual size*

## 86

### Sow

*St. Petersburg, firm of Carl Fabergé*
*Marked in Cyrillic with K. FABERGE; incised inventory no. 9244*
*Eosite, rubies*
*H: 1 in (2.5 cm); L: 4 in (10.2 cm); D: 1 ½ in (3.8 cm)*
*A La Vieille Russie, New York*

The droll sow lies with her head on the ground, her teats exposed, and her tail twisted in a curlicue. Her hair is suggested by finely incised lines. Eosite is an aventurine quartz mined in the Altai Mountains in Central Asia. It is extremely rare for one of Fabergé's hardstone animals to be signed and inscribed with an inventory number.

## 87 (opposite)

### Sow

*St. Petersburg, firm of Carl Fabergé*
*Chalcedony, gold, diamonds*
*L: 4 ½ in (11.4 cm)*
*Original fitted case, lining stamped in gold with the*
*Imperial warrant and Fabergé, St. Petersburg,*
*Moscow, London*
*The John A. Traina, Jr., Collection*

By using a pinkish-brown chalcedony, or quartz, the artist has been able to approximate the natural color of the sow's coat. Its hair has been delineated with finely incised, curved lines. For the eyes, minute diamond chips have been set in gold.

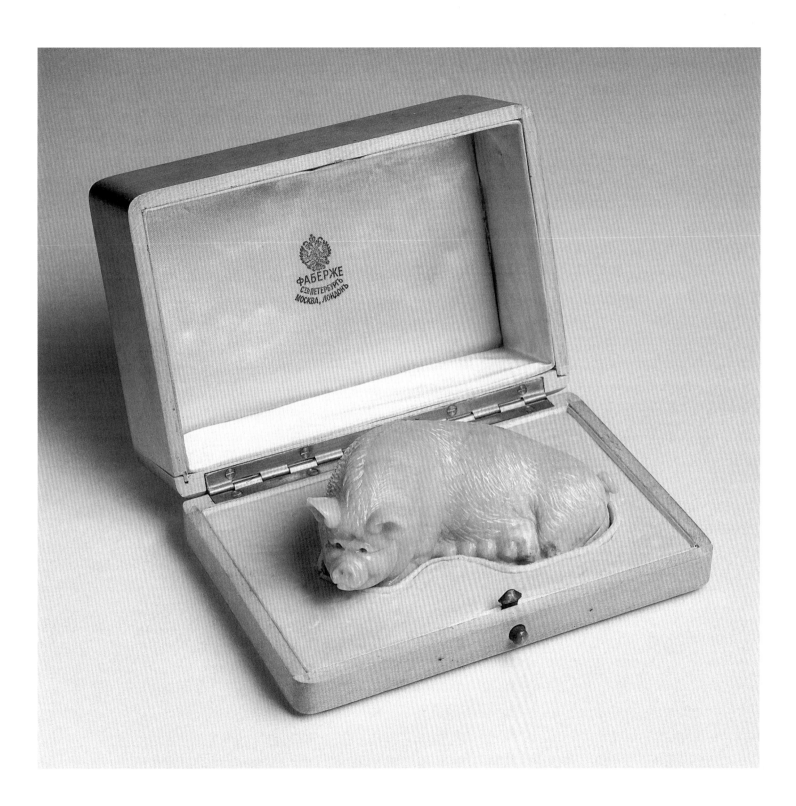

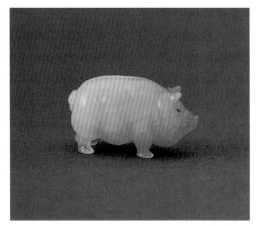

*Actual size*

## Pig

*St. Petersburg, firm of Carl Fabergé*
*Bowenite, diamonds*
*H: ⅞ in (2.3 cm); L: 1 ⁹⁄₁₆ in (4 cm)*
*Provenance: Agathon Carlovitch Fabergé; Leo Wainstein*
*Private Collection, Finland*

For comic effect, Fabergé's sculptors have exaggerated the rotundity of this potbellied pig carved of pale green bowenite. This carving originally belonged to Fabergé's second son, Agathon (1876–1951), who joined the family firm in 1894 and was also employed at the Diamond Room of the Winter Palace as a gemstone expert four years later.

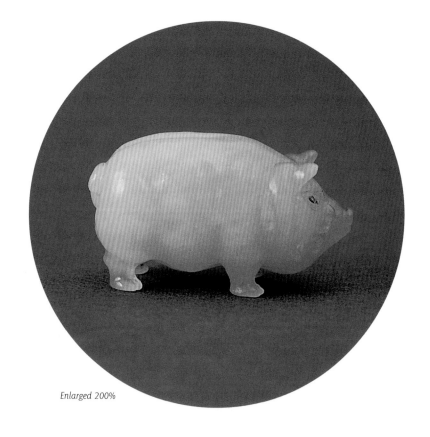

*Enlarged 200%*

*Actual size*

89

*Elephant*

*St. Petersburg, firm of Carl Fabergé*
*Obsidian, rubies*
*H: 1 ⅜ in (3.5 cm); L: 2 in (5.1 cm)*
*Provenance: Agathon Carlovitch Fabergé*
*Private Collection, Finland*

This large-eared elephant is whimsical rather than naturalistic in appearance. It is carved of obsidian, a volcanic glassy rock readily available in Russia, and its eyes are inset with rubies.

*Actual size*

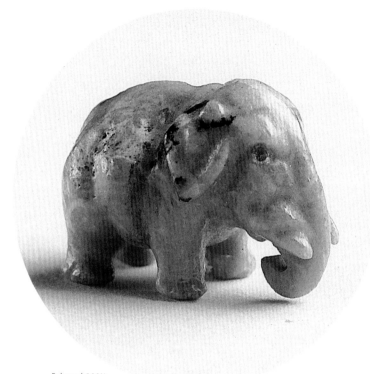

*Enlarged 300%*

## 90

## Elephant

*St. Petersburg, firm of Carl Fabergé*
*Rhodonite*
*H: ¾ in (2 cm)*
*The John A. Traina, Jr., Collection*

This miniature elephant is carved of rhodonite, or orletz, a mineral mined in the Ural Mountains. Franz P. Birbaum, Fabergé's senior master craftsman, praised the intensity of its pink color, but also commented on the challenges that it posed to the carver because of its cracks and spots.[1] He regarded rhodonite as appropriate for such small objects as parasol knobs and seals. An elephant of the same material and similar in size belonged to the noted collectors of Fabergé, Joan and Melissa Rivers.[2] The record books of the workmaster Albert Holmström for the years 1909 to 1915 included numerous jewelry designs incorporating miniature elephants, including a pair of cuff links with similarly shaped rhodonite elephants.[3]

[1] *The History of the House of Fabergé according to the Recollections of the senior master Craftsman of the Firm, Franz P. Birbaum* (St. Petersburg, 1992), 40.
[2] G. von Habsburg et al., *Fabergé, Imperial Craftsman and his World* (London, 2000), 304, fig. 797.
[3] A. K. Snowman, *Fabergé Lost and Found* (New York, 1993), 124.

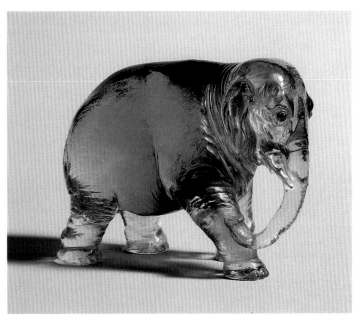

*Actual size*

## *Striding Elephant*

*St. Petersburg, firm of Carl Fabergé*
*Smoky quartz, rubies, silver*
*L: 2 ¾ in (7 cm)*
*Provenance: Lord Ivar Mountbatten*
*The Terence Isakov Collection*

This striding Asian elephant is carved of smoky quartz and has cabochon ruby eyes inset in silver.

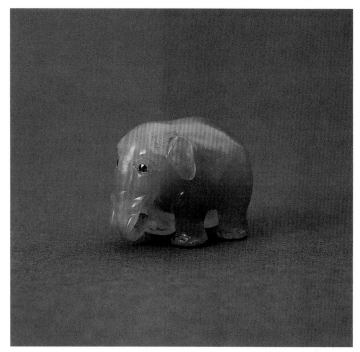

*Actual size*

92

*Elephant*

*St. Petersburg, firm of Carl Fabergé*
*Bowenite, rubies*
*H: 1 ¼ in (3.1 cm); L: 1 ½ in (3.9 cm)*
*Provenance: Agathon Carlovitch Fabergé; Leo Wainstein*
*Private Collection, Finland*

The artist has caricatured the young animal and carved it of pale green
bowenite, emphasizing the size of its head and its large ruby eyes.

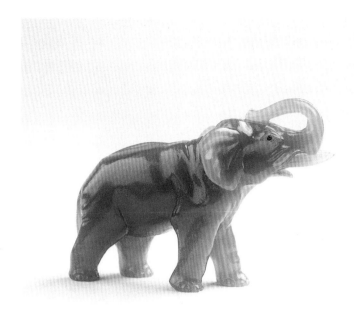

*Actual size*

93

## Striding Elephant

*St. Petersburg, firm of Carl Fabergé*
*Nephrite, sapphires*
*L: 2 ¾ in (7 cm)*
*Original fitted case, lining stamped in black in Cyrillic with the Imperial*
*warrant and* Fabergé, St. Petersburg, Moscow, London
*The Andre Ruzhnikov Collection*

Although elephants were among Fabergé's most popular subjects, a
striding example with its tusk raised upwards is actually quite rare.
Generally, Fabergé's elephants are depicted with their trunks curved
downwards. This Indian elephant, distinguished by its small ears, is
carved of nephrite and has inset eyes of cabochon sapphires.

*Actual size*

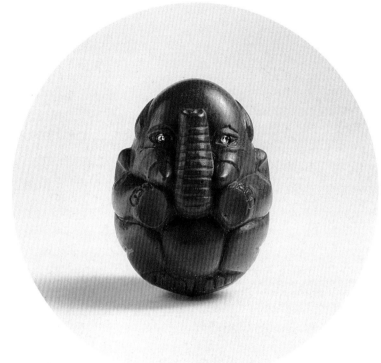

*Enlarged 200%*

*94*

## Elephant

*St. Petersburg, firm of Carl Fabergé*
*Purpurine, diamonds*
*H: 1 ³⁄₁₆ in (3 cm)*
*The Woolf Family Collection*

The highly stylized purpurine elephant with rose-cut diamond eyes
recalls in shape a Japanese *ojime*, the carved bead used to tighten the
cord that held the portable utensils suspended from the waistband.

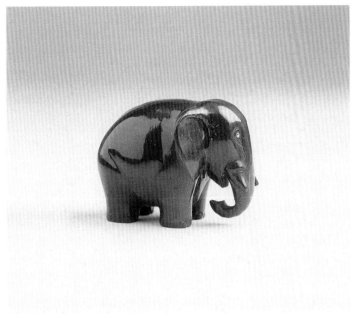

*Actual size*

95

## Elephant

*St. Petersburg, firm of Carl Fabergé*
*Jasper, diamonds*
*L: 1 ¾ in (4.4 cm)*
*Original fitted case, lining stamped in gold in Cyrillic with the Imperial*
*warrant and Fabergé, St. Petersburg, Moscow*
*The Andre Ruzhnikov Collection*

This comical-looking elephant carved of reddish-brown jasper with rose-cut diamond eyes resembles in form a Japanese netsuke, an art form that Carl Fabergé admired and collected.

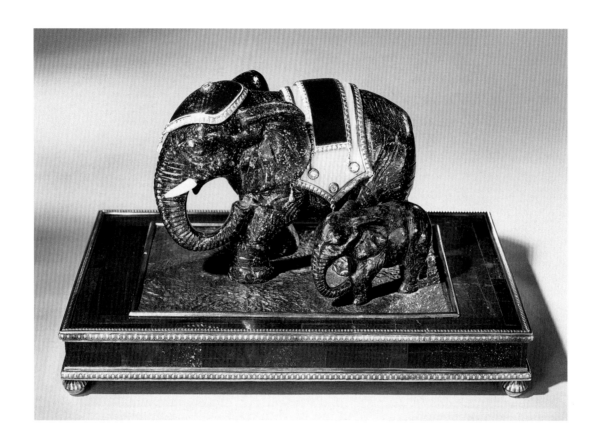

96

*Mother Elephant and Her Offspring*

*St. Petersburg, firm of Carl Fabergé*
*Lapis lazuli, gold, enamel, diamonds, ivory*
*H: 6 5/16 in (16 cm); L: 3 11/16 in (9.4 cm); D: 3 9/16 in (9 cm)*
*Provenance: Mrs. Clara Peck*
*American Museum of Natural History, gift of the estate of Clara Peck,*
*97961*

The elephants have been naturalistically carved of mottled lapis lazuli with special attention being given to such details as the folds in their trunks. Both elephants' eyes are inset with diamonds, and the mother's tusks are of ivory. Although one would expect the elephants to be of the Asiatic species, their large ears, in fact, are characteristic of the African species. The adult elephant's fittings include a saddle carpet and a cap in red and mustard yellow translucent enamel over a guilloché gold ground. Six small diamonds have been affixed to the saddle cap, and one is suspended from it. The animals are positioned diagonally on a rectangular, varicolored, and textured gold ground set in a base faced with rectangular panels of lapis lazuli. Similar saddle fittings are found on an elephant automaton in the Royal Collection, London.[1]

[1] *Fabergé 1846–1920* (London, 1977), 37, no. C31.

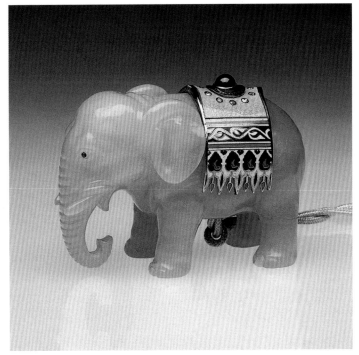

*Actual size*

## 97

### Elephant Bell Push

*St. Petersburg, firm of Carl Fabergé*
*Bowenite, gold, enamel, diamonds, rubies, sapphire*
*H: 2 in (5.1 cm); L: 2 ¾ in (7 cm); D: ½ in (1.3 cm)*
*Provenance: Matilda Geddings Gray*
*New Orleans Museum of Art, on loan from Matilda Geddings Gray*
*Foundation, EL.1983.163*

Elephants appear to have been favorite subjects at the House of Fabergé,
and not only because they represented the arms of the Danish royal
family. In this instance, a bowenite elephant with ruby eyes is equipped
with a tasseled caparison rendered in champlevé and guilloché enamel
and decorated with rose-cut diamonds. A cabochon sapphire serves as
the bell push.

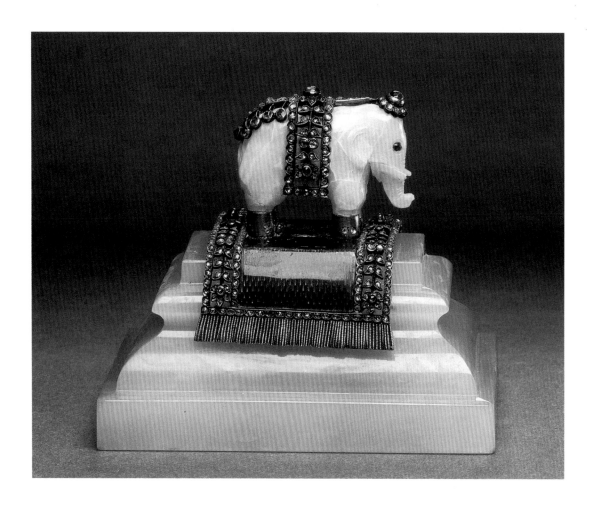

98

*Elephant Bell Push*

*St. Petersburg, firm of Carl Fabergé*
*Assay mark for 1899–1908*
*Workmaster: Henrik Wigström (marked with his initials)*
*Jade, opal, gold (56 zolotnik), rubies, emeralds, diamonds, enamel*
*H: 2 ⅝ in (6.6 cm); L: 3 in (7.6 cm); D: 2 ⅛ in (5.4 cm)*
*Provenance: Said to have been made for Dowager Empress Marie*
*Fedorovna; India Early Minshall*
*The Cleveland Museum of Art, the India Early Minshall Collection,*
*1966.474*

An opal elephant with ruby eyes and fitted gold feet stands on a fringed, red-enameled carpet placed over a stepped, green jade plinth. Both the animal's howdah, or fittings, and the carpet are rendered in gold inset with rubies, emeralds, and diamonds.

The elephant had special associations for the dowager empress Marie Fedorovna (1847–1928), who was born Princess Dagmar of Denmark. The elephant was a symbol of the Danish royal family and the badge of the kingdom's highest decoration.

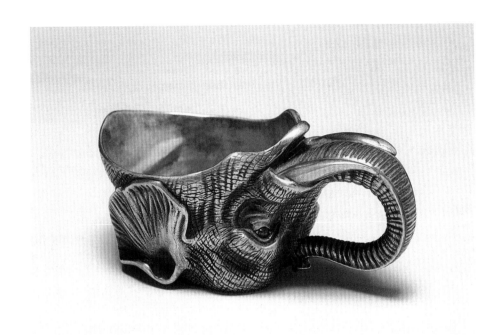

*Actual size*

99

## Elephant-Head Charka

*St. Petersburg, firm of Carl Fabergé*
*Workmaster: Julius Rappoport (marked with his initials)*
*Silver, rubies*
*H: 1 ½ in (3.8 cm); W: 3 ⅜ in (8.6 cm)*
*Provenance: John A. Traina, Jr.*
*Fine Arts Museums of San Francisco, gift of John A. Traina, Jr., 1998.116.2*

The *charka*, a traditional vodka cup, is of silver in the form of an
elephant's head. Its raised trunk forms the handle, and its eyes are
rubies. The silver body of the charka is skillfully rendered to simulate the
wrinkled and tough hide of an elephant.

## 100

### Cigarette Case with Elephants

*St. Petersburg, firm of Carl Fabergé*
*Marked in Cyrillic with K. FABERGE; assay mark for 1908–17*
*H: 3 ¾ in (9.5 cm)*
*Nephrite, gold, rubies*
*The John A. Traina, Jr., Collection*

Cigarette cases represent a category of modern, deluxe utensils in which the Fabergé firm was particularly prone to depart from its more usual, eclectic revival styles in favor of an avant-garde approach. The dark color of the nephrite contrasted with the ruby eyes and push button, and the highly stylized rendering of the elephants on this cigarette case anticipate the Art Deco movement of the 1920s. An earlier silver cigarette case, hallmarked for St. Petersburg, 1899–1908, is in the Royal Collection of Thailand and is decorated with very similar elephants.[1]

[1] B. Krairiksh, ed., *Fabergé* (Bangkok, no date), 172–73.

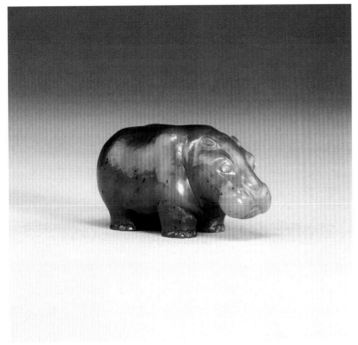

*Actual size*

*101*

## Hippopotamus

*St. Petersburg, firm of Carl Fabergé*
*Nephrite, diamonds*
*H: 2 in (4.9 cm)*
*Provenance: Henry Walters*
*The Walters Art Museum, acquired by Henry Walters, 1900, 42.355*

This baby hippopotamus is one of the animal carvings Henry Walters
purchased at the House of Fabergé during his visit in 1900. It is carved of
nephrite with small rose-cut diamond eyes. A more ponderous
hippopotamus, carved in obsidian with diamond eyes, belongs to a
private collector.[1]

[1] *Carl Fabergé, Goldsmith to the Tsar* (Stockholm, 1997), 108, no. 39.

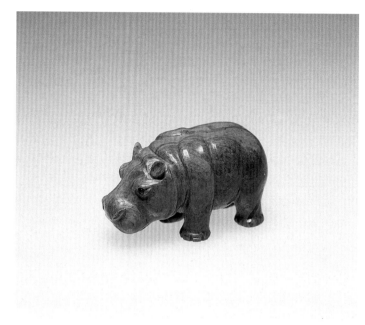

*Actual size*

102

## Hippopotamus

*St. Petersburg, firm of Carl Fabergé*
*Jasper, diamonds*
*H: 1 ½ in (4 cm); W: 2 in (5 cm)*
*The Christian de Guigné Collection*

Like the elephant, the hippopotamus's rotundity provided Fabergé's artists an opportunity to express their wit. Hippopotamuses were carved in a variety of stones and in a range of sizes. Despite its diminutive scale, the folds of the hide on this jasper example are more clearly delineated than they are on the nephrite piece in the Walters' collection (cat. no. 101).

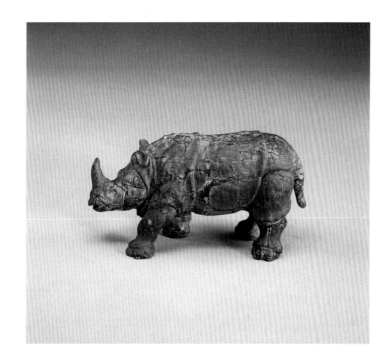

*103*

## Rhinoceros

*St. Petersburg, firm of Carl Fabergé*
*Jasper*
*H: 2 ⅜ in (6.2 cm); L: 4 ⅝ in (11.7 cm)*
*Provenance: Henry Walters*
*The Walters Art Museum, acquired by Henry Walters, 1900, 27.480*

This rhinoceros, which has been identified as being of the Indian breed (*Rhinocerous unicornis*), is said to have come from Russia. This species was found to the east of the Caspian, around the Aral Sea, an area the Russians took by conquest in the mid-nineteenth century.

The coarse texture of the animal's hide is conveyed by the use of mottled-red jasper. This rhinoceros was purchased by Henry Walters during his visit to St. Petersburg in 1900.

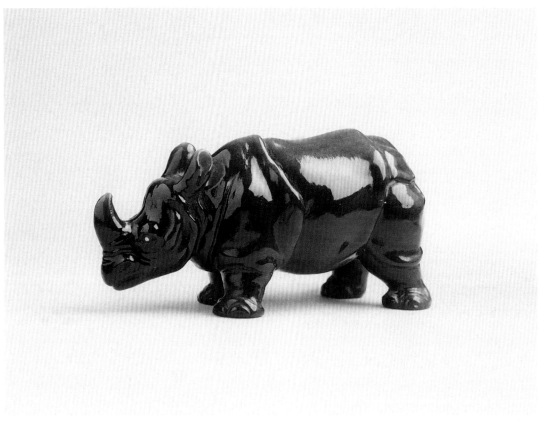

*Actual size*

## 104

## Rhinoceros

*St. Petersburg, firm of Carl Fabergé*
*Obsidian, diamonds*
*L: 3 ¹³⁄₁₆ in (9.7 cm)*
*Original fitted case, lining stamped in black in Cyrillic with the Imperial*
*warrant and* Fabergé, St. Petersburg, Moscow, London
*The Andre Ruzhnikov Collection*

The Great Indian rhinoceros is distinguished by its single horn and extremely thick hide that hangs over the body in layers resembling plates of armor. This example is carved of obsidian, a dense, slightly translucent stone formed of natural glass, and has eyes inset with rose-cut diamonds. Other examples of this subject in Fabergé's output include the Walters' jasper rhinoceros (cat. no. 103) and a larger, less detailed example of dark bowenite in the Castle Howard Collection, Yorkshire.[1]

[1] G. von Habsburg et al., *Fabergé, Imperial Craftsman and his World* (London, 2000), 302, fig. 786.

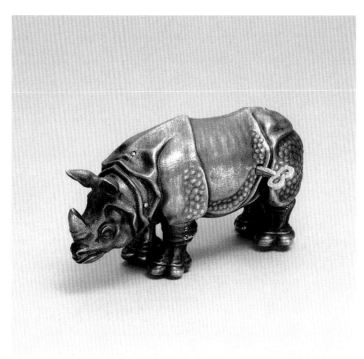

*Actual size*

## *Automated Rhinoceros*

*St. Petersburg, firm of Carl Fabergé*
*Oxidized silver; gold key*
*L: 2 ⅞ in (7.3 cm)*
*Original fitted case in red morocco leather stamped in black with the*
*Imperial warrant and Fabergé, St. Petersburg, Moscow, London*
*Provenance: A La Vieille Russie, New York*
*The Forbes Magazine Collection, New York*

When the rhinoceros is wound with a gold key, it lumbers forward, simultaneously raising and lowering its head and swishing its tail. The oxidized surface of the silver simulates the color and coarse texture of the animal's skin. The single tusk and the raised lumps on the animal's hide indicate that it is a Great Indian rhinoceros. Lord Howe, the Lord Chamberlain, presented a similar rhinoceros to Queen Alexandra in 1909 on the occasion of her 65th birthday. In recalling the Queen's reaction to the gift in his memoirs, Viscount Knutsford, who mistakenly referred to the rhinoceros as a hippopotamus, wrote: "What pleased her most, I think was Howe's present of a little hippopotamus made of silver by this Russian, perfectly modeled, and when wound up, it walked by means of little clockwork wheels in the legs, and wagged its tail."[1] The firm's London sales ledgers list the Queen's gift as no. 17665, whereas the Forbes example is no. 17591.

[1] S. Holland, Viscount Knutsford, *In Black and White* (London, 1926), 238–39.

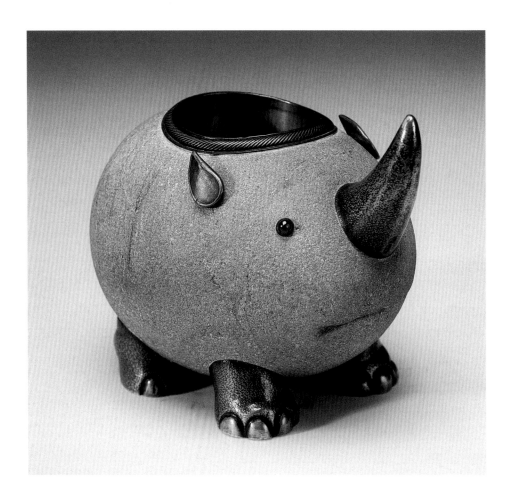

## 106

### Match Holder and Striker in the Form of a Rhinoceros

*St. Petersburg, firm of Carl Fabergé*
*Assay mark for before 1899*
*Workmaster: Julius Rappoport (marked with his initials)*
*Sandstone, silver, garnets*
*L: 4 in (10.2 cm)*
*The Christian de Guigné Collection*

This rhinoceros-shaped utensil serves a dual function: it provides a silver-lined recess for holding matches and a coarse surface on which to strike them. The feet that support the sandstone body are of silver, as are the animal's horn and ears. The mouth is indicated by an irregular incision, and garnets mounted in silver serve as the eyes.

Rappoport's workshop produced several quixotic sandstone match holders and strikers. In an example that is similar in size and form, the eyes are inserted below the tusk, thereby dramatically altering the facial expression.[1] A slightly larger match holder in the form of a pig came from the Rappoport workshop after it had been taken over by the workmaster's successor, the First Silver Artel.[2]

[1] P. Schaffer, *Fabergé, A Loan Exhibition for the benefit of The Cooper-Hewitt Museum, The Smithsonian Institution's National Museum of Design* (New York, 1983), fig. 409.
[2] Ibid., fig. 408.

*107*

## Bactrian Camel

*St. Petersburg, firm of Carl Fabergé*
*Agate, rubies*
*H: 2 ½ in (6.3 cm); L: 1 ⅛ in (2.8 cm); D: 2 ¼ in (5.7 cm)*
*Provenance: A La Vieille Russie, New York; Mrs. Clara Peck*
*American Museum of Natural History, gift of the estate of Clara Peck,*
*97950*

The two-humped Bactrian camel of Asia wears its heavy winter coat. It is carved of banded agate varying in color from brown to gray and has tiny ruby eyes. Fabergé crafted other Bactrian camels, including one in the Smithsonian Institution's National Museum of Design that is shown with its short summer coat rendered in bowenite.[1]

[1] A. K. Snowman, *Fabergé: Jeweler to Royalty* (New York: Cooper-Hewitt Museum, ex. cat., 1983), 66–67.

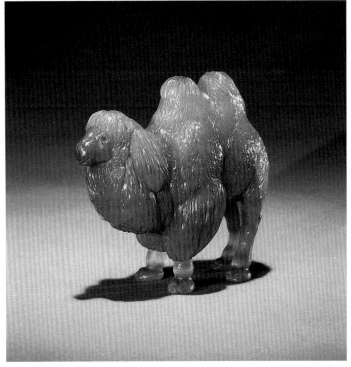

*Actual size*

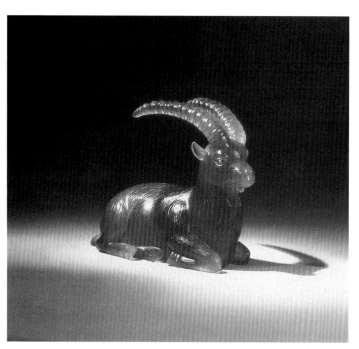

*Actual size*

## Ibex

*St. Petersburg, firm of Carl Fabergé*
*Agate, diamonds*
*H: 1 ⅞ in (4.8 cm)*
*Provenance: Mrs. Hasson; Sir George Cooper*
*The Castle Howard Collection, Yorkshire*

The seated ibex (*capra sibirica*) is executed in honey-colored agate and has rose-cut diamond eyes. This central Asian wild goat characterized by knotted horns that can attain a length of over five feet is more striking than its smaller European counterpart, the Alpine wild goat (*capra ibex*).

## 109

## *Chimpanzee*

*St. Petersburg, firm of Carl Fabergé*
*Banded agate, diamonds*
*H: 2 ⅛ in (6.4 cm)*
*Provenance: Henry Walters*
*The Walters Art Museum, acquired by Henry Walters, 1900, 42.353*

This whimsical agate chimpanzee was one of Henry Walters' purchases during his visit to the House of Fabergé in 1900. Given their droll expressions, chimpanzees were popular subjects. A similar example, also in agate, but with olivine eyes, belongs to the Royal Collection, London.[1]

[1] *Fabergé*, The Queen's Gallery, Buckingham Palace (London, 1995), 40–41, (inv. no. 40377).

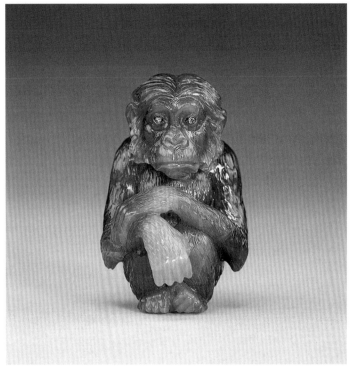

*Actual size*

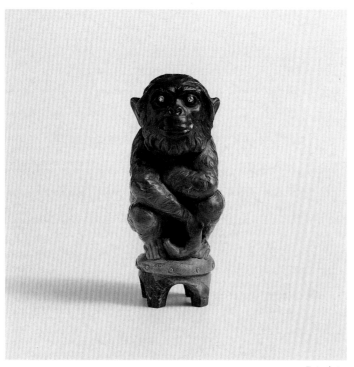

*Actual size*

## Chimpanzee

*St. Petersburg, firm of Carl Fabergé*
*Petrified wood, diamonds, agate, gold*
*H: 2 ½ in (6.3 cm)*
*Provenance: Lady Paget, London*
*The Woolf Family Collection*

Posed on a small agate circus stool is a chimpanzee carved of petrified wood with brilliant-cut diamond eyes set in gold. In Fabergé's London sales ledgers for 1903–15, it is listed as: "Lady Paget: Chimpanzee, petrified wood, inventory number *24223*, December 12, 1915, 55 pounds, 328 rubles."[1] Henry Bainbridge wrote of Lady Paget: "wife of General Sir Arthur Paget, an American if I remember rightly, and charming for a certainty. It was she who put Fabergé's wares on public exhibition for the first time in England. The occasion was the bazaar in the Albert Hall on June 21st, 22nd, 23rd, 1904. . . ."[2]

[1] G. von Habsburg, *Fabergé, Imperial Craftsman and his World* (London, 2000), 309, fig. 829.
[2] H. C. Bainbridge, *Peter Carl Fabergé, Goldsmith and Jeweller to the Russian Imperial Court* (London, 1949), 90.

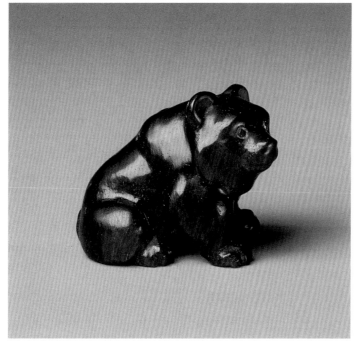

*Enlarged 200%*

*/ / /*

## Black Bear

*St, Petersburg, firm of Carl Fabergé*
*Obsidian, rubies*
*H: ¹⁵/₁₆ in (2.4 cm); L: ¹³/₁₆ in (2.1 cm); D: ¼ in (.6 cm)*
*Provenance: A La Vieille Russie, New York; Helen B. Sanders*
*The Brooklyn Museum of Art, bequest of Helen B. Sanders, 78.129.12*

This tiny carving represents a rotund seated bear cub. It is carved of
obsidian and has eyes inset with rubies.

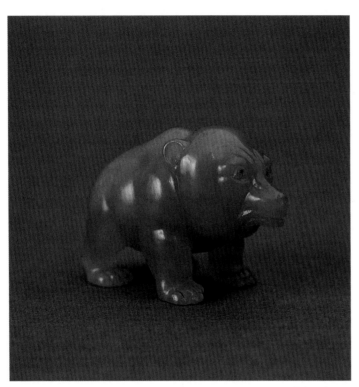

*Enlarged 150%*

## *Bear*

*St. Petersburg, firm of Carl Fabergé*
*Bowenite, rubies*
*H: 1 ¼ in (3.3 cm); L: 2 ¼ in (5.1 cm)*
*Provenance: Agathon Carlovitch Fabergé; Leo Wainstein*
*Private Collection, Finland*

The bear cub, executed in light green bowenite, has ruby eyes (the rubies were lost and replaced in 1979).

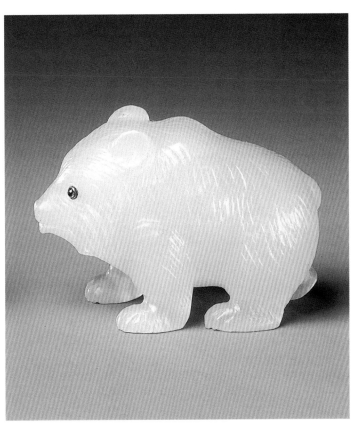

*Enlarged 150%*

## Polar Bear Cub

*St. Petersburg, firm of Carl Fabergé*
*Bowenite, rubies*
*H: 1 ⅝ in (4.1 cm); L: 2 in (5.1 cm); D: 1 in (2.5 cm)*
*Provenance: A La Vieille Russie, New York; Helen B. Sanders*
*The Brooklyn Museum of Art, bequest of Helen B. Sanders, 78.129.10*

This young bear has been carved from pale yellow bowenite, and its eyes are inset with rubies. Finely incised lines suggest the bear's fur. Fabergé produced an even younger bear cub, also carved from bowenite with ruby eyes.[1]

[1] G. von Habsburg, *Fabergé, Hofjuwelier der Zaren* (Munich, 1986), 194, no. 303.

## Polar Bear

*St. Petersburg, firm of Carl Fabergé*
*Workmaster: August Hollming (marked with his initials)*
*Rock crystal, rubies*
*L: 6 in (15.2 cm)*
*Provenance: A La Vieille Russie, New York; Lansdell K. Christie, Long Island,*
*New York; A La Vieille Russie, New York*
*The Forbes Magazine Collection, New York*

This bear is of rock crystal, a translucent material that, where carved, suggests the whiteness of the bear and, at the same time, where left uncut, conveys a sense of the chilled iceberg on which the bear, with his ruby eyes, stands. A drilled hole in the crystal indicates that a hardstone fish was originally attached to the base.

August Frederik Hollming (1854–1913), a Finnish jeweler, settled in St. Petersburg in 1876 and qualified as a master goldsmith in 1880. That year he opened his own workshop, which he moved to the third floor of 24 Bolshaya Morskaya, Fabergé's address, in 1900.

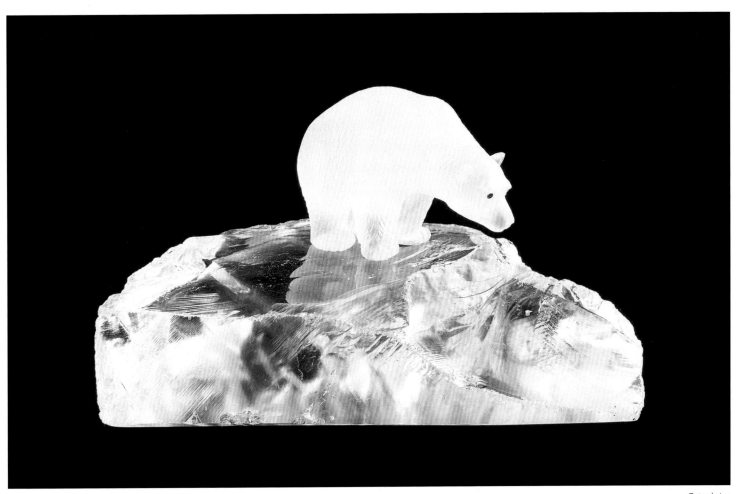

*Actual size*

*115*

## Seals on an Ice Floe

*St. Petersburg, firm of Carl Fabergé*
*Obsidian, rock crystal, diamonds*
*H: 6 ½ in (16.6 cm); L: 6 in (15.1 cm); W: 3 ¾ in (9.5 cm)*
*Provenance: Mrs. Clara Peck*
*American Museum of Natural History, gift of the estate of Clara Peck,*
*97965*

On an ice floe of rock crystal, a pup seal nuzzles against its mother. The highly polished, lustrous, gray chatoyant obsidian suggests the smooth, glistening fur of the animals. Their eyes are rendered with small rose-cut diamonds. The rock crystal is left in a rough state and contains cracks that simulate the appearance of fissures in an ice floe. To enhance the sparkling appearance of the crystal, ten diamonds have been inserted in its surface.

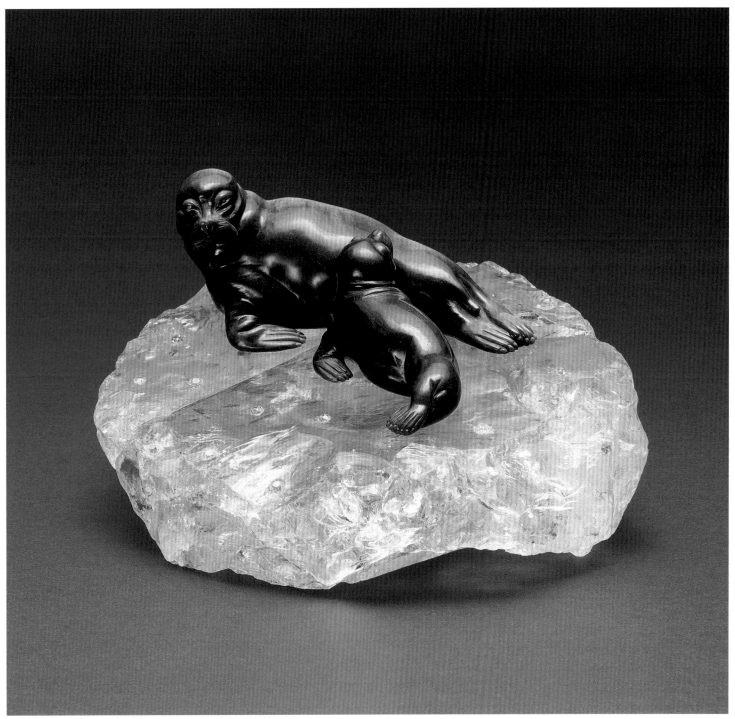

*Actual size*

*Actual size*

## Cicada

*St. Petersburg, firm of Carl Fabergé*
*Siberian nephrite, diamonds*
*L: 2 ⁹⁄₁₆ in (6.5 cm)*
*The Woolf Family Collection*

This carving may have been inspired by a Japanese source such as a netsuke. In poetry and painting, the cicada and its song bear wistful associations with autumn, death, and regeneration.

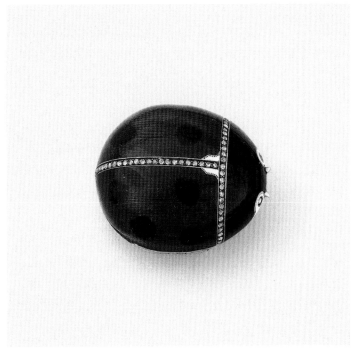

*Actual size*

*117*

## Ladybug Box

*St. Petersburg, firm of Carl Fabergé*
*Assay mark for 1896–1908*
*Workmaster: Mikhail Perkhin (marked with his initials)*
*Gold (56 zolotnik), enamel, diamonds*
*H: 13/16 in (2 cm); L: 1 15/16 in (4.9 cm); D: 1 3/8 in (3.5 cm)*
*Provenance: India Early Minshall*
*The Cleveland Museum of Art, the India Early Minshall Collection, 1966.465*

The hinged gold box, shaped as a ladybug, is decorated in translucent enamel in naturalistic colors over an engraved ground. The insect's wings are outlined with rows of rose-cut diamonds, and its feet on the bottom of the box are of gold. The Fabergé firm also produced an enameled gold ladybug vanity case.[1]

[1] M. C. Ross, *The Art of Karl Fabergé and his Contemporaries* (Norman, OK, 1965), 57.

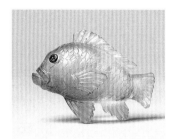

*Actual size*

## 118

## *Goldfish*

*St. Petersburg, firm of Carl Fabergé*
*Topaz, diamonds, gold*
*H: 1 in (2.6 cm); L: 1 5/16 in (3.4 cm); D: 5/8 in (1.6 cm)*
*Provenance: India Early Minshall*
*The Cleveland Museum of Art, the India Early Minshall Collection,*
*1966.453*

The topaz fish has rose-cut diamond eyes set in gold. Remarkable
attention has been given to the patterns of scales that vary over the
fish's surface, particularly in the region of the mouth. The fins are
thought to have been re-carved. Another goldfish in tiger's eye with
diamond eyes is illustrated in *The Art of Peter Carl Fabergé*.[1]

[1] *The Art of Peter Carl Fabergé*, A La Vieille Russie (New York, 1961), no.18.

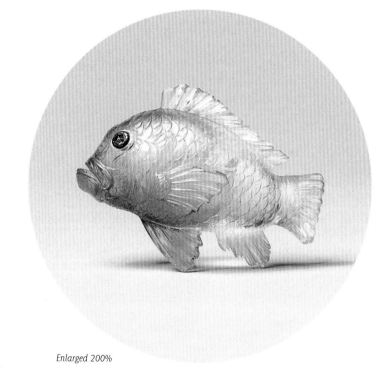

*Enlarged 200%*

*119*

## Chameleon Hand Seal

*St. Petersburg, firm of Carl Fabergé*
*Nephrite, diamonds, gold, silver, enamel*
*H: 3 ⅝ in (9.2 cm); W: 1 ⅛ in (2.9 cm); D: 2 ⅛ in (5.4 cm)*
*Provenance: The Imperial Apartments, St. Petersburg (until 1918);*
*Government of the U.S.S.R.; Hammer Galleries, Inc., New York;*
*Matilda Geddings Gray*
*New Orleans Museum of Art, on loan from Matilda Geddings Gray*
*Foundation, EL.1983.163*

A naturalistically rendered nephrite chameleon with scaly textured skin
and diamond eyes inset in gold is precariously perched at the top of the
seal handle. The handle is enameled in pink over an *ondé*, or wavy,
guilloché ground. Originally, the seal, which unscrews, may have been
engraved with an Imperial cipher or monogram, but it now bears in
script the monogram of Matilda Geddings Gray.

   Fabergé's use of amphibians as decorative motifs for hand seals and
parasol handles may reflect his response to the combined influences of
the Art Nouveau and Japonisme movements that swept Europe at the
turn of the twentieth century. For Europeans, the Japanese artists'
adoption of such creatures as frogs, lizards, snails, mice, and insects for
decorative use proved revolutionary.

*Actual size*

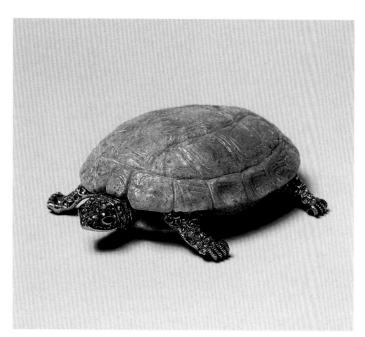

*Actual size*

## Turtle Bell Push

*St. Petersburg, firm of Carl Fabergé*
*Incised with inventory no. 7434*
*Agate, gold, silver, diamonds, rubies*
*H: 1 in (2.5 cm); L: 3 in (7.6 cm); D: 2 ⅜ in (6.1 cm)*
*Provenance: India Early Minshall*
*The Cleveland Museum of Art, the India Early Minshall Collection,*
*1966.473*

This creature has a pink agate shell and ruby eyes. Its head, feet, and tail are of silver, pavé-set with rose-cut diamonds, and its claws are of gold. Despite the fanciful color, the turtle is carved with remarkable attention to such naturalistic details as the irregular surface of its shell and its large, hooded eyes. To activate the electric bell, the head is pushed. Similar in appearance is a tortoise carved of crocidolite, also with silver feet pavé-set with rose-cut diamonds, and with gold claws, which is said to have been fabricated in the workshop of Mikhail Perkhin.[1] Another agate-shelled tortoise was sold at Christie's in 1976.[2]

[1] *Important Objects by Carl Fabergé and Russian Works of Art*, Christie's, Geneva, 10 May 1989, lot 104.
[2] Christie's, Geneva, 28 April 1976, lot 184.

*121*

## Toad

*St. Petersburg, firm of Carl Fabergé*
*Bowenite, rubies*
*H: 2 in (5.1 cm)*
*Original fitted case, lining stamped with the Imperial warrant and*
Fabergé, St. Petersburg, Moscow
*Provenance: The Sterling Trust*
*The Woolf Family Collection*

The carver has realistically depicted the green bowenite toad, warts and all. Its eyes are inset with cabochon rubies. A Japanese netsuke may have provided a prototype for this carving.

*Actual size*

*122*

## Frog

*St. Petersburg, firm of Carl Fabergé*
*Jadeite, rubies, gold*
*H: 1 ⅜ in (3.5 cm); L: 2 in (5.1 cm); D: 1 ½ in (3.8 cm)*
*Provenance: A La Vieille Russie, New York; Helen B. Sanders*
*The Brooklyn Museum of Art, bequest of Helen B. Sanders, 78.129.11*

The pale green jadeite has been carved to resemble closely the color and texture of a frog's moist, glandular skin. Attention has been given to such distinctive features as its tympana, or ear, and the ridges extending along its back.

*Actual size*

*123*

## Frog on a Stand

*St. Petersburg, firm of Carl Fabergé*
*Serpentine, marble, diamonds, silver*
*H: 4 ½ in (11.4 cm)*
*The Christian de Guigné Collection*

Even though they were carved with remarkable naturalism, amphibians served as amusing grotesqueries for Fabergé's parasol handles, hand seals, and decorative stands. In this example, a green serpentine frog with diamond eyes set in silver perilously clings to his marble stand. In a related work in which a serpentine frog is poised on a later agate stand, an almost identical approach is used in delineating the veins in its webbed feet.[1] In yet another variant, the nephrite frog is perched on a modern velvet stand with its toes spread wide apart and its veins ignored.[2] Very similar to the latter is a nephrite frog mounted on a white guilloché parasol handle that belongs to Joan and Melissa Rivers.[3]

[1] G. von Habsburg, *Fabergé in America* (San Francisco, 1996), 49, fig. 27.
[2] Idem, *Fabergé, Hofjuwelier der Zaren* (Munich, 1986), 200–1, fig. 347.
[3] G. von Habsburg et al., *Fabergé, Imperial Craftsman and his World* (London, 2000), 304, fig. 298.

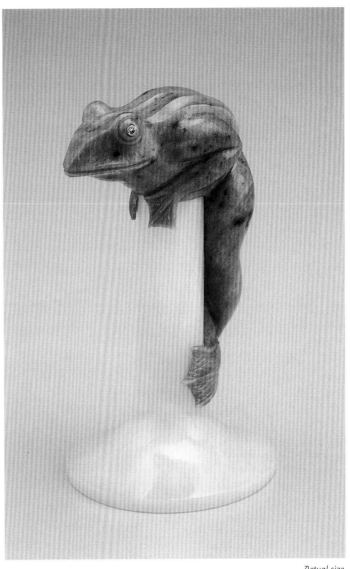

*Actual size*

# Selected Reading

*The Art of Peter Carl Fabergé*, A La Vieille Russie. New York, 1961.

BAINBRIDGE, H. C. *Peter Carl Fabergé, His Life and Work*. London, 1949.

*Carl Fabergé, Goldsmith to the Tsar*. E. Welander-Berggren, ed. Stockholm, 1997.

CHENEVIÈRE, A. *Russian Furniture, The Golden Age, 1780–1840*. New York, 1988.

CURRY, D. P. *Fabergé, Virginia Museum of Fine Arts*. Richmond, 1995.

EDWARDS, L. A., and M. M. Krebs, *Netsuke, The Collection of the Peabody Museum of Salem*. Salem, MA, 1980.

*Fabergé*, The Queen's Gallery, Buckingham Palace. London, 1995.

*Fabergé, 1846–1920*. London, 1977.

*Fabergé from the Royal Collection*. London, 1985.

FABERGÉ, T. F., L. G. Proler, and V. V. Skurlov. *The Fabergé Imperial Easter Eggs*. London, 1997.

——, A. Gorinya, and V. V. Skurlov, *Fabergé and the Petersburg Jewelers*. St. Petersburg, 1997.

——, and V. V. Skurlov. *Faberzhe I petersburgskie iuveliry: statei, arckhiunykh dokumentov po istorli ruggkogo iuvelirgnogo iskussiva*. St. Petersburg, 1977.

FARRINGTON, K. *Fabergé*. San Diego, 1999.

FORBES, C. *Fabergé Eggs, Imperial Russian Fantasies*. New York, 1980.

——, and R. Tromeur-Brenner. *Fabergé, The Forbes Collection*. New York, ca. 1999.

——, J. G. Prinz von Hohenzollern, and I. Rodimtseva. *Fabergé, The Imperial Eggs*. San Diego and Moscow, 1989.

GHOSN, M. Y. *Collection William Kazan, Objets de vertu par Fabergé*. Paris, ca. 1996.

*Golden Years of Fabergé, Drawings and Objects from the Wigström Workshop*, New York, 2000.

HABSBURG, G. VON. *Fabergé*. Geneva, 1987; New York, 1988.

——. *Fabergé, Hofjuwelier der Zaren*, Kunsthalle der Hypo-Kulturstiftung, ex. cat. Munich, 1986.

——. *Fabergé in America*. London, 1996.

——, and M. Lopato. *Fabergé, Imperial Jeweler*. New York, 1994.

——, and A. von Solodkoff. *Fabergé, Court Jeweler to the Tsars*. New York, 1979.

——, A. Solodkoff, and R. Bianchi. *Fabergé, Imperial Craftsman and his World*. London, 2000.

HAWLEY, H. *Fabergé and His Contemporaries, The India Early Minshall Collection of the Cleveland Museum of Art*. Cleveland, 1967.

HILL, G., ed. *Fabergé and the Russian Master Goldsmiths*. New York, 1989.

*The History of the House of Fabergé according to the Recollections of the Senior Master Craftsman of the Firm, Franz P. Birbaum*, T. F. Fabergé and V. V. Skurlov. St. Petersburg, 1992.

KEEFE, J. W. *Masterpieces of Fabergé, The Matilda Geddings Gray Foundation Collection*. New Orleans, 1993.

KRAIRIKSH, B. ed. *Fabergé*. Bangkok, n.d.

LESLEY, P. *Fabergé, A Catalog of the Lillian Thomas Pratt Collection of Russian Imperial Jewels*. Richmond, 1976.

LOWES, W. and C. L. McCanless. *Fabergé Eggs, A Retrospective Encyclopedia*. London, 2001.

McCANLESS, C. L. *Fabergé and his Works, An Annotated Biography of the First Century of his Art*. London, 1994.

ODOM, A. *Russian Enamels, Kievan Rus to Fabergé*, The Walters Art Gallery, ex. cat. London, 1996.

PFEFFER, S. *Fabergé Eggs, Masterpieces from Czarist Russia*. New York, 1990.

ROSS, M. C. *The Art of Karl Fabergé and his Contemporaries*. Norman, OK, 1965.

——. *Fabergé, Illustrated with Objects from the Walters Art Gallery*. Baltimore, 1952.

SCHAFFER, P. FABERGÉ, *A Loan Exhibition for the Cooper-Hewitt Museum*, A La Vieille Russie, ex. cat. New York, 1983.

SKURLOV, V. V. *Jewelers and Stonecutters of the Urals*. St. Petersburg, 2001.

SNOWMAN, A. K. *The Art of Carl Fabergé*. London, 1952.

——. *Eighteenth Century Gold Boxes of Europe*. London, 1966.

——. *Carl Fabergé, Goldsmith to the Imperial Court of Russia*. London and New York, 1979.

——. *Fabergé, Jeweler to Royalty*, Cooper-Hewitt Museum, ex. cat. New York, 1983.

——. *Fabergé: Lost and Found, The Recently Discovered Jewelry Designs from the St. Petersburg Archives*. New York, 1993.

SOLODKOFF, A. VON. *Masterpieces from the House of Fabergé*. New York, 1984.

——. *The Art of Carl Fabergé*. New York, 1988.

——. *Fabergé, Juwelier des Zarenhofes*. Heidelberg, 1995.